THE
Transparent
TOUCH

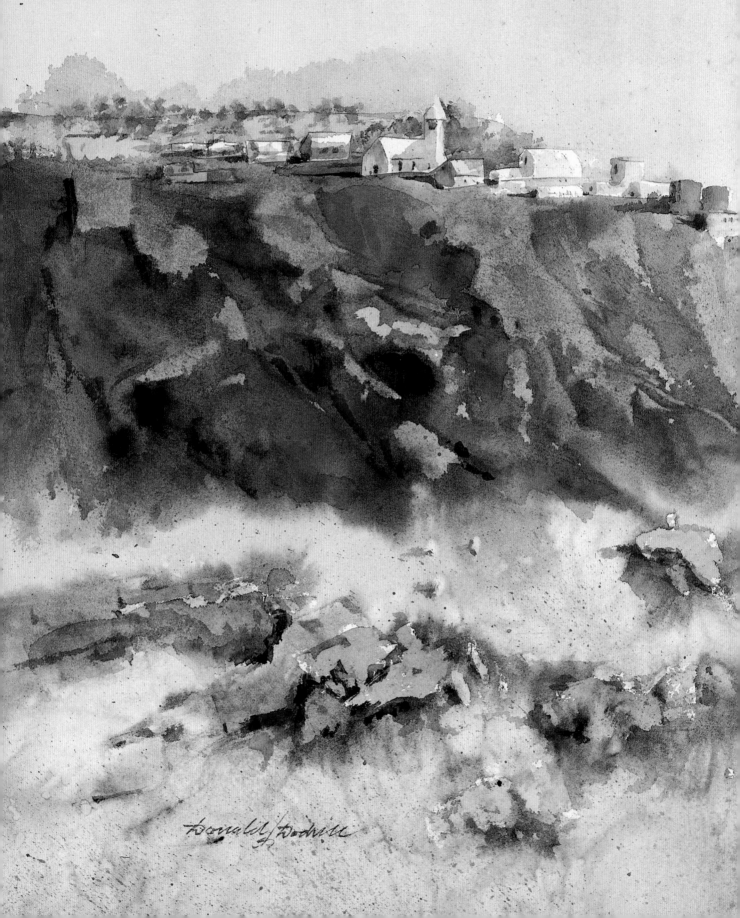

DONALD L. DODRILL

THE
Transparent
TOUCH

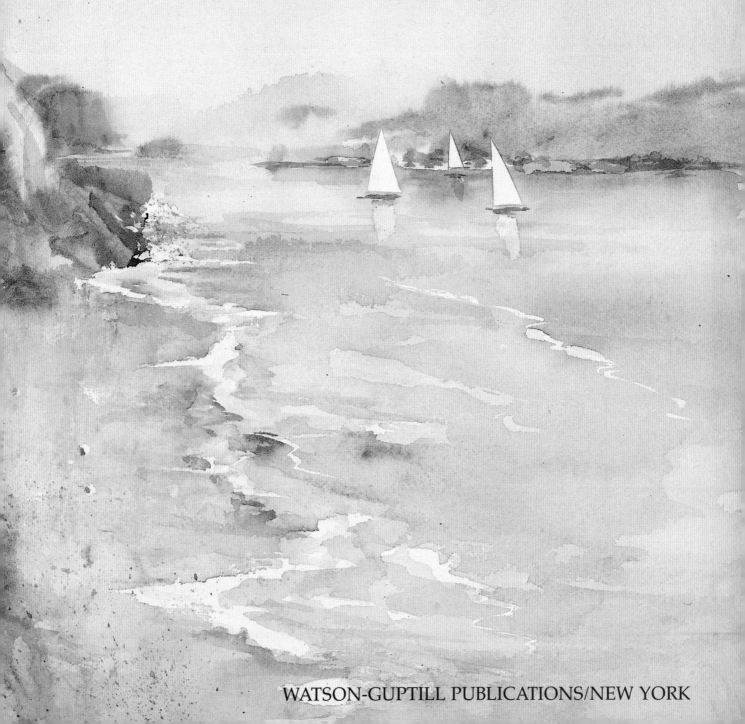

WATSON-GUPTILL PUBLICATIONS/NEW YORK

My sincere appreciation to my wife, Winifred, and our friend,
Anne F. Trupp, for their encouragement and contributions, and to
Mary Suffudy, executive editor, and Grace McVeigh, associate editor,
Watson-Guptill Publications, for professional guidance.

Painting Information
Title page:
Morning on the Inlet, 15″ × 20″ (38.1 × 50.8 cm). Collection of Steven Lichtblau.
Page 6:
In for Repairs, 15″ × 20″ (38.1 × 50.8 cm). Collection of Windon Gallery.
Page 8:
Alan's Garden, 20″ × 14″ (50.8 × 35.5 cm). Collection of Alan Twyman.
Page 10:
Marblehead Lighthouse—Lake Erie, 17″ × 24″ (43.1 × 60.9 cm). Collection of Mr. and Mrs. Roby Schottke.

Copyright © 1989 by Donald L. Dodrill
First published in 1989 by Watson-Guptill Publications,
a division of Billboard Publications, Inc.,
1515 Broadway, New York, N.Y. 10036

Library of Congress Cataloging-in-Publication Data

Dodrill, Donald L.
 The transparent touch / by Donald L . Dodrill
 p. cm.
 Includes index.
 1. Transparent watercolor painting—Technique. I. Title.
 ND2430.D64 1989 751.42′2—dc20 89-5729
 ISBN 0-8230-5440-3

Distributed in the United Kingdom by Phaidon Press Ltd.,
Musterlin House, Jordan Hill Road, Oxford OX2 8DP

Manufactured in Singapore

1 2 3 4 5 6 7 8 9 10 / 93 92 91 90 89

*To Fara Danielle Gianas (1976–1988), our granddaughter,
whose indomitable courage, love, and perceptiveness will forever serve
as inspiration in my work with people, painting, and writing.*

CONTENTS

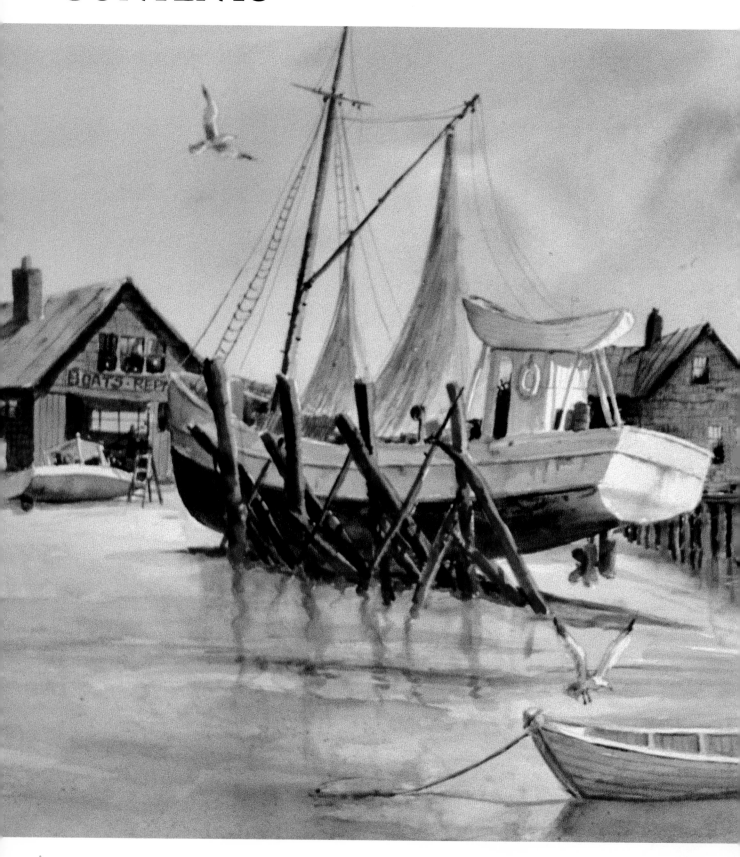

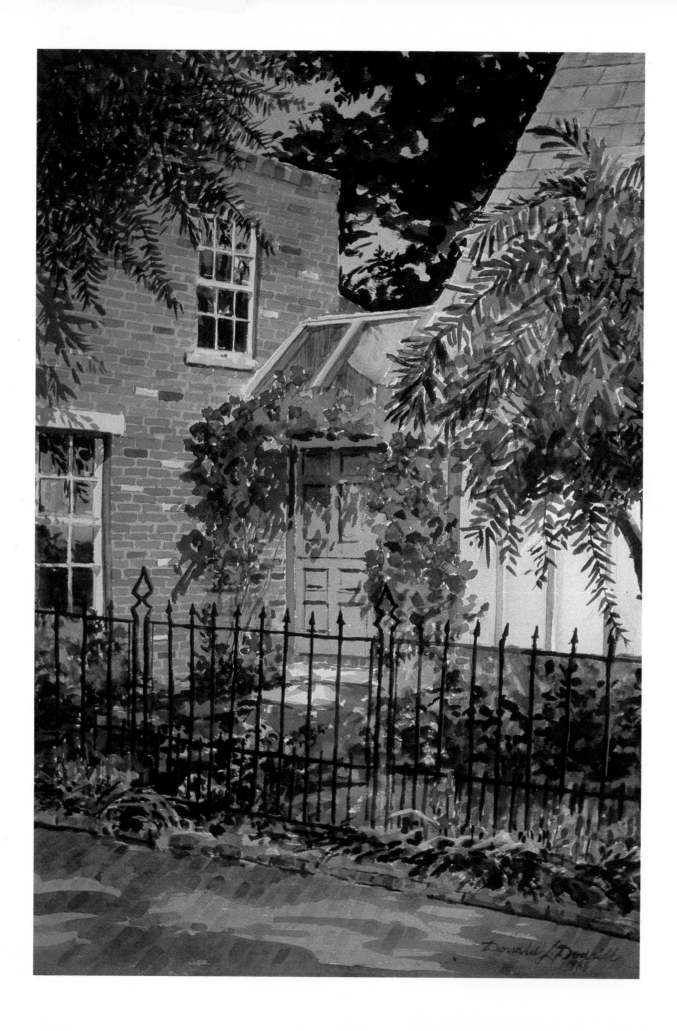

Donald J. Donahue
1988

PREFACE

Art has been a fundamental part of my life ever since I can remember. Even before I entered the first grade, I recall sketching elephants, an artistic effort inspired by a circus procession that passed our house on its way to the nearby town of Waldo, Ohio. The sight was so vivid in my mind that I spent endless hours drawing elephants—my first encounter with wildlife art. Art as a visual expression of the world about me never lessened from that time on. I felt compelled to draw, illustrating lessons that required no illustration and filling countless theme books with drawings of animals and people.

During high school years, my family lived on a farm in Delaware County, Ohio, land that had passed through generations of my mother's family. The one hundred acres of farmland and virgin woods served as a haven for wildlife. Another natural habitat, the Scioto River, coursed a short distance away. Nature and wildlife were a part of my life then, and they left a lasting impression that carried into my artistic life in later years.

After graduation from high school, I attended business school in Marion, Ohio, but my interest centered on art more than on business courses. I was first introduced to the watercolor medium when I accepted a job at a local advertising agency as an apprentice artist. The art director rendered many of his illustrations in watercolor. He was also a weekend and vacation painter, and it was through his work, instruction, and interest, in his role as mentor, that I began to see the difference between painting as fine art and painting as commercial illustration.

Opportunity for me to draw at the agency was minimal, but working with professional artists for nearly two years before I was drafted into the United States army was a valuable learning experience. In the army I was appointed art director of the service publication for the Panama Canal Zone and worked on the publication in my spare time. It was there that I painted my first watercolors as a "Sunday painter," using non-watercolor paper and a box of Prang paints. The watercolor bug had bitten me, and I was never to recover.

After the service years, I enrolled at The Ohio State University, where I earned a bachelor of fine arts degree, majoring in advertising art. In the 1970s I was accepted into the master's degree program in advertising illustration at Syracuse University, New York, a program of study designed expressly for professionals working in illustration and design. A master of fine arts degree qualified me to teach at the college level.

Drawing has always been a key part of my artistic development, and the courses at The Ohio State University and Syracuse University helped me to improve my drawing skills and broaden my technical knowledge. But, for me, constant sketching and direct observation are the principal impetus. Working as a graphic designer has also honed my skills with regard to composition and color relationships.

Watercolor organizations have played an important role in my development as a painter. Having the opportunity to talk with other artists painting in water mediums and to become more aware of different concepts is both stimulating and rewarding and gives the artist an opportunity to evaluate his or her work in the contemporary arena.

When I first started painting, I concentrated primarily on landscapes, but this interest soon grew to include architectural subjects, wildlife, figures, marine subjects, and, later, surrealistic and abstract images. So, rather than be termed a landscape, marine, or figure painter, I prefer to be called simply a *watercolor painter*, one who uses the medium to take advantage of transparent properties to best depict the subject matter.

When I painted certain types of subject matter, it was my custom to work in a series, doing several watercolors on the same theme. Frequently, I work on more than one series at a time.

I firmly believe that it is necessary to become involved with the subject you wish to paint. To have witnessed the scene—watched the bird or animal, ridden the roller coaster, walked in the snow, or observed sunlight gilding a building—heightens the emotional content, which thereby strengthens the painting.

The amount of time I spend on a watercolor painting varies. I prefer to spend more time on the concept than on the actual painting of it. For me, transparent watercolor is a medium of immediacy, and overworking the image or adding superfluous detail usually detracts from the work rather than enhancing it.

Watercolor as an agent of expression speaks a universal language of the people, the land, and the times. As a painter in the watercolor medium, I am privileged to be able to contribute to and share in this great and expanding experience.

DONALD LAWRENCE DODRILL, N.W.S.
Upper Arlington, Ohio, 1989

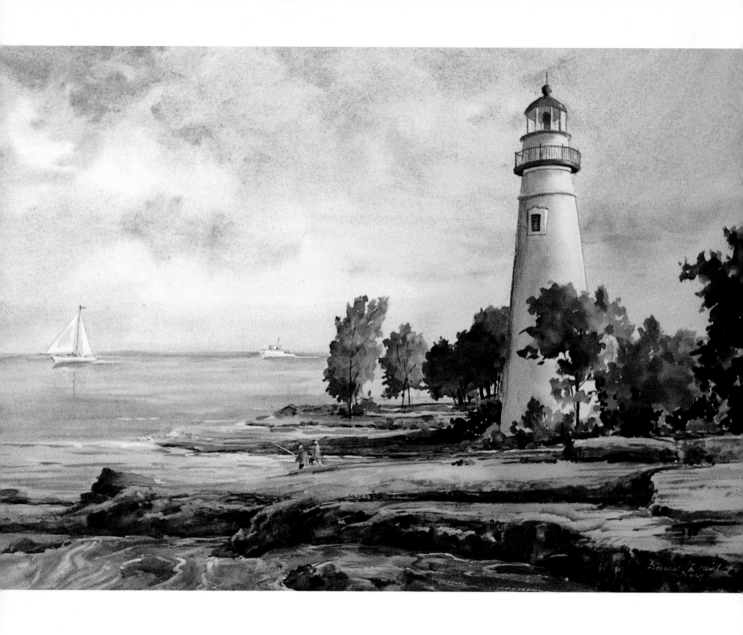

INTRODUCTION
Preparation for Painting

E ven after painting in transparent watercolor for nearly twenty-five years, I am still finding new means of expression in this challenging medium. Each new painting invites fresh discoveries and solutions. Watercolor presents a challenge that demands yet stimulates. Without the addition of gouache (opaque) dyes, inks, or collage material, transparent watercolor as a painting medium reflects a vibrancy and sparkle that is unique. To retain and explore this transparent quality is one of the enjoyments of being a watercolorist.

Here in *The Transparent Touch*, I explain how this exciting medium can be used in a variety of painting approaches for different subject matter. Each chapter groups paintings that are similar in a certain respect: whether by theme, location, subject, season, or time of day. The emphasis is not so much on step-by-step procedures in painting as on concept, environmental stimulus, color combinations, interpretation of time of day, time of year, as well as emotional involvement with the subject, and use of watercolor for maximum expression.

I encourage the reader to analyze and see the subject in terms of color, composition, mood, and emotional content so that he or she can adapt these elements to his or her own work. It is my objective to motivate and inspire artist-readers to seek more from their *own* vision, talent, and experience. For the nonartist readers, I hope my paintings evoke a view of the world that they can share in and enjoy.

Why, *when*, and *where* a subject was painted can sometimes be more interesting and enlightening than *how* it was painted. However, certain painting procedures using transparent watercolor are explained concurrently with individual paintings in this text. These procedures cover certain techniques necessary to achieve specific effects. Since the initial preparation for my watercolor paintings is basically the same, the setup steps and the materials used are outlined in a general way here.

Resources for Choosing the Painting's Concept

In a sense, most artists are collectors of visual information. I have found this inclination helpful in storing up images and concepts for future paintings. Having worked as a graphic designer and a watercolorist, I have built up an extensive file of reference materials that helps me select and narrow down my choice of concept and subject matter for my next painting. Much of this material consists of photographs of potential material for paintings, chosen from a wide range of subject matter.

To shoot these reference photographs, I use a 35-mm Pentax camera. For outside exposure, I use Kodak

Kodachrome 100 or 200 film. Interior color shots require 400 or 600 for available light and 200 film when using a flash. For black-and-white daylight exposure, I use Kodak 125 Plus-X Pan film. When I complete each painting, I make a slide record of it, using Kodak Ektachrome 160 film with a tungsten light source. I usually take three shots at slightly different F. settings and then select the slide with the best color quality for permanent record.

Besides photographs, I keep a collection of pencil or ink sketches that I completed on location. When traveling, I carry a sketchbook in the car. Naturally, I keep one at home and in my studio. Periodically I clip visual references from printed publications, which may be useful for my future work. All my resource materials are alphabetically arranged and filed according to subject, location, and time. I also find local libraries to be excellent sources of material.

Of course, the most direct inspiration for me is still the stimulus of painting on location. I enjoy this way of working; it is hard to achieve the same result in the studio that the outdoor atmosphere evokes. My on-location paintings depict water scenes, landscapes, cityscapes, architectural subjects, and interior scenes.

Sometimes I write verses before I paint, when a concept is just beginning to develop. Writing seems to strengthen my visual concept and helps to bring more emotional impact to it. At other times, the completed painting acts as inspiration for my verse. In *The Transparent Touch*, you will see samples of my descriptive verse at the start of each chapter—my "painting with words," as our son, Davan, calls it, to voice the theme of the chapter.

Watercolor Paper

The right kind of watercolor paper plays a major part in painting. Of the 100-percent rag, pH-neutral watercolor papers available on the market today, D'Arches, Fabriano, T. H. Saunders, Strathmore, and Whatman are the more familiar brand names and are produced in a variety of weights, sizes, and surface finishes, including hot-pressed (very smooth), cold-pressed (semirough), and rough (definite "tooth").

Most of my paintings have been produced on D'Arches Watercolor Paper, a 100-percent rag, pH-neutral, gelatin-sized, deckle-edged paper, mold-made in France. I use the 140-pound weight, cold-pressed surface, 22″ x 30″ size. This consistently dependable paper is excellent. Its surface is not disturbed by using masking agents, natural sponges, or scrapers.

D'Arches 22″ x 30″-size sheets, the most popular size, are produced in various weights: hot-pressed in 90-

pound and 140-pound weights; cold-pressed and rough in 90-, 140-, 300-, and 400-pound weights. Single, double, and triple elephant-size sheets of watercolor paper, plus watercolor rolls and watercolor blocks, may be found at local art supply stores. These watercolor papers are available in various weights.

In preparing paper for paint, I thoroughly soak the paper in water, quite often in a bathtub, where it can be completely and evenly covered. On other occasions, I simply saturate each side of the paper with a natural sponge. Then I place the paper on a quarter-inch-thick sheet of plywood board, allowing one inch of board space beyond the edge of the paper in each dimension. To make certain there are no air pockets, I press the paper flat by hand.

Although clamp systems are available, I use a long-necked stapler and staple the paper to the plywood, leaving approximately two to three inches of space between staples. To facilitate removing the staples, place a thin strip of cardboard about a half-inch wide on the four edges of the paper before stapling. When you complete the painting, pull up the four strips of cardboard. The staples will come up at the same time.

Paper can also be stretched on the plywood with gummed package tape. Wet one-half of the gummed surface of the tape and attach it to the plywood sheet. The other half will adhere to the wet sheet of watercolor paper without wetting and will create a tighter bond. Masking tape should not be used for this purpose because it will not adhere to the wet surface. I prefer using staples rather than tape because, on occasion, water backs up under the tape and creates "flowering" of the paint at the edges.

Painting Wet-in-Wet

Throughout the text of this book, I refer to the wet-in-wet approach. Briefly explained, this is working with damp pigment on the surface of watercolor paper that has been thoroughly wet either with a sponge or a large brush loaded with clear water. This technique uses one of the basic qualities of transparent watercolor, the blending of one color into another or the fine gradation of values.

Wet-in-wet painting, in addition to achieving beautiful luminous effects, offers a clear-cut advantage over gouache, acrylic, or tempera. None of these mediums can be blended to achieve the same luminous effect as the transparent watercolor medium, which uses the white of the paper beneath the transparent washes to intensify the luminosity.

Color and Light

Simply stated, color is the sensation that is aroused when light falls on the retina of the eye. Light may be perceived as originating directly from a light source or as reflected light. Color perception depends on the different degrees to which various wavelengths of light stimulate the eye.

Theoretically, objects themselves do not have color, but color is caused by their relative ability to absorb light rays. Because objects do not absorb the same amount of light as each wavelength, different colors are produced. When light strikes the object itself, it penetrates the surface to a degree. The amount of penetration and absorption depends upon the texture of the object. For example, if an object is blue, blue rays are reflected to the eye and we see the object as blue.

White light is a mixture of all colors. These may be seen when a narrow beam of light is passed through a glass prism or when sunlight, striking the curved surfaces of raindrops, is spread into a rainbow. White surfaces reflect all colors; black surfaces absorb them.

Scientists, especially those working in optics and photography, have gathered much information about color and light, but painters who work with painting pigments must look at color not merely as a reflection but as an entity in itself, with its own properties of hue, value, and intensity (or chroma). *Hue* describes the position of the color on a classic color wheel (a chromatic circle) and is used to name the color as, for instance, red, blue, green, or yellow. *Value* describes the lightness or darkness of the color—its position on a scale from white to black. *Intensity*, or *chroma*, refers to the brightness, saturation, and impact of color.

In trying to solve the problems of the telescope, Sir Isaac Newton discovered that all color is contained in sunlight and that when a beam of light passes through a prism, the direction of light waves is changed so that the violet waves, for example, are bent more sharply than red, and a rainbow results. Based on this information, Newton formed the first chromatic circle by bending these colors, pulling the red and violet ends around, and separating with purple. This color wheel invention was developed in the 1660s.

Color Systems

One of the most widely used systems of color in the United States is that invented by Albert N. Munsell. This system, designed in the form of a sphere, is a methodical way of standardizing, categorizing, and identifying colors, based on hue, value, and chroma.

Another source of color information is James Stockton's *Designer's Guide to Color* (Chronicle Books, San Francisco). Although meant to serve primarily as a tool for graphic, environmental, and product designers, as is the Munsell system, this compact book is of value to students and teachers of painting in investigating color combinations, their effects on one another, as well as their ultimate effect on the viewer. Information on these systems may be found at your local library.

By using painting pigments, an artist can make his own color wheel for help in determining color schemes and color harmonies. A color wheel may contain twelve or eighteen colors. The twelve-color wheel includes primary colors—yellow, red, and blue. Secondary colors are green, violet, and orange, with each color located halfway between two of the primary colors. Tertiary colors (a color produced by mixing two secondary colors)—yellow-green, blue-green, blue-violet, red-violet, and red-orange—are situated between the primaries and the secondaries on the color wheel. In the eighteen-

color wheel there would be two tertiary colors instead of one between each primary and secondary. For instance, the tertiary immediately to the right of the yellow primary is yellow-green-yellow, followed by green-yellow-green. Between green and blue will be the tertiary green-blue-green, with blue-green-blue on the right. The tertiaries between violet and blue are violet-blue-violet and blue-violet-blue. The tertiaries between violet and red are violet-red-violet and red-violet-red. Those between orange and yellow are orange-yellow-orange and yellow-orange-yellow.

The color wheel made from pigments is not as true as that made from printing inks, where the colors are yellow, cyan (a hue between blue and green), magenta (a reddish purple), and black. (The color reproduction in this book was the result of optical separation of phototransparencies, projected copy, into four pure and basic ink colors—yellow, cyan, magenta, and black—which were then printed precisely on top of each other to yield the full color effect of the original art.)

Physicists believe that red, green, and blue-violet are the true primaries. However, it is impossible to obtain a full-intensity yellow with such a pigment mixture. As artists, we are dealing with pigments and not with light, at least in the same sense as physicists are. By mixing the three primaries—red, yellow, and blue—an artist can obtain a great variety of colors. To produce as wide a range as possible, the primaries would have to include a magenta red and a blue green instead of just a blue.

The qualities of the pigments, how they mix and react with one another, are important to the artist. However, a color wheel is valuable not only for color schemes and harmonies but also because it provides a visual vocabulary of basic colors from which tints and shades may be made.

Color harmony by the use of pigments is a matter of personal taste; each artist has his own preferences, as do architects and interior designers. If an artist is working with either on commission work, it is important to have knowledge of color and color combinations.

Color Schemes

There are two kinds of color schemes in general: one in which the colors of nature are used, and the other in which these colors are modified. Good color schemes are made of only a few colors, properly selected, mixed, and blended. The simplest of all color schemes is one color used with black, white, or gray.

A monochromatic color scheme is one in which many shades of a single color are used. The color has to achieve deep enough tones for emphasis, thus the lighter colors, as, for instance, yellow, are eliminated.

An analogous, or similar, color scheme permits the use of colors that adjoin one another on the color wheel—for example, red, red-orange, and orange. These colors are usually mixed together in varying amounts so that numerous shades may be made from the few colors used.

One of the most common color schemes consists of a series of analogous colors, plus a complementary accent—a color on the opposite side of the wheel to the center of the analogous run. Analogous colors mixed together in varying amounts may be softened, deepened, and complemented by a complementary accent color. For a simple complementary scheme, two colors opposite each other on the color wheel are used, not necessarily in pure amounts—because a neutral gray would result—but in varying amounts. Many shades may be developed this way.

Although many watercolor painter/writers allude to the subject of color in their texts, one watercolorist, Jeanne Dobie, AWS, an artist from Pennsylvania, thoroughly explores the subject of color in her book *Making Color Sing* (Watson-Guptill Publications, New York, 1986). This book is informative and helpful to artists working with watercolor pigments.

The Color Study

In creating a watercolor, I first determine the values of the various parts of the picture. Without contrast, even the most subtle colors will not show off to good advantage. I try to select colors that are suitable to the subject being painted. Often when I am painting, I will do a value or a color study, the latter especially if I am working on a commissioned painting. This study shows me the possibilities and limitations of the colors, as well as the overall design. It also gives the client an opportunity to visualize the work in capsule form.

Pigments

In the early days, painting pigments were rare and the ingredients and ways of making them by hand from soils, minerals, animal matter, etc., were closely held secrets passed down through generations. Modern pigments, although still using some of the same ingredients, are manufactured from a wide variety of substances and combinations of substances through intricate chemical processes. Owing to the combination of elements and chemical reactions, there are many different pigments available today with a wide range of color choices. Today's watercolor pigments may be classified as those that make clear transparent washes and those that make "granulated" washes that give a mottled effect. Granulation occurs whether the color is applied in washes or by direct painting; it is not lessened by mixture with other pigments.

There are many brands of watercolor paints on the market, but I use transparent watercolors in tubes, Artists' Water Colours, made in England by Winsor & Newton. The color range and color consistency is of superior quality. Winsor & Newton also offers certain colors that are not available in some other brands. Colors such as Naples yellow, Davy's gray, mauve, cobalt violet, burnt sienna, neutral tint, and the cadmium colors, although produced by other manufacturers, lack the unique purity of color found in Winsor & Newton.

I do not use a palette with separated compartments. Instead, I use a butcher's tray of white-enameled metal approximately 12 inches by 16 inches in size without compartments. This flat surface provides a large area for mixing and testing colors.

Brushes

Almost all of my brushes are Winsor & Newton Series 7 Kolinsky Sable in sizes No. 1 through No. 8. I also use a two-inch bristle brush manufactured by Winsor & Newton, Series 965, and a Grumbacher 3/4-inch square-tip brush. The two-inch bristle brush is indispensable for laying in washes in large areas such as sky and water areas. The square-tip 3/4-inch brush works well for painting flat washes in more restricted areas.

Special Materials and Tools

Like most watercolorists, I use a few painting aids and materials in addition to the traditional assortment of paints and brushes.

Since there is no opaque white paint in totally transparent watercolor painting, the white of the paper serves as the pure bright whites. To retain the white of the watercolor paper, I use two types of masking agents to hold back the reserved white areas when working in wet washes. Winsor & Newton Water Colour Art Masking Fluid, which has a slight yellow tint, works well. Several other brands of masking agents, manufactured in various colors, can also serve the purpose. I avoid white liquid masking agents because they are difficult to see against the white paper. Liquid masking is used generally to cover areas that are more detailed and complex, and it can easily be removed with a rubber cement pickup once the surrounding painted areas are completely dry.

The other masking device, masking tape, is employed where large simple areas are to be masked off and where crisp, sharp edges are desired. The tape is semitransparent and can be cut to the penciled image using an X-acto knife with a No. 11 blade. However, take care not to exert too much pressure on the knife—just enough to cut through the tape.

To create textured areas, I use a number of common tools—a toothbrush, a mouth-spray atomizer (fixative sprayer), salt in a shaker, and a plastic scraper, such as an expired credit card with rounded corners.

The toothbrush can be used to apply spatter to either a wet or a dry surface; it creates a finer texture on a dry surface and a more diffused effect on a wet one. Apply moist painting pigment to the toothbrush, then snap it on to the painted surface by pulling your thumb across the bristles. Make sure the paint is darker in value than the surface upon which it is used.

To secure a larger and more random spatter, I use a mouth- spray atomizer, an L-shaped hollow rod device, which has one end in a liquid paint container—for instance, a used but clean ink bottle. When the artist blows in the other end of the sprayer, paint is forced from the container up through the tube and out the opening in the L-joint. The effect is a spattering of both large and small dots. Spatter effect can be used to suggest textures, such as sand, gravel, aged wood, and various other surfaces.

Salt applied to a wet painted surface by an ordinary salt shaker creates various patterns depending on the concentration of salt, surface wetness, amount of pigment, and, to some degree, color. It can create many interesting effects, such as the appearance of ice crystals, lichens, cluster of blossoms, decaying wood, rusting metal.

Plastic scrapers can be used to scrape through a wet wash of paint laid over a dry one. Using the edge of the scraper to scrape through the second layer and expose the initial wash, you can achieve fine lines, as, for instance, those suggesting tall grass. Using the side of the scraper, you can create other interesting effects, such as ridges in rocks or bark on trees.

To lift off paint and soften or diminish intensity of color, I prefer to use the natural sponge rather than the synthetic type because it is softer, holds more water, and spreads the water more evenly. The lift-off technique, using a sponge, can be employed to create such atmospheric conditions as haze or fog. For this purpose, I have also used a soft, water-absorbent paper towel. The lift-off technique can decrease color intensity; it can be used to create the illusion of motion in moving figures, animals, and objects. I've used these techniques in paintings in this book, which you will note in the descriptive information accompanying each painting. However, I strongly recommend that special effects be used judiciously, only to enhance and add to the painting as a whole. If you use them in a random way, they become simply a "bag of tricks."

Transferring the Pencil Sketch

Even though I may be using photographic reference, I almost always work out the painting image in half- or quarter-size proportions in pencil, establishing some basic values, usually dark, middle, and light tones. Frequently the photographic reference may come from several photos requiring rearrangements of compositional elements. The smaller image is enlarged to the working size by the use of an opaque projector or a camera lucida. If a projector or lucida is not available, the smaller sketch can be divided by pencil lines into a grid using four equally spaced vertical lines and three equally spaced horizontal lines. The working size is then divided proportionally in the same manner, and the image is transferred visually, square by square, ensuring a more proportionate image.

When working on a painting without a preconceived concept, I use no pencil guidelines, letting the paint 's interaction with the wet surface establish the direction.

Sequence of Painting Steps

Most of my paintings, particularly landscapes, water-scapes, and cityscapes, proceed from sketch to finished painting in similar stages when painted in the studio. To illustrate a typical series of steps, I have photographed my painting *State Capitol* (Ohio Statehouse) as it appeared at separate points in the painting process.

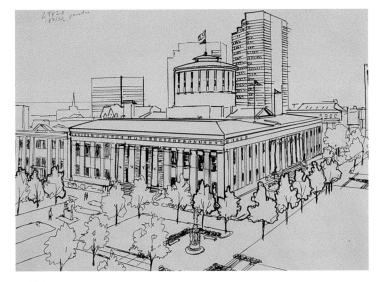

This is a one-half-size sketch of the Ohio Statehouse, which developed from several photographs I had taken from the eighth floor of an office building facing Capitol Square on the north. I drew the sketch with a black felt marker pen so that the image would project well on my camera lucida. No attempt was made to show value changes on the sketch, only linear outlines. The photographic reference had established the light source as coming from the west, striking the front planes of the Capitol and adjacent buildings so there was no need to establish this on the initial drawing.

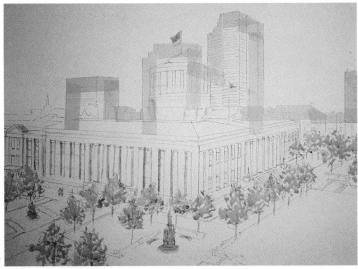

After projecting the sketch directly onto the stretched D'Arches paper stapled to a plywood panel, I masked out the edges of the structure with masking tape to retain sharp definite outlines when painting in the wet-in-wet sky. The X-acto knife can be used to fit the masking tape to the pencil outlines. I masked out the trees bordering the Capitol and the foreground statue with Winsor & Newton Watercolour Art Masking Fluid so the background could be painted in without a lot of tedious circuiting around small objects. Where the outline of the object was irregular or complicated, I used liquid masking agent.

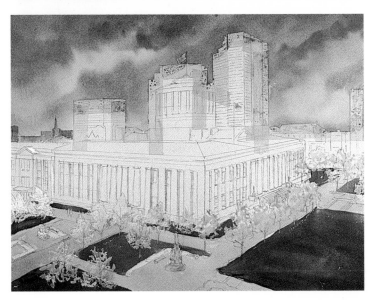

At this stage, I applied the first washes of color in the sky and grass areas. Using a 2½-inch bristle brush, I wet the sky area with clear water before applying washes of cerulean blue, Davy's gray, and a touch of Naples yellow. I left some areas in lighter values to approximate cloud formations. On the wet surface the paint blended into these areas and created an illusion of soft clouds. The grass areas were not prewet but were painted in with a wet wash that blended Hooker's green, cadmium yellow, and burnt sienna.

I removed the tape from the buildings when the sky and grass areas were dry but left it in place on the trees and statue. Using mostly grays, blues, and beiges, I painted in the background buildings, keeping in mind that the light was coming from the west, or the right side, and the building surfaces facing that direction were lighter in value. At this point, also, the red and blue flags, which had been masked out, were painted in.

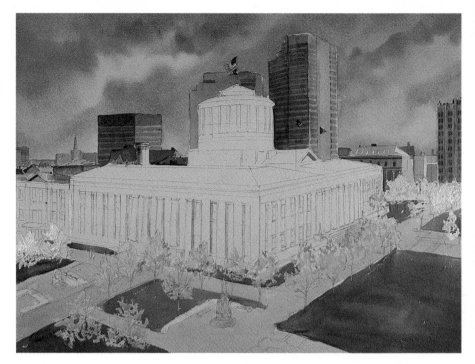

The principal point of interest—the Capitol or Statehouse structure—was next painted with a mixture of Davy's gray, cerulean blue, neutral tint, and Antwerp blue. A light wash of Naples yellow, brushed over the light-struck surfaces of dome and building, added a warm touch. When the wash had dried, I painted in the gray blue tones, differentiating values from the side to the front of the Capitol. The entire cupola was wet with clear water; then paint was let flow across the surface, becoming a darker value on the left side of the cupola, which gave it a rounded shape. In the windows, roof, and architectural details, darker values were added after the lighter ones had dried.

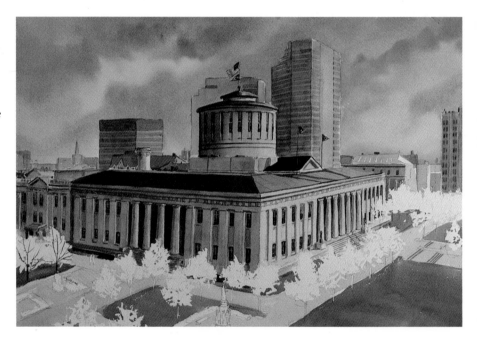

16

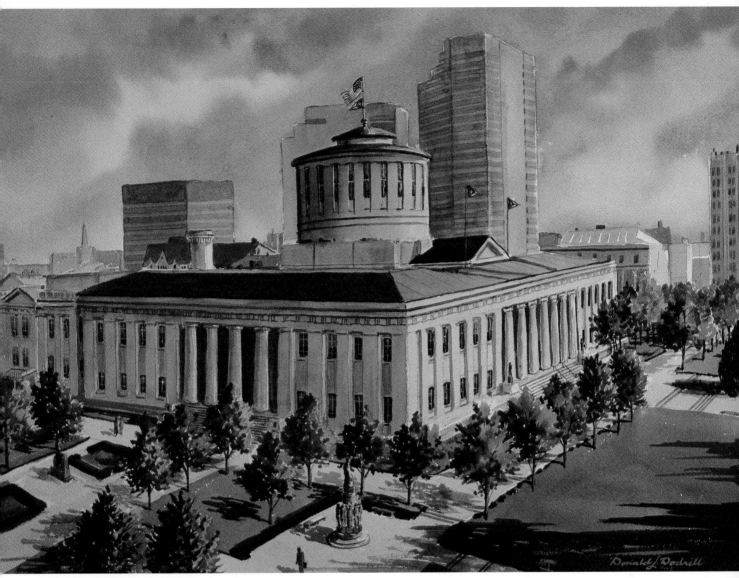

State Capitol, *15″ x 21″ (38.1 x 53.3 cm). Collection of Thane Griffin.*

Here, I painted in the sidewalk areas using a light wash of Davy's gray and Naples yellow. When it had dried, I painted in the trees with combinations of Hooker's green, alizarin crimson, sap green, and burnt sienna. Again, the light source coming from the right created a change of value in the tree shapes. The same value change held for the statue in the foreground. Small figures on walks and the shadows cast by the trees, statue, and figures were the final details worked on.

Although this approach is common in my studio work, on location it varies, from the standpoint of initial sketching, which is done directly on the painting surface. Also, in the field, I rarely use masking techniques. Basically, I always paint the large areas first, as well as the lighter values. Darker values and smaller details follow. Composition and color vary according to subject matter. Special textures, salt, and other aids are used when they contribute to the overall effect of the painting. Other painting approaches relating to particular subject matter are discussed throughout the book.

THE INLAND SERIES
Rivers, Lakes, Streams, and Landscapes of the Rural Midwest

Much in my native habitat—Ohio—has influenced my artistic direction. For the most part, I have always lived in the central area of the state. The major portion of my work shows river scenes, lakes, and landscapes from this region. Here, the countryside is especially flat in appearance. Small patches of woods dot the central farmlands and provide shelter for wildlife and barriers from the wind, which otherwise would make a clean sweep across the open fields.

Many of the scenes in this series—the inland series—are typical of those found in most Midwest states; others are indigenous to Ohio. The paintings of Ohio's rivers, streams, ponds, and lakes, combined with the open countryside provide a brief glimpse of the world that surrounds the city dweller beyond the urban limits. Primarily, they are landscapes and waterscapes, with architecture, people, and animals appearing only occasionally. Some, like barns and bridges, are evidence of a particular time and place, and once gone from man's environment, they may never be seen again. Others, like rivers and lakes, are timeless.

The architecture I am familiar with here stems mainly from the late nineteenth and early twentieth centuries—farmhouses set against a backdrop of barns and outbuildings in a variety of structural designs, the state of repair or disrepair depending on the attitude and affluence of the owners. This is basically a grain and dairy region. And although the number of small farms in Ohio is dwindling, "family farms" still produce diversified crops and livestock, particularly dairy and beef cattle, hogs, and sheep. Holstein-Friesian and Guernsey dairy cattle, stocky Black Angus and Hereford beef cattle are familiar sights on Ohio farms, and occasionally a flock of Shropshire sheep may be seen in the pasture. Duroc, Berkshire, and Poland China hogs—breeds of swine commonly found in Ohio—are raised for market.

During summer months, the animals, the farming activities, the fields ripening with wheat, tall glossy dark-green corn plants, the heads of violet-red clover, capture the imagination and evoke the thought of colors in the painter's mind. Wild mustard and chicory (blue dandelions), although interlopers in the farm fields, add a blaze of deep yellow and bright blue.

As the seasons change, so do the colors of the countryside. Trees and woods take on the wrappings of the season. Sky colors appear variegated and intense, particularly in the early morning and then at dusk. Waterways reflect light in ways that fascinate the watercolorist. Each river, creek, pond, and lake has its own individual character. Hues vary—there are blue-grays, greens, browns, blues in the rivers and the creeks. River islets, shoreline foliage, and a fair amount of wildlife—ducks, migratory great blue herons, and Canada geese—provide subjects from nature for one who paints near the water and shore areas in Ohio. The Scioto River and the Olentangy River pass through and around towns and villages on their way to the Ohio River.

Covered bridges span some of the small brooks and creeks, particularly to the south of Columbus in Fairfield County. Many other painters besides myself have considered these historic attractions interesting painting subjects. To the north along Lake Erie, rock formations, beach areas, and lake ports add interesting features to the landscape. One of the few remaining historic lighthouses—Marblehead Lighthouse, located on Marblehead Peninsula at Lake Erie—is a favorite painting motif of mine. (See page 10.)

As I look for painting material, I sometimes find that a simple motif and composition can be the most compelling, reminding me again and again of what American artist and teacher Edgar Whitney often told his students, "Less is more."

BELOW GRIGGS DAM

The constant low-key roar of
 rushing water
Saturates the still fall air and
 cloaks the atmosphere
With a misty haze making
 the day seem hotter
Than it really is.
Below the dam, the shallow
 water gurgles and
 wanders
Through a myriad of
 glistening stones
On its way downriver past a
 tiny islet,
Lapping at the shoreline,
 creating sparkling tones
Of sepia and emerald green.
Images of autumn foliage
 appear mirrored
In the glasslike river surface
 broken only by a splash
As a hungry bass leaps to
 catch a dragonfly
Gliding silently overhead,
 circling round and round,
Beckoning a solitary angler
 to cast line and lure
Toward the telltale ripples of
 the sound.

Capturing Reflections and Movement in Water Surfaces

Inland bodies of water, whether rivers, creeks, lakes, or ponds, have always held a magnetic attraction for me as painting subjects. Transparent watercolor is a natural painting medium for creating a water surface where shoreline and surface-positioned elements are reflected. When painting in the wet-in-wet washes, the only masking I use on water surface is to protect ripple lines or elements positioned thereon, such as a boat.

Ordinarily, the sky, landmasses, and shore foliage are painted first, leaving the water areas free of paint. The water area is then wet with clear water and left to dry slightly for approximately thirty seconds. Next, the basic color of the water is mixed, keeping in mind that the open areas of the water will reflect some of the sky color. Using a large flat-tipped brush (Winsor & Newton No. 965), the basic color of the water areas is brushed into the damp surface. The basic color of the water will vary depending on the sky color, depth of water, and the overall color relationships of the painting. Before the basic color of the water is dry, the reflections of the shoreline and any surface-positioned elements are painted into the damp surface incorporating color and

reflected shapes as they appear on the water's edge or above its surface.

A simple way to check the proper reflected shape is to make a tracing of the reflected image on tracing paper and simply turn the tracing over. The reversed image will provide an approximation of the reflected shape in the water. Still water is the best reflector of images. Rough or moving water breaks up and abstracts reflected shapes and images. A ripple line intersecting reflected shapes (masked out with liquid frisket) helps to reinforce the reflected image in the water as a reflection. This technique should not be overdone and should always conform to the water surface and objects that appear on it or at its edge. Examples of the use of ripple lines are found in several of the painting examples in this section.

Moving or falling water utilizes the white of the paper to emphasize the water action. To make it more dramatic, a dark background, usually rocks, helps accomplish this. Accents of light water values painted in the direction of the falling or moving water help to emphasize action and water direction.

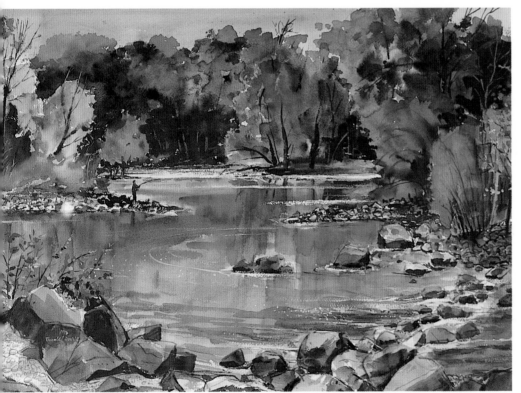

BELOW GRIGGS DAM, *16" x 21" (40.6 x 53.3 cm). Collection of Mr. and Mrs. Fred Patterson.*

Contrasts of Light and Shade on the Quiet Water's Surface

Below Griggs Dam was painted on location, with only minor details added later in the studio. I painted grass and vegetation bordering the river wet-in-wet, letting the fall colors blend and treating the clumps of trees as large shapes. I painted the rock areas in a generally light value of Davy's gray, sepia, and cerulean blue, then added darker definitions in sepia and neutral tint when the initial wash was dry, carefully leaving some white areas around the rocks to highlight the water flowing past. I left larger white areas on the water's surface to indicate sunlight reflecting on the water. I painted the river's surface wet-in-wet. The sun, now directly overhead, created high contrasts of light and shade. A solitary fisherman provides a sense of scale and human involvement.

The Balance of Shades of Green

I painted *Summer on the Olentangy* when the water in the river was low and some of the bed, normally under water, was exposed. These exposed light-value areas "locked in the composition" and provided a color relief from the greens of the trees and the river surface. Suggestions of burnt sienna in the tree trunks and the use of Naples yellow and Davy's gray in the sand and graveled surface of the riverbanks also lent color variation. Sometimes an abundance of green in summer foliage and grass poses a problem. When one color becomes dominant, I try to balance it against the other compatible colors and to vary the value and shade of the dominant color. In this case, I used various shades of green, gray-greens, blue-greens, yellow-greens, olive-greens intermixed with smaller sections of yellows and burnt siennas. Because the Olentangy River at this point was narrow and tree-lined, little sky color was reflected in the river, so the reflections were predominantly green.

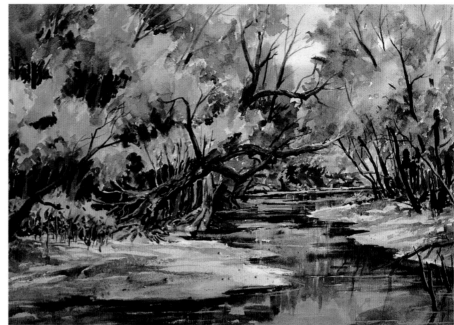

SUMMER ON THE OLENTANGY, *13" x 18" (33.0 x 45.7 cm). Private collection.*

Simplicity of Scene

Although I had originally intended to paint the historic Y-Bridge, I chose this view north of the bridge, which spans the converging Muskingum and Licking rivers in Zanesville. A small dam (in the foreground), combined with interesting surface reflections, and a railroad bridge a distance up the river provided a simpler, equally interesting composition. The dam offered a contrast of moving water vis-à-vis the still mirrorlike surface of the river. The colors in the river surface reflect the shore, bridge, and sky.

The surface of the river above the dam was painted wet-in-wet and the reflected shoreline areas intersected with lighter values of the water. These lighter areas were not masked out but were painted around when the darker reflected areas were added to the water surface. The dam, left as an unpainted area in the foreground, was painted last, which permitted areas of the white unpainted paper to emphasize the moving water. Usually I avoid carrying a compositional element into a corner of the painting, but in this painting, I felt that the positioning was justified and actually captured the viewer's attention.

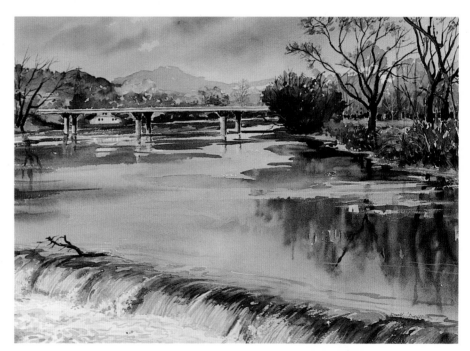

MUSKINGUM RIVER—ABOVE THE Y-BRIDGE, *16" x 21" (40.6 x 53.3 cm). United States Fidelity and Guaranty Company Purchase (private collection).*

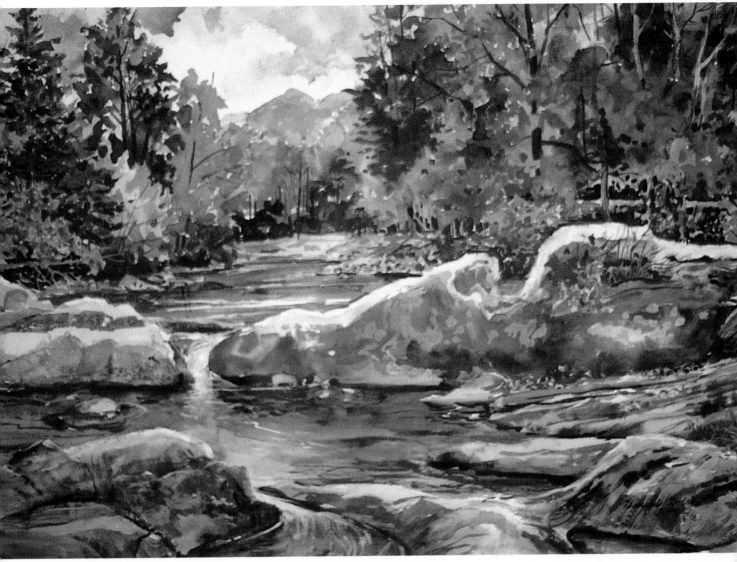

LITTLE PIDGEON RIVER, *16" x 22" (40.6 x 55.8 cm). Courtesy of Windon Gallery.*

Adding Interest with Rock, Texture, and Foliage Variation

Every fall for the past few years, a group of painters from the central Ohio area has traveled to Gatlinburg, Tennessee, for a week of painting. During one such trip to Tennessee, I painted *Little Pidgeon River* while sitting on one of the large boulders found in many sections of the Little Pidgeon River. The shallow—barely knee-deep—water is the color not of the sky or reflected objects but of the bottom of the river—a brownish olive-green, with rocks clearly visible in the riverbed.

Since it was October, an abundance of colorful foliage defined the banks, their colors intensified by the deep green of several tall pine trees. The boulders in the middle plane of the painting were so large that they nearly blocked the passage of the river stream. Where the water was able to flow smoothly among the boulders, an occasional small falls or rapids was formed. Craggy gray-green boulders combined with the sepia tones.

For *Little Pidgeon River*, I used a small amount of liquid masking, brushing it on to the boulders and rocks before applying the base wash. When the base wash, consisting of a mixture of Davy's gray and Hooker's green, had dried, I removed the masking and added another wash of a darker value to the same colors, with a touch of mauve. A scaly-textured surface resulted, approximating the boulder/rock appearance.

When I painted the water, I left light ripple lines around the larger boulders and suggested small falls in the center of the composition by keeping the water value very light. Since the sun was almost directly overhead and partially obscured by the clouds, I relied on value changes in the shoreline trees and rocks to create shapes. Sky, shoreline trees, and water areas were all painted wet-in-wet. Between the trees, you can see a distant ridge of the Great Smoky Mountains, which accentuates the depth of field.

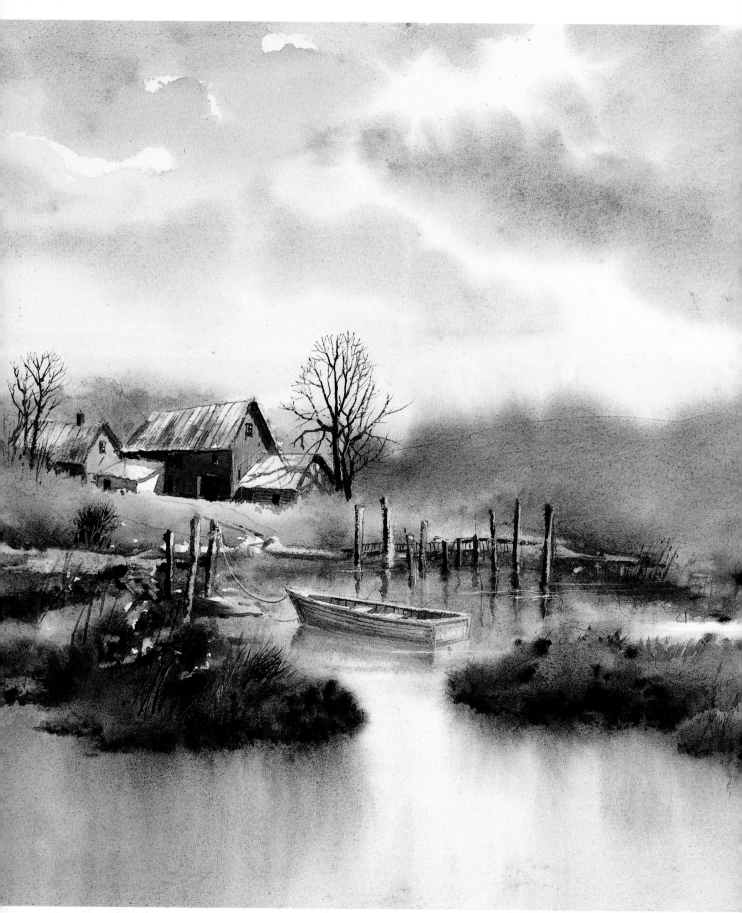

Farm Pond—Early November, *15" x 21" (38.1 x 53.3 cm). Professional collection of Dr. Steven H. Lichtblau.*

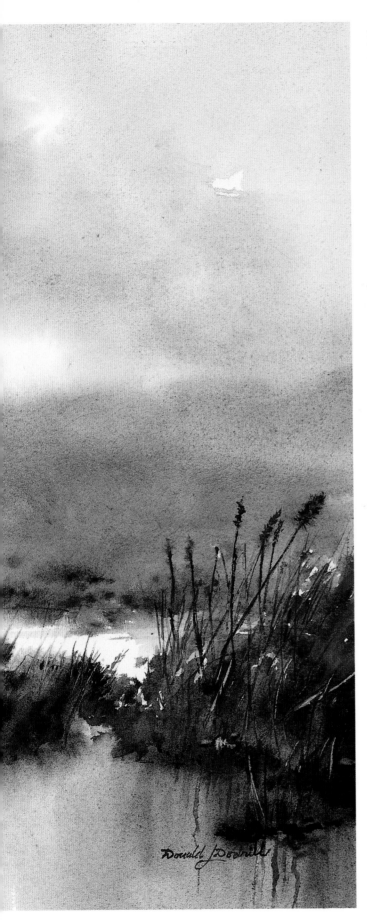

End of the Season, Seen in Somber Light

I painted *Farm Pond—Early November* from a sketch of a recreational-type pond in Union County, Ohio, with the visual dimensions of the pond expanded to improve the composition. Farm ponds are catch basins that provide water for livestock and serve as fire protection or are used for recreational activities. In this painting, I used a "November palette" of burnt sienna, sepia, mauve, and Davy's gray to capture not only the somberness of the month but a sort of melancholy "end-of-the-season" impression, when boating and fishing activities are curtailed until spring.

To begin with, I dampened the entire watercolor sheet with a large brush and let it dry for about thirty seconds. I then brushed in the sky and water areas using cerulean blue, mauve, and cobalt blue. The water area was kept a light, flat, mauve-blue value. Darker mauve-blue values were painted into the sky area to suggest cloud formations. When the sky and water areas were nearly dry, I painted in the grass area along the bank and the "grass islands" in the pond, using a combination of burnt sienna, Naples yellow, neutral tint, and mauve for the shore area grass. Sepia, neutral tint, and a touch of Antwerp blue were used to indicate the dark "grass islands." At this point, the paper was dry, and I added the smaller details of the buildings and boats. Then I rewet the area and added the reflections of the grass islands, the boat, and other shoreline elements, letting the darker mauve-neutral tint value blend in the water surface.

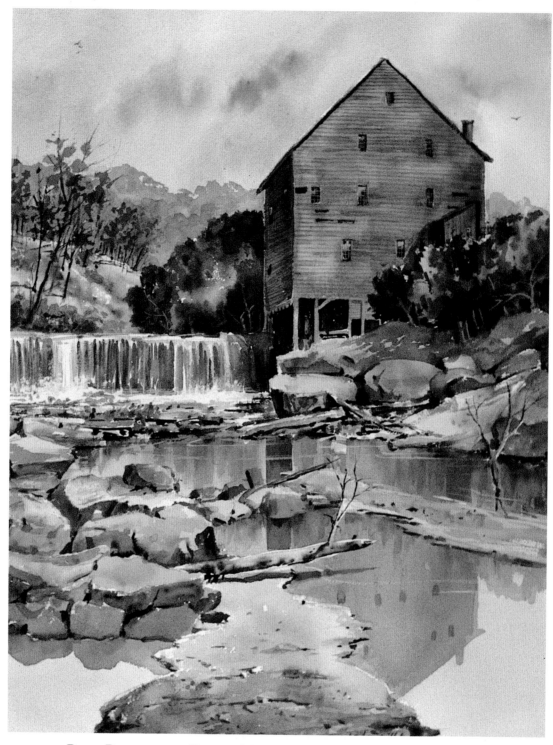

RURAL REFLECTIONS—GRANGER MILL, ZANESVILLE, OHIO, *16" x 22" (40.6 x 55.8 cm).*
Collection of Mr. and Mrs. John Mast III.

Movement, Light, and Color with Water Effects

Grist mills were built on creeks or rivers during the nineteenth and even into the early-twentieth century in order to use water as a source of power to turn the giant mill wheel when a natural waterfall was not in existence. This grist mill has long since disappeared. I re-created it working from library reference material. The mill wheel was gone even before the photographs were taken. This was one of a series of paintings depicting landmarks in or near Zanesville, Ohio. The shallow creek bed below the dam was strewn with rocks and debris, but the water reflections of the old mill, the rock shapes, and the falling water brought movement, light, and color into what might have been a drab and uninteresting subject. This painting is a good example of the contrasts of moving water and still water surface. Unpainted paper and directional brushwork emphasize water movement on the dam and below it.

Integrating the Human Figure into the Landscape

Although the paintings in this section are similar in subject to the paintings illustrated earlier in the chapter, they rely on human involvement to supply an extra note of interest even though the subject is dominated by landscape elements.

Figures appear in *Below Griggs Dam* (page 19) and *Marblehead Light* (page 10), but they were not a planned part of the composition and were added as incidental detail near the painting's completion. In this series the figure (or figures) was taken into consideration at the start of the painting and in each instance was observed at the painting location. With the exception of *Paint Out—Below Griggs Dam*, figure indications in the other paintings were carefully sketched in and masked out with liquid masking to protect the shapes. Where necessary, some masking was also used in the reflected shapes of the figures in order to increase the illusion of water. *Paint Out—Below Griggs Dam* was painted on location, and the background was painted around the figure without any masking.

In each of these paintings the small figure indications are important to the painting in establishing mood, sense of place, and the injection of bright color notes into the landscape elements. An important point to remember is that the figure must look "at home," or natural, in the setting. When I use figures in a landscape, they are almost always the result of actual observation either sketched, photographed, or remembered as being at that location.

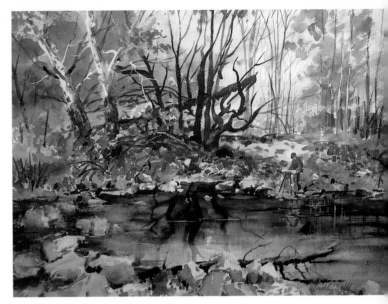

PAINT OUT—BELOW GRIGGS DAM, 15" x 20" (38.1 x 50.8). *Private collection.*

The Figure in Filtered Light
The bright red jacket and central location of the figure of one of my students at a paint-out provide a principal focus here. The fresh, loose use of transparent watercolor helps to emphasize the feeling produced by the sunlight. Capturing that dappled effect was a key element here.

Creating an Atmosphere with Sunlight and Reflections
One June afternoon I had taken my watercolor class for a "paint-out" at Whetstone Park, a recreational and nature-study area. By chance I came across two young girls wading in the ankle-deep water of the creek and took a photograph of the scene. Later, I developed *The Waders—Whetstone Park Creek* with the figures as a center of interest. Reflections in the water, shadows, and consistent play of light throughout the painting helped to integrate the two figures into the composition. Position and pose of the figures had been carefully considered in the working sketch for the final painting. Masking the figures and the reflections of the waders permitted me to paint the wet-in-wet background and water areas.

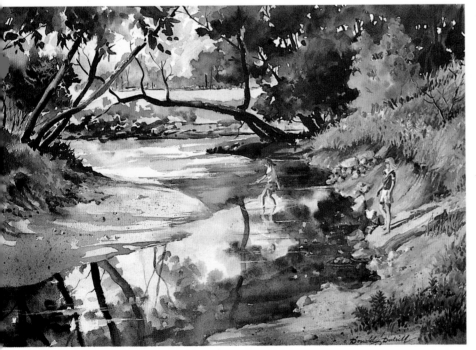

THE WADERS—WHETSTONE PARK CREEK, 14" x 20" (35.5 x 50.8 cm). *Collection of Mr. and Mrs. Lawrence J. Dodrill.*

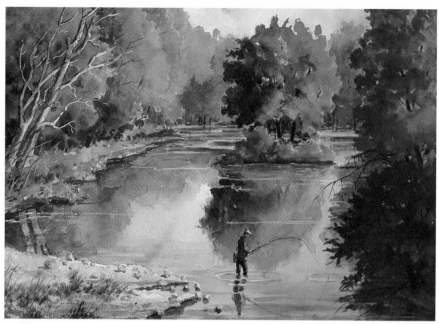

FISHERMAN—OLENTANGY RIVER SOUTH OF POWELL ROAD, *15" x 20" (38.1 x 50.8 cm). Collection of Mr. and Mrs. Fritz C. Arens.*

A Luminous Surface Mirrors a Mood

While crossing the Powell Road Bridge, I observed a solitary fisherman just south of the bridge. Visually, his poised figure, the stillness of the river, the colors of the fall foliage, and the small islet reflected in the water's surface all combined to capture my attention. The reflections brought a special dimension to the figure, already illuminated by the direct afternoon sunlight. I stopped on the bridge and quickly took a couple of 35-mm shots. In order to depict the concentrated mood of the fisherman, I emphasized his presence by means of his brightly colored jacket, intense pose, and central position in the light-struck foreground area of the river. I worked into a wet surface to attain a degree of diffusion that would help establish a luminous water surface. Before beginning, I had masked out ripple lines on the river surface, the fisherman, and the smooth light-colored sycamore trees at the left. I let the color flow freely into many areas of the wet painting surface. When this was dry, I added darker values to define tree shapes and shoreline detail.

The Figure from a Different Perspective

At right is one of a series of paintings done along Whetstone Park Creek, a park area frequented by men and women joggers. While sketching the gnarled contortions of the base of an old cottonwood tree growing near the bank of the nearly dry creek bed, I noticed the reflections created by joggers as they passed the large shallow pool of water near the bank. At this point, I decided to incorporate a jogger into my painting, showing the feet at the top of the painting and the torso reflected in the water. Reflections are of interest in a painting and lend authenticity to water surfaces. The dominant element in this painting in terms of size and value is definitely the base of the cottonwood, but the image of the jogger upside-down in the water remains the center of interest. This slightly divergent perspective introduces an interesting, somewhat disorienting element into this placid scene.

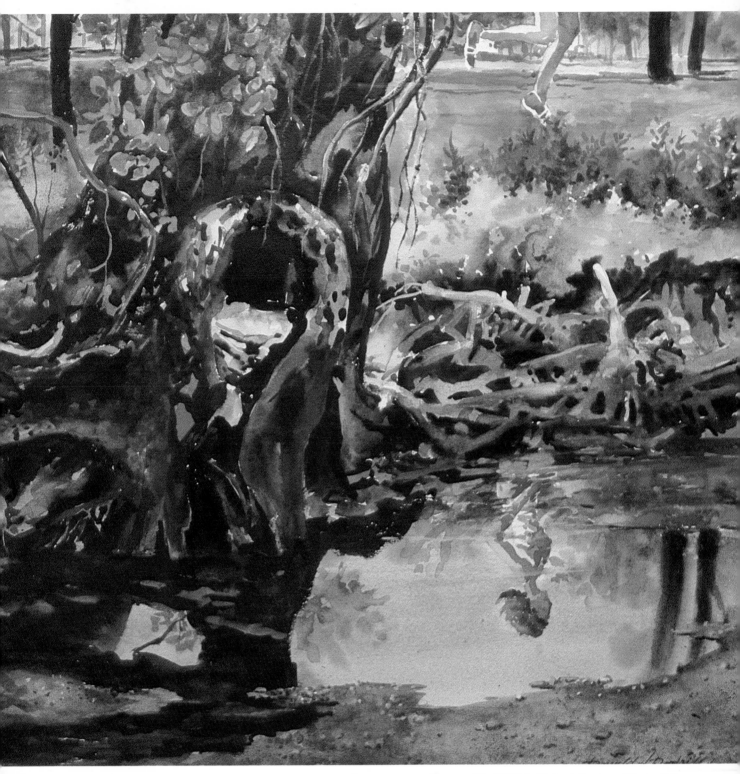

JOGGER BY THE CREEK, *15" x 20" (38.1 x 50.8 cm). Courtesy of Windon Gallery.*

Evoking the Natural Setting in Rural Landscapes and Architecture

Rural landscapes, farms, and farm animals were an integral part of my early life. Even though I have been a city dweller for many years I often return to the farm country to paint. And I still find the subject matter stimulating and inspirational. Having an intimate relationship with the subject matter is important to a painter. Simply looking at a photograph of a split-rail fence does not impart the same information or emotion as having seen and reassembled one. Walking through and around an old covered bridge evokes an emotional bond and sense of place not possible to experience by simply looking at one or even several photographs.

Time of day, time of year, and type of weather play an important role in the use of light and color. I rely on sketches, on-site painting, or just plain memory retention for most rural landscapes. At times, notes as to specific color are written in the margins of the pencil sketches to help keep the visual images fresh.

Paintings of barns are sometimes scoffed at by critics as being "trite," but they are so varied and so much a part of our fast-disappearing farm country and way of life that I still feel compelled at times to include them in rural landscapes.

Although man's presence is apparent or sensed, no figures are included in the paintings in this series. I usually do not include figures unless they are engaged in some activity related to the scene, such as harvesting, plowing the land, or working with farm animals.

The completed painting must convey a feeling that all elements are related and in tune with one another in a natural sense, thus evoking a kindred response in the viewer.

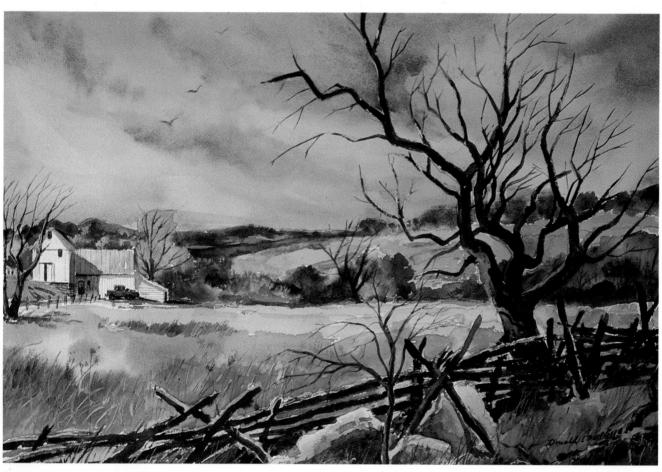

EARLY NOVEMBER, *15" x 21" (38.1 x 53.3 cm). Private collection.*

A Landscape from Boyhood Memories

Although most of my landscape paintings are specific places, this one is more of a composite of remembered colors, landscape elements, and sensations related to the farm country of central Ohio. I painted it primarily from boyhood memories of fence rows, fields, and barns. One clear recollection was a split-rail fence—one of the few then remaining in the area—that separated our farm fields from those of a neighbor's. In this painting, I used a split-rail fence in the immediate foreground. I wanted to show the fields as they are in late fall, with the glow of ochre, gold, and beige that slowly fades as the days become shorter and the air becomes clear and crisp.

Some of the trees still retain their variegated fall foliage colors; others are already barren. The split-rail fence leads the viewer's eye to the naked foreground tree, which, in turn, directs the eye back into the composition.

The Charm of a Wooded Area

I had come upon a narrow country lane in Union County, bordering a wooded area. It had a certain charm that made me make a small sketch of it, which I later developed into this painting. I used a suggestion of some of the wildflowers and flowering weeds in the foreground. Spring's blossoms can add much color variety to a rural landscape. Strong shadows helped to establish depth of field and give definition to the rock shapes. Before the washes were dry, I added some salt on the yellow-green field at the left. When the paint was dry, I brushed off the salt, which created an effect of flowering dandelions.

ROAD UP THE HILL—SPRING, *15" x 20" (38.1 x 50.8 cm). Collection of the Kiwanis Club of Columbus.*

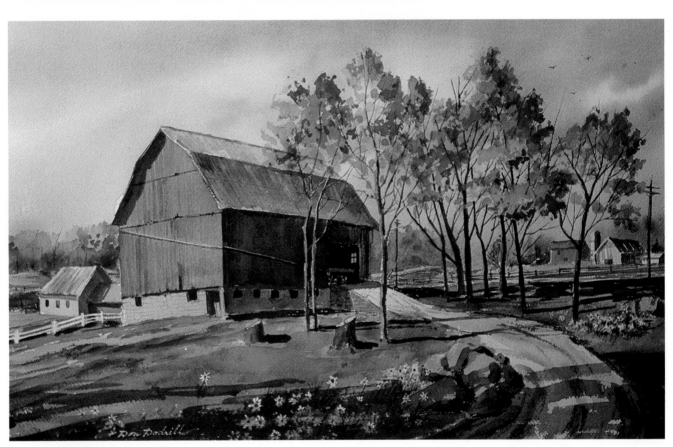

BARN NEAR HILLIARD, *15" x 20" (38.1 x 50.8 cm). Private collection.*

Shaping the Solid Forms of Architecture

To achieve the effect of weathered wood in this old barn, I used a mixture of mauve, burnt sienna, and neutral tint with a touch of alizarin crimson. Since good value contrasts are important in giving structure a solid form, I made certain the light-struck surfaces contrasted strongly with those in shadow. Through an open door, like the one at the far end of the barn, you can see some interior objects and a window on one of the inside walls. Use of those details establishes interior depth and gives the building a more solid shape. I painted the roof in wet-in-wet sections using a combination of burnt sienna, cerulean blue, and Davy's gray, varying the value to suggest individual panels. The group of smaller outbuildings near the main barn, the other farm buildings in the distance, and the trees in the foreground unify the composition. A few of the white-rayed flowers with dark disks that sometimes grow along country roads appear in the shadowed foreground, where I placed them in order not to distract the viewer from the focal point of the barn.

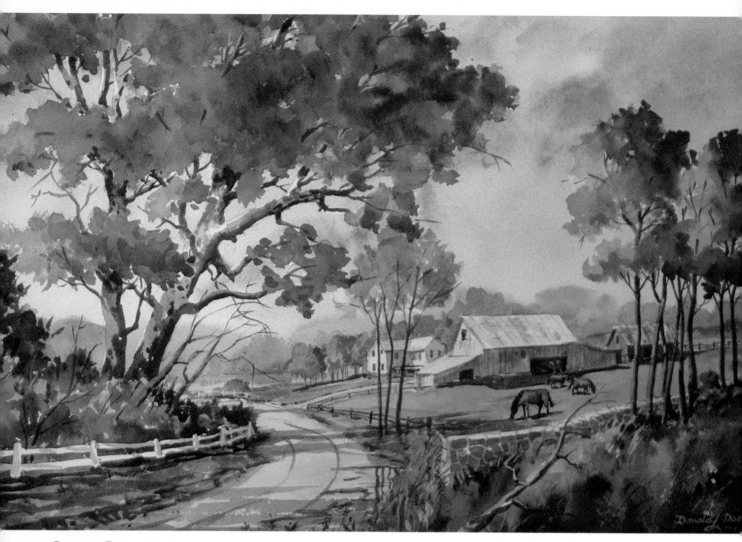

OCTOBER GOLD, *16" x 22" (40.6 x 55.8 cm). Collection of Catharine Warmbrod.*

Painting from Quick Sketches and Photographs

September and October are two of my favorite months for watercolor painting. The overpowering green of summer yields to the variety of yellows, alizarin crimson, ochres, and olive greens. I find this season more visually stimulating, and I like to drive through the countryside, observing the fields, the woods, the grazing livestock.

I painted *October Gold* from a combination of quick sketches and a photograph taken along a country road during one of the day-long painting trips an artist friend and I took into the countryside.

A few of the rural Ohio roads, like the one shown here, remain unpaved. They are composed of gravel impacted into the clay road bed by vehicular traffic. I used a tooth-brush spatter on the damp painted surface to give the road surface a textural appearance.

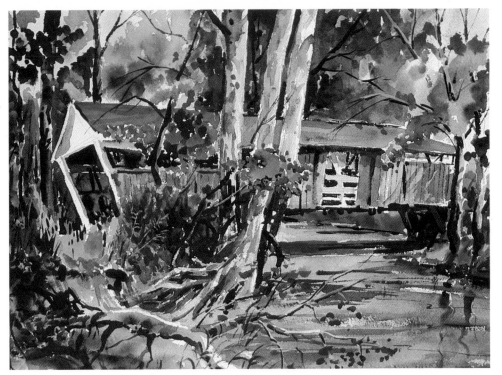

COVERED BRIDGE ON DILLEY ROAD, *14" x 20" (35.5 x 50.8 cm). Private collection.*

A Balance of Lines—Abstract and Conventional
Covered bridges have been home to nesting robins, squirrels, hornets, and mud dauber wasps. They have served as the locale for church suppers, weddings, band concerts, and now and then a lynching. I painted this one on site at Dilly Road in Fairfield County. Battered and weathered, the bridge spanned a nearly dry creek, which had been reduced to a narrow stream of brackish green water. Trees and underbrush along the creek formed an abstract tangle of limbs, trunks, and roots. I decided to paint the bridge as I saw it, using the verticals of the trees in the foreground to counterbalance the horizontal shape of the bridge. As in most of the paintings I do on location, there is an immediacy and directness in the composition.

An Unexpected Pattern, a Compelling Scene
Here, the black-and-white spotted cattle framed between the trees bordering the creek created an interesting pattern. It was late in the day and the sky had a pinkish tint near the horizon that was reflected in the flooded areas of the field. The scene was compelling, and I immediately visualized it as a painting. I made a quick pencil sketch, with more notes about color and content than actual drawing. Later, when sketching in the composition for the painting, I used a Polaroid photograph of Holstein cattle taken several years before to help jog my memory in defining some of the physical details. Relying on memory, the sketch, penciled notes, and a strong mental image of the scene, I completed the painting. Sometimes the best painting subject matter is discovered quite unexpectedly. So be prepared.

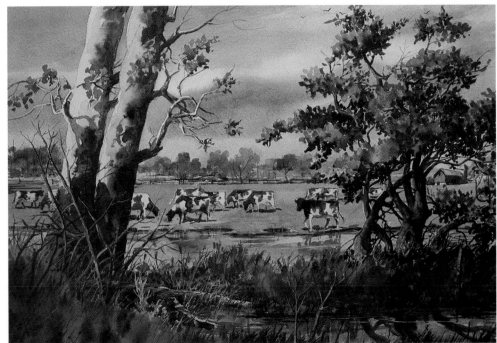

HOLSTEIN HERD, *16" x 22" (40.6 x 55.8 cm). Collection of Ronald G. Mincks.*

THE MARINE SERIES
Boats, Beaches, and Buildings of the Atlantic Coastal Area

From Maine to the Florida Keys, the Atlantic coastal area abounds with subject matter for painting, but for me the greatest challenges in the entire area lie in the Outer Banks and the offshore islands of North Carolina.

From the Virginia/North Carolina line, the Outer Banks stretch southeastward and then bend back to the west for a distance of some 175 miles, a barrier island chain of shifting sand dunes, sea grasses, and scrub vegetation. There are many visual incentives for painting here—beaches, sand dunes, driftwood, fishing boats, boatyards, fishing shacks, piers, and the sky and sea—their colors and images beckoning to the artist.

On visits and painting trips to this area, I have become acquainted with the small coastal towns and some of the wildlife and marine life. I have experienced the unrestrained and ever-changing beauty of the sea, witnessed the capricious weather, and known the determination of the Banks and its people to adapt to the elements.

Lighthouses, Coast Guard stations, and weathered "summer cottages" (actually quite large houses built by the well-to-do in the early 1900s) provide an architectural history of the area and offer meaningful painting themes.

Atmosphere contributes greatly to the overall mood of this region. Coastal fogs and mists hover close to the sea and land. Dark clouds lurk overhead, and storms send heavy surf thundering shoreward. At various seasons, sunrises and sunsets provide insistent color motifs with gold, mauve, amber, and bright pinks streaking the sky and reflecting in the sea. Then, unpredictably, the weather can change, creating an entirely different atmosphere and suggesting a whole new painter's palette.

Many of the year-round residents of the coastal areas earn their living from the sea—by commercial fishing, charter-boat sport-fishing services, or fishing-related businesses. As a result, there is a diversity of fishing boats anchored in sounds and tidal basins or moored alongside small docks. Many of the boats, equipped with a variety of nets and other fishing gear, are old and weatherbeaten. Each boat seems to have its own character, reflecting its own history, and offering a more interesting façade than a newer, more contemporary model might.

In this treasure trove of watercolor painting resources from the Atlantic coastal area, I discovered subject matter that aroused my interest and inspired this series.

Most of the paintings here originated from on-site observation put down on paper as sketches or photographed for reference material to be worked into my paintings later. But five of them—*Return to the Island, Morning Mist, Path to the Sea, Edge of the Island,* and *Early Morning—Outer Banks*—were works I did months later in my studio, relying *totally* on memory (pages 50–53). In this way, I introduced an element of "mood into method." I find that painting from mental imagery usually enables me to concentrate more on mood and emotional content than on detail.

The northern coastal area, a truly natural setting, offers a greater opportunity to paint the action and motion of the sea and to show its force as it thrashes against unyielding rocks. There, where natural shoreline rock formations are common, I derived *Offshore Rocks, House on the Island,* and *Beach Debris* (see pages 38–39) from sketches and observations of the coast. In the midcoastal area, where necessary, the shoreline is protected from stormy seas by man-made jetties of pilings and rocks that extend out into the water.

I feel a strong attraction to the Atlantic coastal area, and this series explores my emotional link to that area. Painters like Winslow Homer and Edward Hopper come to mind; they too painted a series of works associated with a specific geographical area. I feel a kinship with them in this endeavor.

END OF THE ISLAND

A pregnant silence envelops
All of the island's eastern tip,
And even the heron's presence
Is without a call.
The aged trees are stark and
 barren,
With gnarled and weathered
 limbs
Reaching as if to reclaim the
 remnants
Of bark lost to hurricanes
 long past
Mixed with severed limbs
 and cast
Upon the silence of the sand.

Depicting the Coastal Environment

It is almost impossible to walk among the sand dunes, hear the low-pitched roar of the ocean swell as it breaks upon the shore, or feel the touch and smell of the salt-laden ocean air without becoming emotionally involved with the Atlantic coastal area. This series of paintings is based on impressions and scenes of beach areas and other indigenous elements such as rock, driftwood, water, shore birds, as well as beach-related activities.

The first five paintings in this section resulted from trips to the Outer Banks of North Carolina and near offshore islands. Here the beaches are sandy with many dunes along the shores and on the islands.

The last three paintings—*Offshore Rocks*, *Beach Debris*, and *House on the Island* (pages 38–39)—were painted from combinations of sketches and photographs of coastal areas farther north, where the coastline is more rocky. The incoming surf creates a different and more violent action as it explodes against the shoreline rocks.

In this section, there is more of an attempt to convey my impressions of the long Atlantic coastline rather than the depiction of one particular location. Sometimes a painting will result from a combination of coastal paint or pencil sketches, reference photography, or remembered visual sightings.

The wet-in-wet use of transparent watercolor has the power to suggest as well as to depict, and I usually employ this suggestive approach when working predominantly from memory. *End of the Island* and *House on the Island* are examples of paintings that use suggestive portrayal.

Sky coloration, cloud formations, and time of day play a definite part in creating a painting mood. The coastal area provides an ever-changing panorama of dramatic skies. It is a dramatic area in which to paint watercolors, as the immediacy of the scene lends itself to the immediacy of the medium.

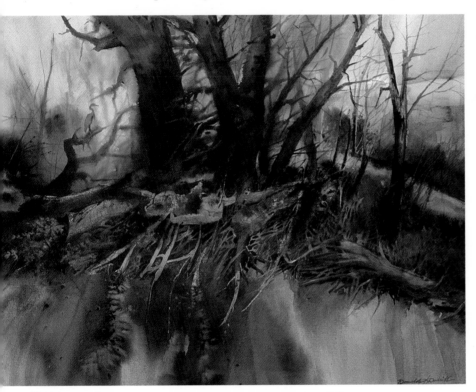

END OF THE ISLAND, 19″ x 29″ (48.2 x 73.6 cm). Collection of Susan Telle.

Following the Flow of the Paint

I created this painting from mental images of the islands off the coast of North Carolina, using a very simple pencil sketch of a deserted beach scene for my composition. The flow of the paint influenced some of the painting direction throughout the work, especially in the beach debris. To begin, I wet the entire surface with a large two-and-a-half-inch brush, then I applied a light value of a mixture of cerulean blue, Davy's gray, mauve, and Naples yellow into the sky area and used the same colors with a heavier emphasis on Naples yellow and Davy's gray in the lower area. I added burnt sienna and Prussian blue to the central area. With the paper still damp, I scattered salt onto the bottom of the painting, which left suggestions of water-pocked sand in the foreground. I painted the large tree shapes with a one-inch flat-tipped brush into a nearly dry surface and scraped in shapes of beach debris and branches below them, then painted smaller tree shapes. As the final touch, I added the silhouette of a blue heron.

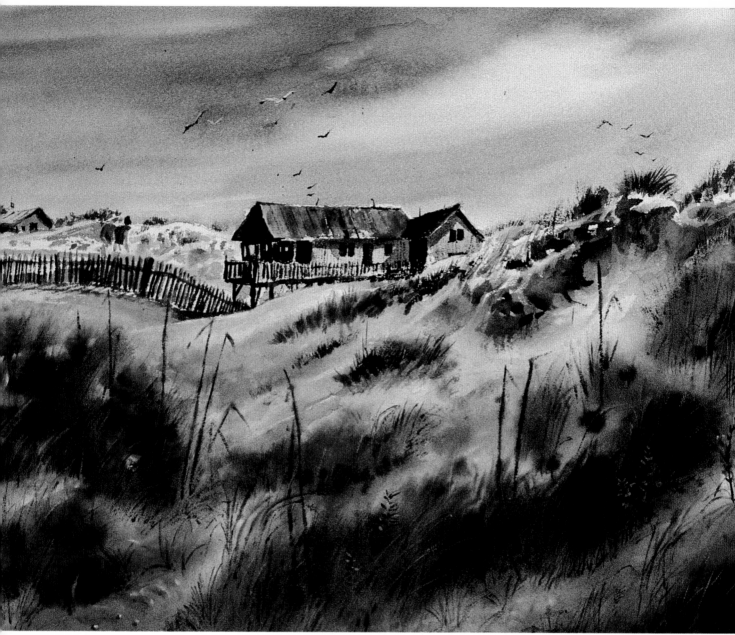

OCTOBER ON THE ISLAND, *16" x 27" (40.6 x 68.5 cm). Collection of Kevin Amos.*

Image of Solitude: A Beach Scene, Dry and Barren

The Outer Banks are sometimes barren, since not many plants can survive the hot sun, shifting sands, and salt-spray-laden winds. I made the initial sketch for *October on the Island* in just such a setting as this during a visit to one of the small islands accessible only by ferryboat. Clumps of green-brown beach grasses singed by sun and salt air created a feeling of drabness on the island, but when the sun broke through the low-lying clouds, the changing light formed attractive color patterns on the grass-protected dunes. A solitary figure might suddenly appear in the distance on the beach, then quickly disappear behind a dune, leaving a trail of solitude through one's imagination.

There are few houses or buildings on the island. One house near the beach was erected on stilts that elevated the structure several feet above the ground for protection against storm-generated high tides. I tried to convey some of these elements in *October on the Island,* using a palette of Naples yellow, cerulean blue, burnt sienna, sap green, olive green, and neutral tint. The figures are incidental to the composition in the picture but serve to inject a note of human involvement into the solitude of the drab beach houses and sand dunes.

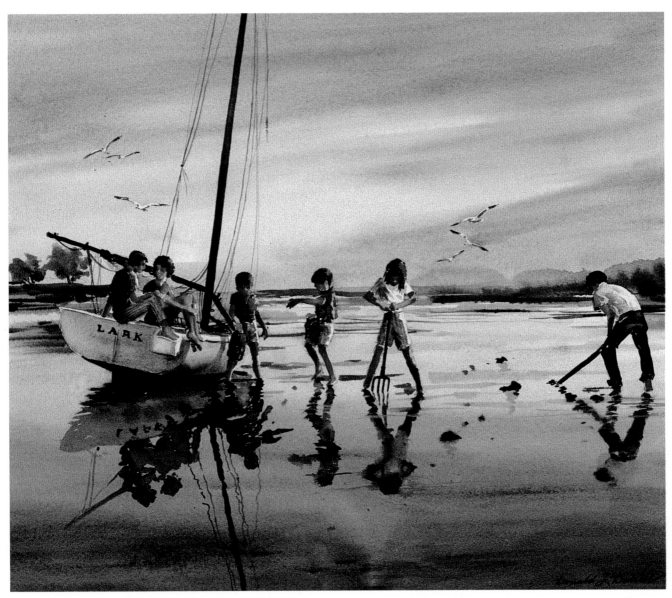

CLAM DIGGERS, *18" x 27" (45.7 x 68.5 cm). Collection of Robert Sayre.*

Making Figures the Center of Interest

People gather salt-water clams at low tide along the shore areas of the Outer Banks of North Carolina. Usually, the clams are submerged in the sand or the mud. Using your feet, you can feel them underneath. They can be dug up with tools, such as the clawlike clam rake, or with your hands. In *Clam Diggers,* figures are the center of interest—a family outing. But the low tide, wet sand, sailboat, and mirrorlike reflections of the late afternoon sky on sand and water set the light mood of the composition. I masked out the figures and the sailboat, then painted in the wet-in-wet sky and beach areas, adding the reflections of the boat and figures to the foreground while the paper was still moist. A combination of pencil sketches and photography was used as reference. I concentrated on the pose and position of the figures with a minimum amount of painting detail within each figure. This painting is a good example of the reflective quality of wet beach sand covered in some areas by a thin layer of water.

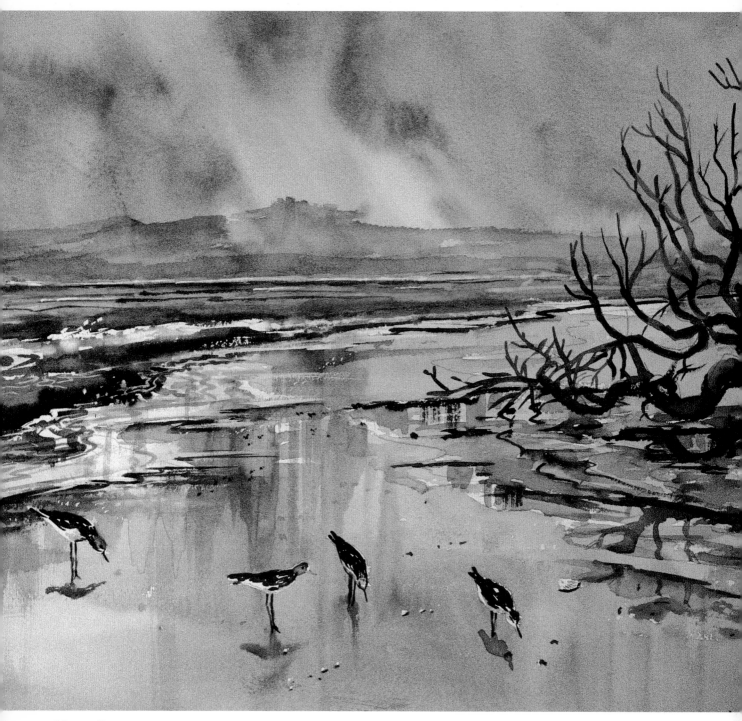

NORTH SHORE, *14″ x 20″ (35.5 x 50.8 cm). Private collection.*

Intensifying the Sparkle of Sea on Sand

Shorebirds, such as plovers and sandpipers, are seasonally common inhabitants of the Carolina barrier islands and mainland. In this painting, I used shadow reflections of the birds and beach debris on the sand area to give the sand a wet appearance, as if the water had just surged across it and then retreated. I selected a warm palette of Naples yellow, sepia, and burnt sienna for both the sky and sand areas with the sea and water puddles painted in a blue-green composed of Winsor blue and cobalt green. White accents were left on the water areas and the beach debris to add "sparkle" to the color combination.

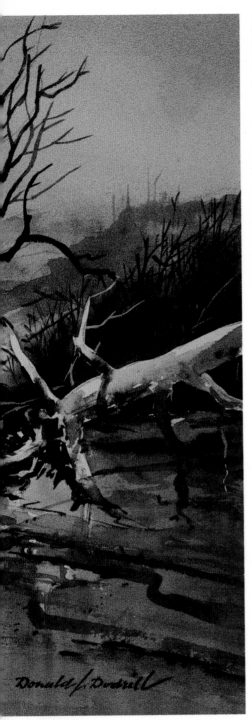

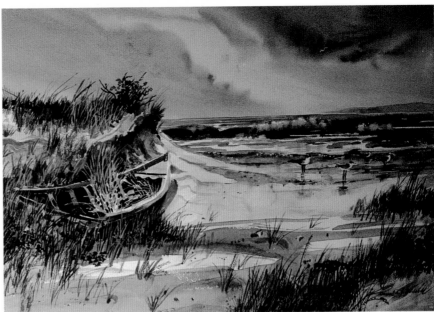

BEACH—OUTER BANKS, *15" x 21" (38.1 x 53.3 cm). Private collection.*

The Drama of Cloud Effects

Skies are very changeable and often dramatic in the Outer Banks area. I painted *Beach— Outer Banks* from a quick sketch made while on Nags Head. The drama of the cloud effects was overstated, but I wanted the clouds to repeat the curves delineated in the sand dunes, beach area, and abandoned boat. Davy's gray, cerulean blue, neutral tint, and Naples yellow were blended and used wet-in-wet in the sky area.

To emphasize the whiteness of the lighter sand areas, I used a combination of Naples yellow and Davy's gray. A little sepia and a touch of Hooker's green were added to these colors in the shadow areas of the beach and sand dunes to suggest ridges and plane changes. The same two colors were used in painting the beach grasses. Prussian blue, cobalt green, and cerulean blue were combined to create the water area, with white and light value accents left to suggest waves and water movement. The small abandoned boat at the left of the composition was one of the key elements in my original sketch, but I decided to play it down in the painting.

The Interaction of Waves and Shoreline Rock Formation

These three paintings were inspired by my observation of ocean turbulence, atmospheric conditions, and rock formations as they appear at points along the northern Atlantic coast. In each painting, rather than use a masking agent to reserve white areas in the foam and spray, I left the areas dry while putting in the wet-in-wet areas of sky, rock, and water. Later, when the background was nearly dry, I softened the edges of the foam or spray with a sponge to heighten their mistlike appearance. To further increase the effect, I put a dab of opaque white paint on the tip of a toothbrush, then rubbed my thumb across the stiff bristles to create a fine spatter effect. Ridges and planes in the rock formations were brought out by scraping through the second color wash while it was semi-dry to expose the lighter value.

Anyone who has observed the ocean is aware that the color varies in intensity from a pale gray-green to an almost inky blue-black. For the gray-green appearance, I used a combination of Davy's gray, cobalt green, and cobalt blue or Prussian blue. The darker water values are combinations of Prussian blue, Winsor green, ultramarine blue, and neutral tint. Rock color ranges from a pale neutral gray made up of Davy's gray, Naples yellow, and cerulean blue to darker values, which were achieved by using burnt sienna, sepia, neutral tint, and mauve.

The foreground of *Beach Debris* is composed of a tangle of rocks and driftwood. This area, which originated from a sketchbook drawing, became the key part of the painting. The middle and distant water planes are basically remembered impressions of the action of water, with some reference to photographs.

For a feeling of space and depth, both *Offshore Rocks* and *Beach Debris* rely on a change of value from the darker foreground areas to the lighter values in the distance.

House on the Island illustrates the use of the "scratch-through" technique to achieve the effect of rugged texturing in the foreground rock area. In this painting, I injected a small amount of opaque white into the wet surface of the "foam" areas. Blending cerulean blue into these damp foam areas created a feeling of light playing across these surfaces.

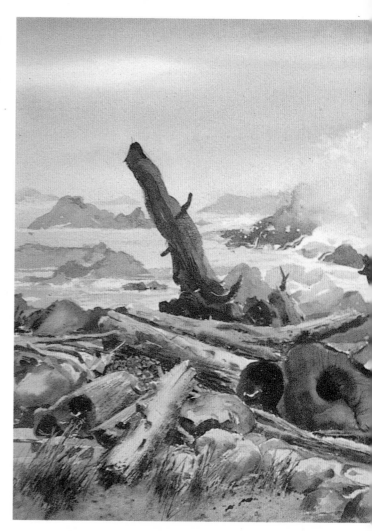

OFFSHORE ROCKS,
16" x 22" (40.6 x 55.8 cm).
Collection of Edward Sparks.

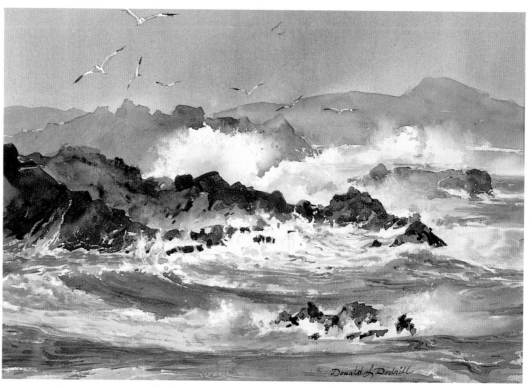

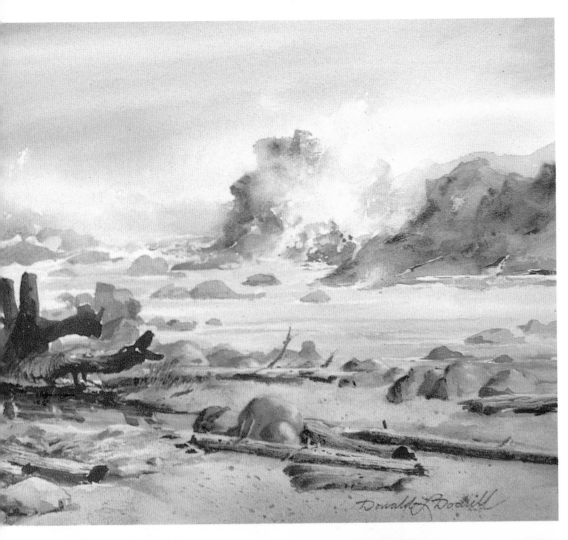

BEACH DEBRIS, *15" x 27"*
(38.1 x 68.5 cm).
Collection of
Evelyn Nowack.

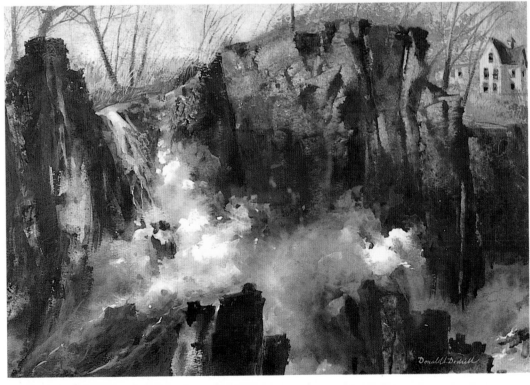

HOUSE ON THE ISLAND,
12" x 16" (30.4 x 40.6 cm).
Private collection.

A Medley of Boats in Characteristic Settings

Of all the boats that traverse the offshore waters of the Atlantic Coast, the weathered fishing and lobster boats have always held the most interest for me as painting subjects. The lobster and crab boats are concentrated for the most part in the New England area but may be seen on occasion farther down the coast. The paintings in this section are mostly fishing boats anchored or beached near the coastal towns and villages of the Outer Banks of North Carolina.

The effect of hard and prolonged use in the rugged sea environment is evident on many of the weathered hulls. Frequently I will use a touch of burnt sienna in a wet-in-wet treatment randomly spotted on the hulls and other areas to indicate rust. Dry brushing is also used on the wooden areas to give the appearance of chipped and peeling paint.

Each boat has its own character and name, often that of a person, or sometimes a bit more descriptive—as *The Gleaner* or *The Night Bird* (page 45). The equipment on board is usually indicative of its function and use.

One of the most important elements of a boat painting is the marine setting in which the subject appears. Although the boat is the center of interest, the surrounding water, beach, or pier areas should appear authentic and complement the boat in both value and color. Because there is a great variety in size, color, and shape of boats, each painting offers different compositional possibilities.

Usually when a boat is pulled up on a beach, it is for repair or maintenance work. Indicating the scaffolding and the men at work creates an additional note of interest. A "beached boat" can sometimes inject a tone of abandonment or an air of mystery concerning its present resting place.

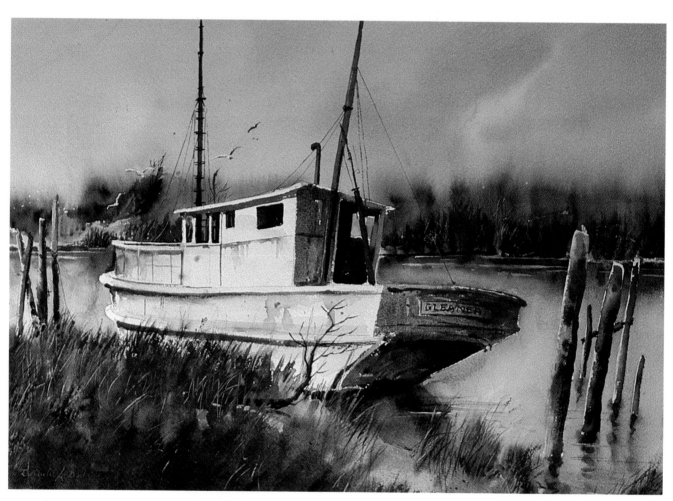

THE GLEANER, *14" x 19" (35.5 x 48.2 cm). Private collection.*

On-site Observation as Sensory Enhancement
One very hot summer day while driving on narrow Highway 70 East bordering one of the tidal creeks along the mainland coast north of Beaufort, North Carolina, I came upon this long-abandoned old fishing boat, *The Gleaner*. Its state of general disrepair, its still-white hull thrusting out of the brown-green marsh grasses and the murky gray-green water stimulated in me a desire to make a painting. After photographing the boat, I sat listening to the shrill cries of sea gulls circling overhead and watching the rippling heat lines rise above the tall marsh grass. Later, as I worked on the painting, my impressions of that scene melded into the beige-yellow sky, which accentuated the sense of heat. On-site observation of subject matter stresses the physical experience one feels, and this contributes so much to a work.

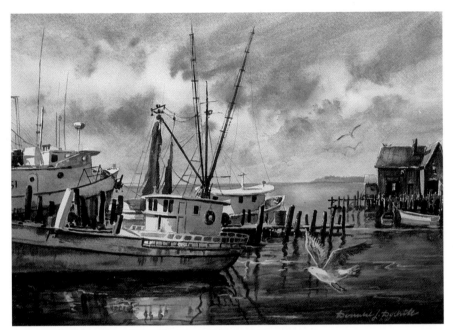

Using Values to Heighten Structural Patterns

Early one Sunday morning, when I visited the docks in Beaufort, North Carolina, I found the sun highlighting certain structural details of the boats in very interesting patterns of light, middle, and dark values. I photographed the scene from several vantage points. When I looked more closely, I noted rusted metal and intricate structural features cloaked by the shaded areas. A week or so later, as I began working on the painting, I replaced the rather complex detail on the right side in the reference photograph with a simpler dock structure I had previously sketched. In combining compositional elements in this way, remember to keep light consistent on all surfaces. The strong highlighted white areas of the boats provide an abstract pattern of light areas that lead the viewer's eye across and through the painting.

BOATS AT BEAUFORT, *16" x 21" (40.6 x 53.5 cm). Private collection.*

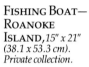

FISHING BOAT—
ROANOKE
ISLAND,*15" x 21"
(38.1 x 53.3 cm).
Private collection.*

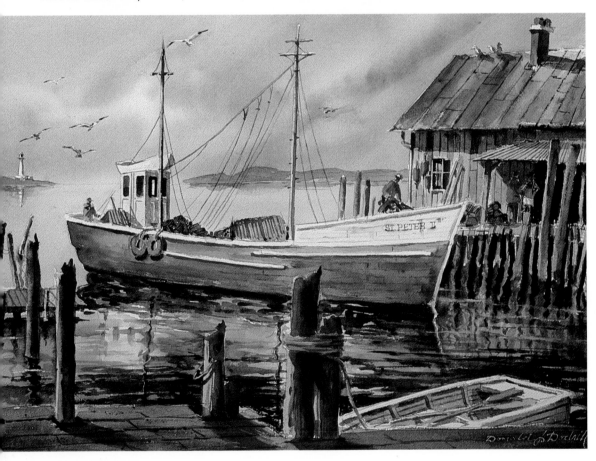

Reflections on Choppy Waters

Roanoke Island is one of the most picturesque of the coastal fishing village areas. *Fishing Boat—Roanoke Island* is a composite of sketches made there and does not represent a specific site. I have always been intrigued by reflections of objects on the water surface. On perfectly still water, the image will be reflected in some detail, but on a surface broken by small wavelets, as in this painting, the image will appear more abstract, reflecting only the major value changes—in this instance, the white cabin, hull mast, and the lighter or darker values of the pier pilings. Mirrored images are primarily darker values of the color of the water with only hints of color from reflected elements.

THE PAULA LEWIS, *12" x 15" (30.4 x 38.1 cm). Private collection.*

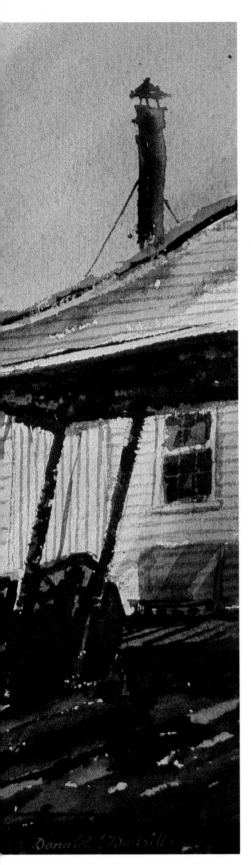

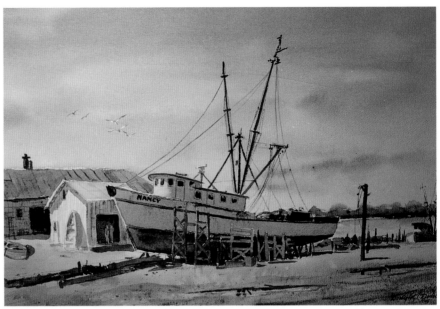

The Nancy—Beaufort, North Carolina, *15" x 20" (38.1 x 50.8 cm). Private collection.*

Focusing on Color and Light

In the painting above, I was most interested in time of day. The salmon-pink and mauve-blue sky colors of late afternoon enlivened the painting and complemented the more neutral colors used in the sand, boat, and buildings. Typical of the many old fishing boats in the Beaufort and Morehead City area, *The Nancy* is in dry dock for maintenance and repair work. The scaffolding used by workmen for painting and cleaning the hull creates a logical reason for its being on shore and also adds compositional interest. Late afternoon sunlight coming from the left creates a focal point on the front of the boat and the façade of the small white building left of the boat prow. Owing to the light direction, only the very front of the cabin and the prow of the boat are highlighted, with the remainder of the boat appearing in the shadow area.

Setting Time and Mood by Means of Atmosphere

Although I am uncertain of the exact location of this painting site, it was one of the many tidal creeks in the Roanoke Island—Outer Banks area. As in most of my paintings, I kept detail to a minimum and emphasized composition to establish a mood related to the environment. Since I painted it in the early morning, I used the bright but hazy atmosphere to set the time and help determine the mood. Reflections were not many but just enough to suggest water. To keep the boat as the focal point, I played down the details in the foreground elements. An array of vertical masts and booms serves to counterbalance the dominant horizontal shape of the boat and foreground elements.

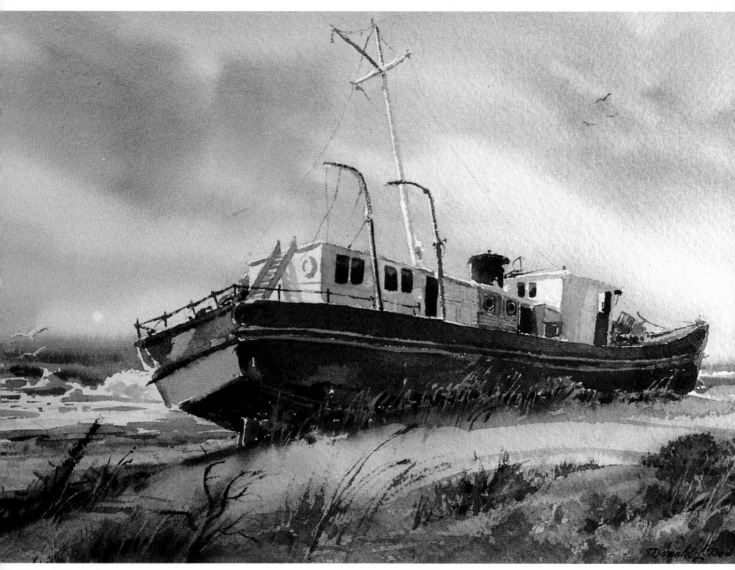

No Longer in Use, *12" x 17" (30.4 x 43.1 cm). Private collection.*

Interpretation of an Abandoned Boat—Changing Its Setting

This is a painting of one of the older ferryboats formerly used to traverse inlets and sounds to reach the Outer Banks villages. When I first saw it, it was being used as a tourist attraction on Nags Head. People were lined up to tour the interior and learn something of the boat's history. I regretted not having the time to take the tour. I took a couple of 35-mm shots, which I later studied. I was still interested in the details of the boat's structure, but for my painting I didn't like its current resting place or function. I decided to reposition it closer to the ocean on a deserted beach. Somehow that setting seemed to suit its character more—an abandoned beached boat that no longer fulfilled its original purpose.

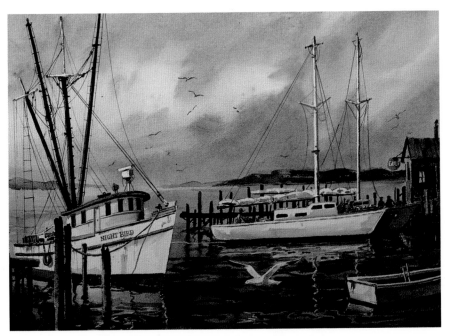

Arranging a Cluster of Moored Boats

In addition to this painting of the *Night Bird,* which I had painted on site, I was so intrigued by the boat itself that I painted it on two other occasions. The *Night Bird* is a little larger than the average fishing boat and has been in service for some time, as you can see by the weathered and rust-spotted cabin and hull. Docked with the *Night Bird* this particular morning was a slender, graceful sailboat offering a diversity of shapes and angles for the composition. A small rowboat in the lower right-hand corner completed the three-boat anchorage. When painting a cluster of moored boats, I use an odd number—in this case, three. I also used a sea gull flying from right to left as a compositional element to redirect the eye back into the composition, since the boat prows tend to direct the eye to the right and out of the picture.

BERTH OF THE NIGHT BIRD, *16" x 21" (40.6 x 53.3 cm). Collection of Sandra Nelson.*

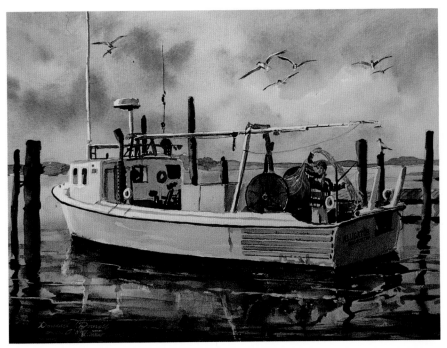

Using a Figure to Relieve a Static Setting

Although the fishing boats of the Outer Banks area vary in size and shape, some, like *The Alligator,* are quite small and sparsely equipped. To add more interest to this painting, I chose to include our son, Jon, on board, working at clearing and straightening the fishing nets that wrapped around the reel cylinder. A flight of sea gulls overhead provides another touch of suggested motion in an otherwise placid scene. I relied on the early morning light to help define the essential shapes of creating value changes.

I have always been interested in the history of the boats I have painted but, with the exception of *The Alligator,* have rarely had the opportunity to learn much about them. Jon had worked as part of a three-man crew on this forty-foot boat for more than a year, operating out of Beaufort, North Carolina. Knowing the history of the painting subject can sometimes evoke an extra spark of empathy for it, which can bring about a stronger painting.

JON ON THE ALLIGATOR, *14" x 19" (35.5 x 48.2 cm). Collection of Mr. and Mrs. Jon Warner Dodrill.*

The Forces of Nature: Atmospheric Weather Conditions

Forces and features of nature such as wind, rain, fog, and cloud formations are experienced in diverse degrees across the United States. For some mysterious reason, these forces of nature have always appeared to me to be more prevalent and dramatic on the coast and offshore islands of North Carolina.

Possibly because water and moisture are usually involved in these natural forces, they are best depicted by the wet-in-wet application of transparent watercolor. The appearance of weather conditions such as fog, storm clouds, ocean spray, falling rain, or mist can be achieved. Sometimes the interaction of wet paper and paint is enough to create the desired illusion. On occa-sion, sponging into the damp paper surface can enhance the appearance of fog, falling rain, incoming surf, or certain types of cloud formations.

This group of three paintings takes a look at some of these weather conditions and the effect they have on certain coastal scenes. Light is dealt with differently in these paintings, as there is no direct source of sunlight. In most instances, the strongest light source comes from the sky area in a diffused manner. To show dimension and shape in architectural elements and boats without a definite light source, it is necessary to rely on changes in color values in the structural planes of the pictorial elements.

AFTER THE STORM,
15" x 22"
(38.1 x 55.8 cm).
Private collection.

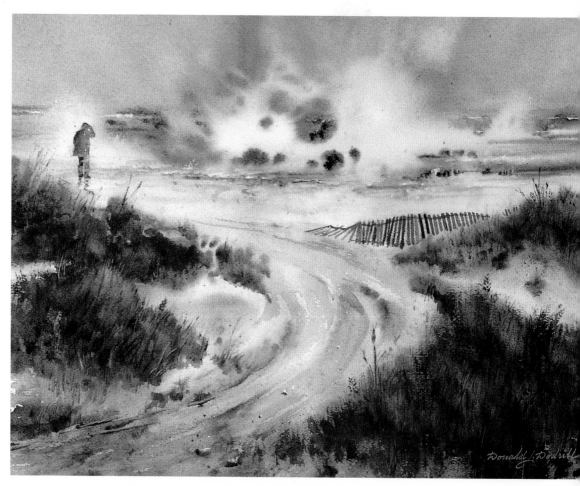

In a Turbulent Air

In *After the Storm*, I tried to isolate the climactic moment when the full force of the in-coming wave erupted into a white burst. First, I painted in sky and sand areas on a pre-wet paper, then added darker values, making sure to leave some abstract white shapes unpainted. These became the white foam and spray. Before the color wash had dried, I used a damp sponge to soften the top edges of the spray shapes. After rewetting the sandy foreground area, I used a No. 8 sable round brush loaded with a mixture of Hooker's green and burnt sienna to brush in random shapes that suggested beach grass. Before the colors dried, I added a mixture of mauve and Prussian green to these semi-damp sections and scratched out indications of tall grass blades, exposing the lighter values of Hooker's green and burnt sienna. When the foreground area was near-ly dry, I used a dry-brush technique in the ruts in the road, applying a mixture of mauve and sepia. The figure and fence were painted last, the small figure suggesting man's vulnerability to the forces of nature.

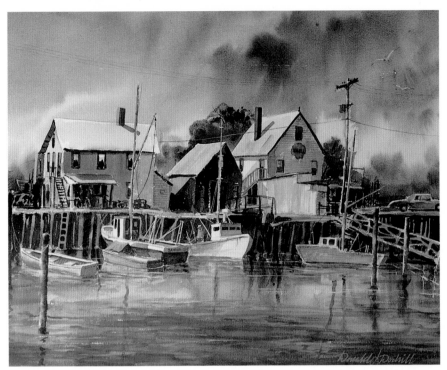

APPROACHING SQUALL LINE, *15" x 21" (38.1 x 53.3 cm). Collection of General Electric Company.*

Threatening Skies, Clear Water

This painting originated from a fairly detailed pencil sketch of a dock in the Outer Banks area. While I was working on the sketch, the sun went under, and threatening clouds quickly appeared. Fortunately, my sketch was nearly completed before rain began to fall, so I simply made a note, "squall line moving in," and incorporated that aspect in the painting later. Dramatic sky treatments can alter the appearance of subject matter so much that the mundane appears enriched. Skies, with the exception of clear blue ones, are never the same, providing an infinite range of mood and compositional possibilities. Because color was at a minimum in this painting, the threatening clouds and the light sky areas reflecting in the water helped create viewer interest. The diffused light from the sky reflected on the surfaces facing it, primarily the roofs, boat tops, and water surface.

Nature in a Dark Mood: Storm Clouds

Low storm clouds rolling in from the sea sometimes seem but a scant few feet above the crashing surf. From a Polaroid photograph of such a sky, I created *Storm Brewing,* combining it with elements from another photo I had of some beached sailboats and a weathered boarded-up house near the water. I used a wet-in-wet treatment for the stormy sky by completely wetting this area and brushing in a wash of Davy's gray accented with darker values of neutral tint. Since there was no definite light source in this painting, I relied on perspective changes in the drawing to help create spatial relationships. Grass areas were painted with a combination of burnt sienna and olive green. My color selection for the boats consisted of a combination of alizarin crimson, cadmium red, and neutral tint. Davy's gray and Naples yellow were used for the gravel road, and mauve and neutral tint for the foreground rock.

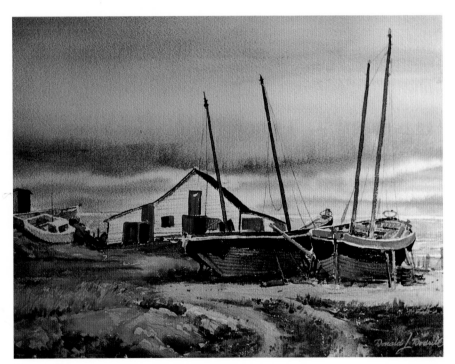

STORM BREWING, *15" x 20" (38.1 x 50.8 cm). Collection of Jan Ragan.*

The Effects of Light on Architecture in Coastal Scenes

A wide variety of architectural structures including a number of historic landmarks appears along the sweeping expanse of the Nags Head—Outer Banks, Okracoke Island region. Many of the buildings facing the innumerable inlets and the Atlantic Ocean are weathered and unpainted. Most are in some manner connected with the Coast Guard, boat maintenance business, fishing, transportation, or construction industries.

The previous three paintings dealt with scenes in which there was no direct sunlight; these next three show the effect of sunlight at different times and from different kinds of semi-clouded skies.

Sunlight creates shadows and definite changes in values from sun-struck surfaces to those in the shadow areas. When painting architectural surfaces illuminated by the sun, I usually paint the lightest sunlit surface color first, covering the entire structure. When this wash has dried, I paint in the darker shadow areas using a darker value of the same color and frequently adding a touch of blue or mauve to keep the shadow color on the cool side.

Sometimes the color of the light, especially early morning or late afternoon, affects the hue of the light-struck surfaces of the architectural structure. Glass surfaces sometimes become brightly illuminated by this type of light.

When painting architectural subjects, I try to suggest the type of surface I am painting on the structure, whether it is weathered siding, shingle, tin, masonry, brick, glass, or concrete. Each material has its own individual characteristics and requires different painting techniques to express this definition. For weathered wood or shingles, I generally apply a wash of the lightest value first and, after this dries, use a dry-brush technique to provide a weathered look. Tin and glass require working wet-in-wet in order to achieve a blend of color that suggests a reflective or semi-reflective surface.

Architectural subject matter is a fleeting part of history, transitory in time. Each structure serves to reflect the area, the climate, and the inhabitants, their needs and preferences, in a particular era of time.

Sunlight Serendipity

There was an old shack between Morehead City and Beaufort that had been used as a storage place for fishing equipment, boat maintenance tools, and fuel. The pier had partially collapsed, and there was only one section available for tying up a much-used dory. The shack caught my full attention when I passed by one day and saw the sun suddenly burst through a threatening sky, illuminating the battered structure and giving it an unexpected air of mystery. I stopped and made a quick watercolor sketch, concentrating on the sunlit surfaces that held my attention. When a lone fisherman suddenly appeared on the rickety deck at the rear, I quickly sketched him in—the final touch to my painting. By this time, the light had changed and the dilapidated structure once again appeared to be a drab place. I had intended to do further work on the painting, but when I studied it later in the studio, I decided that nothing important could be added and that any additional work might alter the directness of the effect I already had. When you work in transparent watercolor, it is critical to know when to stop.

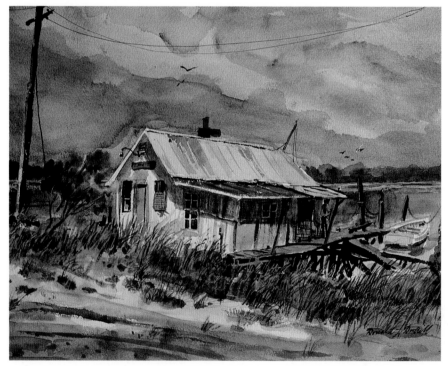

ABANDONED FISHING PIER—BEAUFORT, NORTH CAROLINA, *12" x 16" (30.4 x 40.6 cm).*
Private collection.

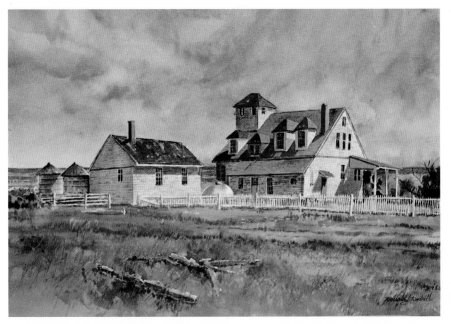

Adding Dimension to Shapes with Light and Shadow

The varied shapes of the structure provided an interesting composition with the light-struck surfaces creating a series of repeated shapes. Textural contrast between the weathered shingles, sand areas, and wind-swept sky increased interest, counterbalancing the rather subdued palette of beiges, browns, grays, and blues. I gathered reference material for this painting at the same time as I did for the *Hatteras Light*. Both sketches and photographs were preliminary to the painting. Drybrush technique was employed extensively in this painting, both on the shingle-sided structures and the dried foreground grass areas. The white picket fence was masked out with liquid frisket before the background areas were painted.

CHICAMACOMICO LIFESAVING STATION, *15" x 22" (38.1 x 55.8 cm). Collection of Jon Raymond Dodrill.*

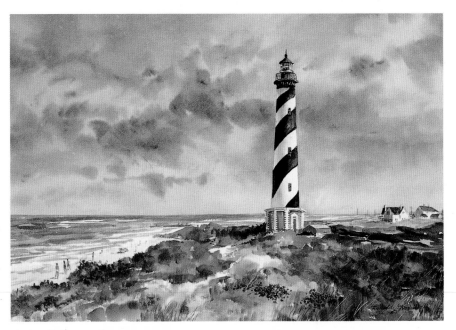

CAPE HATTERAS LIGHT, *14" x 21" (35.5 x 53.3 cm). Collection of Jon Raymond Dodrill.*

The Right Light for a Bright Light

Cape Hatteras Lighthouse stands majestic and aloof on Cape Hatteras between the Atlantic Ocean and Pamlico Sound. The tallest lighthouse ever built in the United States, it rises 208 feet above the sometimes peaceful, sometimes turbulent sea. I worked from photographs of this imposing structure. Light from the right gives the structure its cylindrical shape. The small "keeper's" buildings at its base emphasize the height of the lighthouse, and the almost flat strip of pearly sand with bathers contrasts with the atmosphere of isolation there. I imagined a more dramatic sky than in the photographs in order to stress the tower's role as the guardian beacon whose powerful light warns ships of the dangerous Diamond Shoals.

Working wet-in-wet, I used a combination of neutral tint, cerulean blue, and Naples yellow for the sky. Sunlight creates a tapestry of light and dark patterns. The sand areas in the foreground and the beach are light washes of Naples yellow; the grass areas are a combination of olive green, Vandyke brown, and Indian yellow.

Painting from Visual Impressions

Many times the visual impression of a scene, specific place, or object is so strong that paintings can result without reference or on-site painting. I have a store of visual images of atmospheric conditions, landscapes, sea, architecture, and boats that I have observed in the coastal areas for so many years. It is enjoyable and challenging for me to produce paintings based on these visual impressions: *Early Morning—Outer Banks* (below), *Morning Mist—Outer Banks* (page 51), *Outer Banks—Path to the Sea* (page 51), *Return to the Island —Outer Banks* (page 52), and *Edge of the Island—Northern Coast* (page 53).

Before starting paintings based on this approach, I usually make a series of quick thumbnail sketches, rarely larger than four inches by three inches. This helps to roughly organize the composition based on the mental impression that I have of the scene. The paintings are sometimes small—*Early Morning—Outer Banks* is 11" x 16"—or sometimes as large as *Return to the Island*, which was painted on a full sheet of watercolor paper.

Once the basic composition is established, I permit the wet-in-wet washes of color to establish a direction and build the painting partially on what evolves. Occasionally I will use salt, toothbrush spatter, or scrape-through techniques to reinforce surface textures such as the rock forms in *Edge of the Island—Northern Coast*. I generally rely more on shape and suggestion than detail.

Atmospheric conditions, such as fog and haze, frequently play dominant roles in these paintings, adding an air of intrigue and mystery and making it more feasible to use minimum detail in the subject matter.

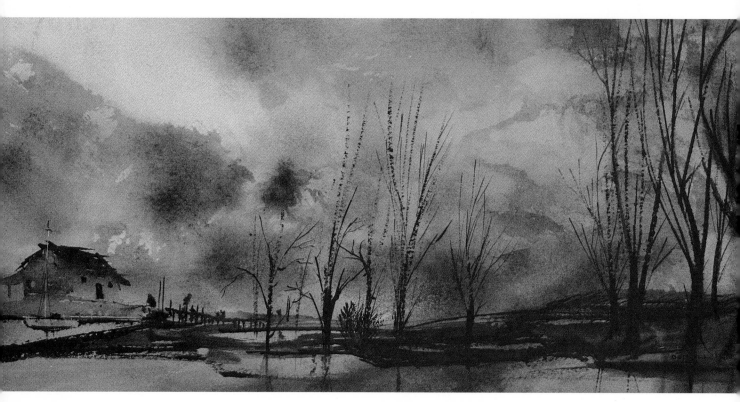

EARLY MORNING—OUTER BANKS, *11" x 16" (27.9 x 40.6 cm). Collection of William A. Scheurer.*

Mystery—the Colors of the Morning

This small painting was the first in a series of "impression" paintings that I painted of the Outer Banks. I used a very limited palette of cerulean blue, Prussian green, neutral tint, and Winsor blue to capture the feeling of the morning fog beginning to cover the coastal area. The light value of the sky is reflected in the water in the foreground. By limiting the color range, I created an atmospheric illusion that lends a note of mystery to an otherwise ordinary composition.

The sky and water areas were painted in first on a dampened paper surface. Darker cloud values were added while the paper was still moist. When these initial washes had dried, I painted in the trees, small building, and land areas on the dry surface, using a mixture of Winsor blue and neutral tint.

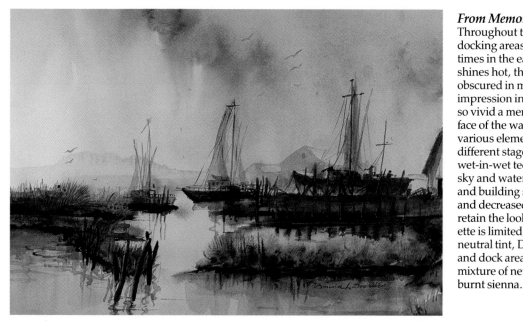

From Memories of Misty Dawns

Throughout the Outer Banks are many docking areas for fishing boats. Sometimes in the early morning before the sun shines hot, these areas appear strangely obscured in mist. I wanted to show this impression in watercolor because it was so vivid a memory. I wet the entire surface of the watercolor paper and painted various elements of the composition at different stages in the drying process. The wet-in-wet technique helped relate the sky and water values. I suggested boat and building shapes with limited detail and decreased the value and contrast to retain the look of the mist. The color palette is limited, consisting of cerulean blue, neutral tint, Davy's gray in the sky, water, and dock areas; the "grass islands" are a mixture of neutral tint, raw sienna, and burnt sienna.

MORNING MIST—OUTER BANKS, *15" x 21" (38.1 x 53.3 cm). Private collection.*

A Sense of Place

I painted this low-key impression of the Outer Banks area after returning home from a vacation trip to the Carolina coastal region. It is a combination of things remembered—a walkway made of wooden slats, spanning a marshy water inlet, a weathered old house, tall beach grass, a sky brewing with storm clouds, and a glimpse of beach and ocean. I made no attempt to establish detail; my sole intent was to present mood and give a sense of place. I used the wooden walkway as a visual guide to lead the eye through the composition. Reflections are suggested in the marshy water in the foreground to help create the water illusion and balance the dark and light values of the composition.

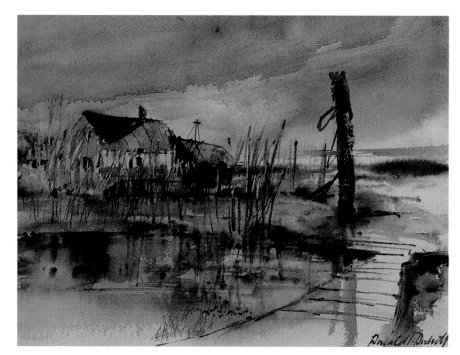

OUTER BANKS—PATH TO THE SEA, *14" x 19" (35.5 x 48.2 cm). Private collection.*

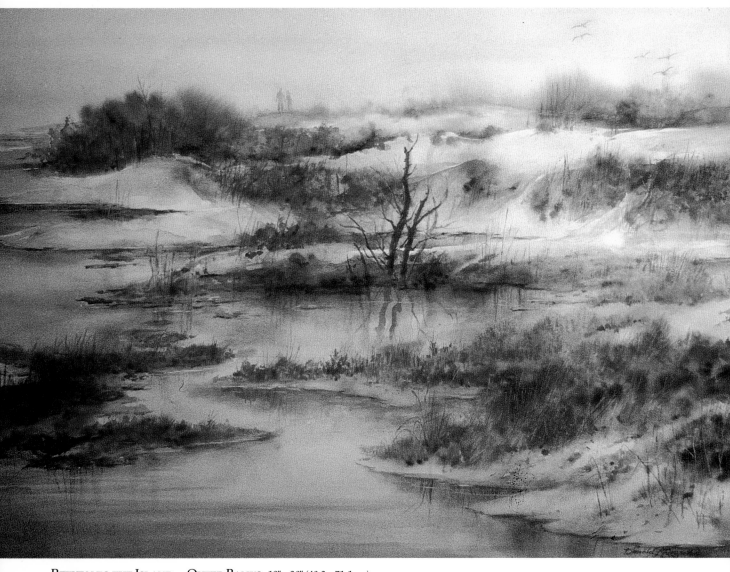

RETURN TO THE ISLAND—OUTER BANKS, *19" x 28" (48.2 x 71.1 cm).*
Collection of Mr. and Mrs. Albert Myers.

Wind-swept Dunes—Sands of Time Past

I started *Return to the Island—Outer Banks* as an experimental painting in an adult-education watercolor class. I first painted abstract areas in burnt sienna, Davy's gray, and cerulean blue into wet-paper surfaces. A vivid mental impression of Bear Island has always remained with me, and as the painting progressed, my memory of Bear Island became stronger and I incorporated sand, water, clusters of scrub growth, and trees. Since the sand on the island was almost white, I used the white of the paper for these areas with very light washes of cerulean blue and Davy's gray to help create ridges and planes. I used mauve, burnt sienna, and neutral tint to indicate the grass and brush areas. The faint image of two distant figures added a touch of nostalgia to the scene.

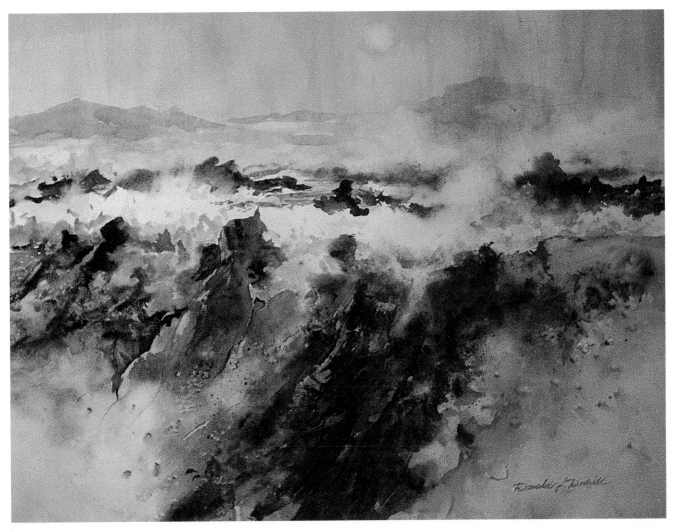

EDGE OF THE ISLAND—NORTHERN COAST, *19" x 28" (48.2 x 71.1 cm).*
Collection of Ann O'Rourke.

Evolving Shapes of a Churning Sea

Like *Return to the Island,* this painting was also an experimental class project. With the exception of an irregular area in the middle, I pre-wet the entire sheet of 140-pound D'Arches watercolor paper with a large three-inch bristle brush loaded with clear water. After permitting the surface to dry for a few minutes, I loaded the large brush with mauve, burnt sienna, sepia, and cerulean blue in sequence and let the color spread into the wet surface of the central area. I also permitted the cerulean blue together with a little alizarin crimson to flood the sky area. Before these combinations of color dried, I scattered salt on the bottom portions at random. When the painted surface was almost dry, I scratched through the pigment on the surface to create the effect of jagged rock in the darker values of the middle planes. Additional work with a sponge and paper towel softened and defined spray and foam in the water areas. As shapes evolved, the image began to suggest the rocky shoreline found along the North Atlantic coast and some of the offshore islands that are largely exposed rock. I sponged out the image of the sun breaking through the mist in the sky area and, when the surface was completely dry, removed the salt, which had created an effect of pitted sand with small rock and pebbles embedded in it.

THE WILDLIFE AND NATURE SERIES
Wildlife and Flowers in Their Natural Habitat

Wildlife and nature painting is most successful when the artist is dealing with familiar subject matter. A great blue heron wading near the bank of the Scioto River, bluegill and crappie darting about in the water, the splash of a mallard making contact with the river's surface, the roosting call of a ring-necked pheasant summoning its mate . . . these are but a few of the sights and sounds of nature that were an integral part of my early life growing up on a farm in Ohio. After college, I became a city resident, but I continued to make frequent weekend trips into the countryside to sketch and paint.

Selecting subject matter, gleaning the essence of bird, animal, or plant, and creating convincing environmental settings are all part of wildlife and nature watercolor painting. While many wildlife painters choose to concentrate on the particular animal as the dominant element, I am more inclined to place wildlife in its own habitat, where I first saw it and where it is an integral part of the natural world. I try to keep the animal as center of interest but not necessarily as the dominant element.

Continued involvement with landscape painting has had a significant influence on my wildlife subjects and has prompted me to be more aware of the proper relationship between the animal and its environment. I have also come to realize that the correct shape and positioning of body appendages rather than the specific details are of prime importance. Observations of birds, as portrayed by the painting *Morning Flight* (page 66), made me aware that only general color areas and wing and feet positioning were needed to convey birds in flight.

Even while studying animals in a zoo, I found that their constantly shifting movement made it difficult to sketch much more than fragmentary poses. Close-up studies of animals, butterflies, birds, flowers, or plants warrant more accurate detailing. *Beginnings and Endings* (page 68), *Monarch and Morning Glories* (page 69), and *Pheasant in the Grass* (page 57) are paintings that rely on

> ### REFUGE
>
> *Winter's breath has permeated*
> *The meadows and the woods.*
> *Crusted snow has created*
> *A temporary barrier to grain*
> *Yet remaining in the open*
> * fields.*
> *And seeking to ease winter's*
> * pain,*
> *Pheasants enter cautiously*
> *A deserted barn in man's*
> * domain.*

more specific detailing. In these instances, I worked from photographic references. Our niece and her husband, who live in northern Ohio, raise ring-necked pheasants for preserves. Their pheasant farm offered an opportunity for close-up photography and sketching of this beautiful but elusive game bird.

For other paintings, the landscape background came first in the design. Once an interesting and appropriate setting was worked out in pencil, the wildlife element was added at its most advantageous location. *Mallard Trio, Creek with Coon,* and *Sun Bathers* are examples of this approach (see pages 60–61).

Two of the paintings in this series— *The Unseen Sea* and *Venturing Out*— were started with a more abstract approach to the background (see pages 62–63). *The Unseen Sea* evolved from remembered images that developed after I had viewed a number of underwater scenes, slides taken by an underwater photographer, a friend of our son, Jon. *Venturing Out* was the result of experimental interpretation of the shapes and roots and trees near the edge of a stream. The marine life in *The Unseen Sea* and the frog in *Venturing Out* were added once the overall background image was established. More detailed explanation of this procedure is included with each individual painting illustrated under the subhead "Creating a Setting." Also in this chapter are examples of wildflowers or flowers combined with insect life in a natural setting, which serves as visual enhancement for the wildflowers or insects.

Light and its effect can help add drama and interest, especially in wildlife and nature paintings. *Refuge* (page 55) shows the effects of interior and exterior sunlight—in this instance, coming through the partially deteriorated roof of an old barn. Light patterns are cast on the interior, adding extra interest to the trio of pheasants.

Exterior winter sunlight, with its shadows cast on the snow, dramatizes *Winter Retreat* (page 56), which relies primarily on landscape to create the pictorial effect.

Creative Use of Photography and Reference Material

Photography can provide a helpful reference source for a painting, but without initial on-site viewing of the subject, it is not sufficient. Photography must be considered only as a means to an end, with the painter using it judiciously and creatively. When I painted *Refuge*, the main contribution of the setting photograph was the establishment of the interior sun-struck areas. Photographic reference for *Winter Retreat* provided reference for the snow-covered stump.

In wildlife painting, use of photography is almost mandatory for reference in painting animals and birds because of their activity and the time available.

The paintings in this section, *Refuge, Winter Retreat* (page 56), *Pheasant in the Grass* (page 57), *The Gathering* (page 58), and *Sea Oats and Sea Gulls* (page 59) are paintings in which photographic reference played a part in the pictorial elements or composition. In each instance, however, the finished painting was completed using a combination of photographic reference or photographic reference sketches and remembrances of the actual scene.

As you can see, photographic material must be used selectively with creative interpretation of the photographic elements as they apply to the painting.

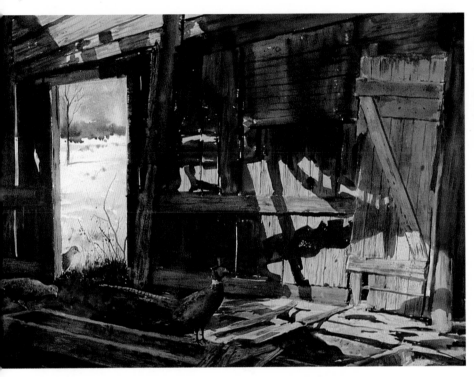

REFUGE, *20" x 29" (50.8 x 73.6 cm). Collection of George D. and Shirley F. Combs.*

Wildlife in an Uncommon Setting

Working from photographs, I sketched in the background with pencil on a full-size sheet of stretched D'Arches. After trying several arrangements using tracings of the pheasants, I placed them as they now appear, with one of the hen pheasants outside. When I use wildlife elements in a painting, I usually choose an odd number because it creates a more interesting composition.

After penciling in the pheasants, I masked them out with liquid frisket and then painted in the landscape, using wet-in-wet washes. On the barn interior were the large light values of burnt sienna, sepia, and Naples yellow. When these were dry, the dark values of sepia and a small amount of Prussian blue were glazed over the first wash. I painted the pheasants last, my foremost consideration being their shape and relationship to the background.

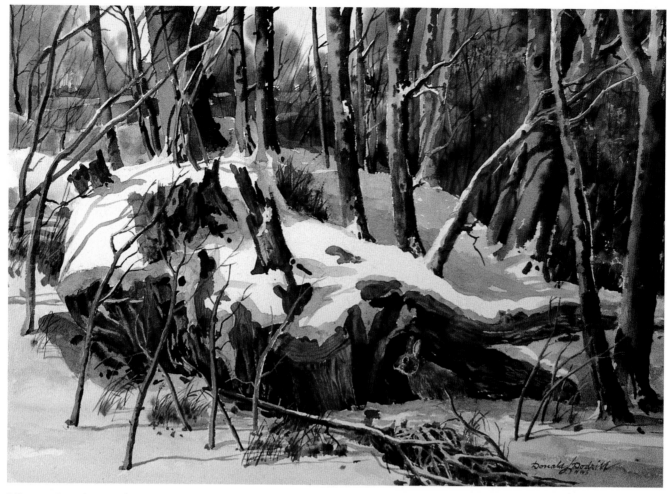

WINTER RETREAT , *16" x 21" (40.6 x 53.3 cm). Professional collection of Richard B. Barry, D.D.S.*

A Natural Hideaway for a Hare

Although *Winter Retreat* is smaller in size, I painted it in much the same way as *Refuge.* The painting was inspired by a personal experience with nature. Walking along the Scioto River one Saturday in February, I startled a cottontail, which darted from a clump of grass, hopped several yards, then suddenly disappeared beneath an old tree stump. Moving closer to the stump, I saw no sign of the rabbit but sensed that it was now safely hidden within its retreat. The day was bright and the tangle of trees and brush cast intricate shadows on a blanket of snow.

As I looked about me, an image began to form, a suggestion for a wildlife painting. Using 35-mm color film, I took shots of the weathered stump and the general surroundings. I thought that the photo illustrations would serve as valid reference for the setting and tree shapes.

Later, at my studio, I composed the background for the painting and established a direction for the source of sunlight so that there would be a definite pattern for the shadows. Definite shadows were not discernible in the photo. Areas requiring soft edges were painted wet-in-wet. My palette included cerulean blue, Naples yellow, burnt sienna, sepia, Prussian blue, Davy's gray, and neutral tint. I painted in values from light to dark. Last but not least, I placed the rabbit at the opening of its burrow, a very small but important part of my painting. I referred to my wildlife sketches for reference.

PHEASANT IN THE GRASS, *16" x 20" (40.6 x 50.8 cm). Collection of Mr. and Mrs. Anthony Sanna.*

Painting Rich-hued Plumage

This painting places emphasis on the wildlife subject, the pheasant, rather than the environment, its grassy hiding place. I have always had a special affection for this richly hued, free-spirited bird. I grew up in an area that was well populated by ring-necked pheasants. The photographic reference for the pheasant was selected from my photo morgue. This source was valuable in providing the correct coloration and plumage detail.

I masked out the shape of the pheasant with liquid masking agent. Blades of grass overlapping the pheasant were not masked out. After masking out the contours of the pheasant, I wet the entire background of the painting with clear water, using a 2-inch brush. I then applied light washes of sap green, Hooker's green, and a little burnt sienna to the wet surfaces and

permitted the colors to dry. Then I applied heavier washes of the same colors. Before this darker wash dried, I scraped through the semi-wet wash to expose the lighter preliminary wash. This technique suggested long blades of grass, a natural hiding place for the pheasant. The background was entirely improvised in the studio. The plumage of the pheasant was painted, working wet-in-wet in some small areas and on dry surfaces in others in order to achieve the variegated coloration of the feathers.

For this painting, I used D'Arches 140-pound hot-pressed watercolor paper in preference to cold-pressed because of the more intricate detailing on the pheasant. The smoother surface of hot-pressed paper facilitated finer detail and greater control in small detailed areas of the plumage.

THE GATHERING, *23" x 16" (58.4 x 40.6 cm). Collection of Jeffrey M. Wilkens.*

Eagles—Airborne and at Rest

The inspiration for *The Gathering* grew from observing American bald eagles at the Columbus Zoo in Ohio. I made several quick pencil sketches of them, one in particular perched high atop an old tree trunk within the cage. These sketches yielded the initial composition, and our son Jon's photographic references provided the further details of the birds, including wing positions in flight. As in *Pheasant in the Grass*, the emphasis was on the wildlife subject rather than the background.

For the painting of *The Gathering*, I used cold-pressed watercolor paper, primarily because of the large wet-in-wet area in the sky and background, which tends to blend more softly on the cold-pressed surface. Also, the detail in the feathers of airborne birds did not require fine enough treatment to warrant the use of the hot-pressed paper surface. I masked out the shapes of the bird to ensure the retention of the pure white areas in particular. I used dry-brush technique on a previously painted dry surface to create texturing on the weathered tree.

SEA OATS AND SEA GULLS, *23" x 16" (58.4 x 40.6 cm). Professional collection of Dr. George Paulson, The Ohio State University.*

Elements of Flight

Using photographic references as backup for my pencil sketches, I drew a number of gulls in a variety of sizes on tracing paper and positioned them in the sky areas. When I was satisfied with the compositional arrangement, I traced the gulls onto the watercolor paper for the final painted version. The dark plumage on the gulls was a combination of burnt sienna, mauve, and neutral tint. I masked out the birds before painting the sky.

The land, sea, and sky elements helped to establish location, mood, and time of day. I painted these from memory of the North Carolina coastal area. The sky color was a mixture of mauve, cerulean blue, alizarin crimson, and Davy's gray. A simple, direct wash of cerulean blue, neutral tint, and Davy's gray made up the water area. In the sandy foreground, I used a mixture of Davy's gray, Naples yellow, and sepia, and added a small amount of salt to create texture in the sand.

Selecting the Setting from Reference Material

Taking along a camera and sketchpad on Saturday outings, vacations, or business trips enables me to collect a wide range of photographs and sketches for reference material. Much of this reference material evolves into landscape paintings, but frequently a landscape or waterscape also serves as a setting for wildlife or other nature paintings. *Creek with Coon* (below), *Mallard Trio* (page 61), and *Sun Bathers* (page 61) are in this category.

I always keep in mind that the setting must be a natural environment for a particular living creature and that any light source apparent in the reference sketch or photograph must be consistently used when painting that subject. On occasion, I will see wildlife, marine life, or reptiles when sketching or taking photos and make notes concerning the subject's environmental relationship to the scene.

CREEK WITH COON, *15" x 20" (38.1 x 50.8 cm). Private collection.*

Correlating Subject with Natural Setting

The settings for *Creek with Coon* and *Mallard Trio* originated from 35-mm photographs of a creek and a small lake that I had shot some time before. *Sun Bathers* was painted using a small detailed color sketch of an old tree that had fallen into a creek. This sketch, too, I had kept in my files.

In choosing the subject to accord with the environmental setting, I selected an animal or bird or—in the case of *Sun Bathers,* reptile—that would naturally relate to the setting. The photograph of the creek scene had a fall flavor. This photo reference, combined with the raccoon washing a stolen ear of corn, a subject derived from my sketch file, seemed compatible. Although the raccoon is a fairly small element in the *Creek with Coon* painting, it assumes the center of attention, or focal point.

Mallards are one of the more common of the wild duck species that inhabit Ohio water areas such as this lake. I selected three different poses of them in flight from several sketches and incorporated them into the composition of *Mallard Trio* using a photo of Marysville Lake for background reference.

For *Sun Bathers,* I found the color sketch of the old tree so interesting that I decided to make the background the dominant element and the turtles subordinate. I chose small fresh-water turtles because of their size, their adaptability to the background, and their habitation in Ohio's rivers and streams.

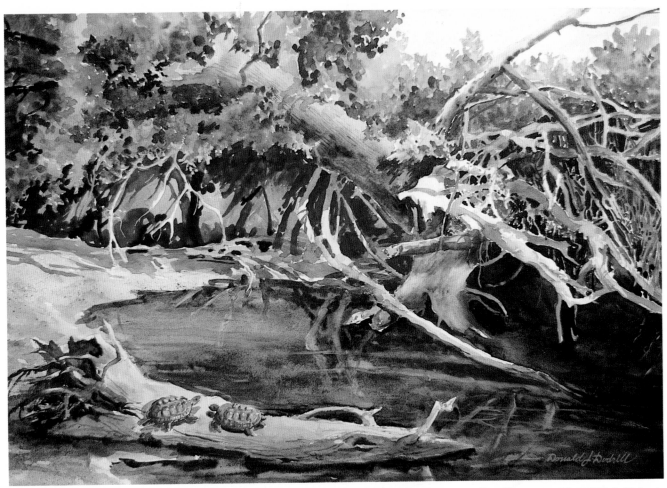

SUN BATHERS, *16" x 22" (40.6 x 55.8 cm).*
Courtesy of Windon Gallery.

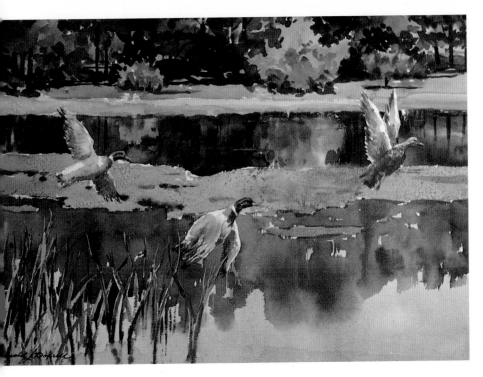

MALLARD TRIO, *14" x 17"*
(35.5 x 43.1 cm). Courtesy of
Windon Gallery.

Creating a Setting

Many artists, myself included, rather than depending on reference material, frequently reach into their imaginations to inject an atmosphere of emotion, mystery, or impact into a painting. The transparent watercolor medium is ideal for achieving exciting results. *Venturing Out* (below), *The Unseen Sea* (page 63), *Winter Pheasants* (page 64), and *Wild Turkeys* (page 65) use environments created from imagination rather than from reference material. The wildlife or marine life elements were derived from either sketches or photo references.

The first two paintings in this series, *Venturing Out* and *The Unseen Sea*, were painted with only a vague concept in mind. As the wet-in-wet paintings progressed, the concept evolved, based upon what was occurring on the paper. The frog in *Venturing Out* and the marine life in *The Unseen Sea* were added after the backgrounds had been practically completed.

There was more preplanning in *Winter Pheasants* and *Wild Turkeys*. After deciding on the wildlife subjects, I carefully worked out drawings of the pheasants and wild turkeys using photo references from my files. I then worked out the backgrounds loosely on tracing paper and positioned the birds in the composition. The combined images were then transferred to the paper.

The composition for the pheasant seemed to work better horizontally, whereas the turkeys seemed more comfortable in a vertical format. Although I normally use an odd number of subjects in my wildlife paintings, I felt the compositions with the strong tree shapes offset the need for another bird there.

Letting Imagination Lead

Venturing Out began as an experimental painting. I wet the entire surface with a 2-inch bristle brush and added several colors onto the wet surface, letting them spread at different times during the drying process. I used burnt sienna, Naples yellow, sap green, sepia, Antwerp blue, neutral tint, and opaque white. I rarely use opaque white, but in this wet-in-wet approach, it reacted to the wetness of the surface and created abstract rootlike patterns. At various stages, I added more pigment to enhance the evolution of shapes. As the painting progressed, the image suggested the tangled roots of a tree near a body of water. I saw two green shapes as water lily pads. That led to choosing a frog as the wildlife element.

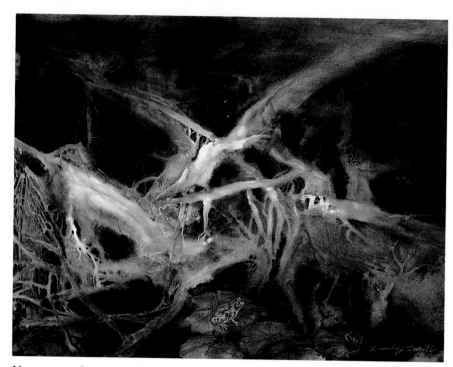

VENTURING OUT, *17" x 23" (43.1 x 58.4 cm). Collection of Judith White.*

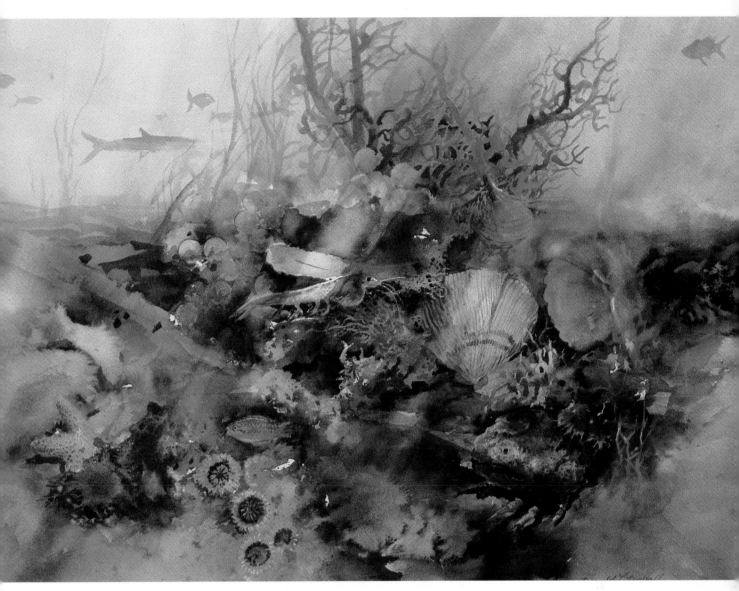

THE UNSEEN SEA, *19" x 29" (48.2 x 73.6 cm). Collection of Mr. and Mrs. Geoffrey D. Manack.*

Creating a Composition in Space

I developed *The Unseen Sea* in a similar way to *Venturing Out* with three major exceptions: (1) no opaque paint was used; (2) prior to wetting the entire surface, liquid maskoid was applied at random spots on the surface of the paper; and (3) the subject was loosely determined by vague memories of marine life, inspired by a recent photographic exhibit I had seen.

After applying the masking agent somewhat randomly to areas in which I wanted to create an interesting composition, I wet the entire surface of the paper and left it to dry for approximately thirty seconds. Using a 2-inch brush, I blended washes of cerulean blue, Prussian blue, Winsor green, and neutral tint into the surface, changing the value intensity at various points. While the paper was still damp, I dropped a small amount of salt onto the lower portion of the painting . As the surface began to take on an "underwater" appearance, I could see a more definite direction for the painting.

Some of the details, such as images of fish in the distance and the seaweed, were painted in varying shades of blue and green. When the surface was completely dry, I removed the masking agent, exposing the abstract paper-white areas. I set the painting aside for several days while I decided how to use the masked-out areas. As I looked at the work, most of the abstract areas began to suggest shapes related to underwater subject matter—starfish, crab, shrimp, shells.

I checked out a book on deep-sea life that corresponded most closely to the shapes of open areas I was working with. Using a natural sponge, I enlarged some areas and painted in on other areas to define shapes that were primarily pinks, pale yellow, orange. In some instances, I put light washes of the blue and green over elements to reinforce the underwater atmosphere. Portions of the masked-out areas that did not work as part of sea-life shapes were painted with various values of the blue and green background.

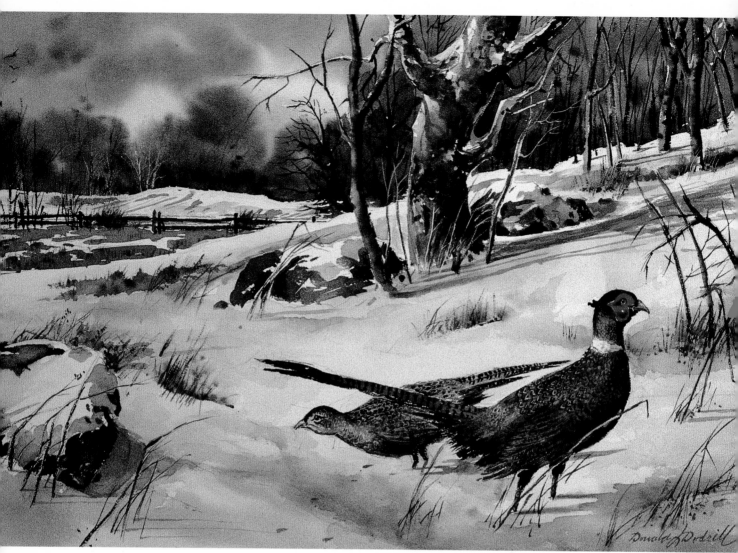

WINTER PHEASANTS, *15" x 22"*
(38.1 x 55.8 cm). Collection of Ann
Boland.

Placing Wildlife in an Imaginary Landscape

Winter Pheasants incorporated an imaginary landscape setting but with a preplanned approach. I worked out the winter background setting on tissue paper without references. Using two pheasant photographs for reference, I set the pheasants into the landscape, making sure their shapes were correct and the light direction accurate. In this instance, I placed the birds against a light background and did not mask them out. While the sky area was still damp, I added the distant trees in the landscape, giving them a soft, feathered appearance at the top.

Focusing on Wildlife with an Out-of-Focus Background

In *Wild Turkeys* the pictorial emphasis was on the turkeys. I used an imaginary environment, working wet-in-wet to achieve a soft semi-out-of-focus effect in the background trees. I masked out the turkeys to keep the background washes free and loose. The trees in the distant background were painted when the paper was at various degrees of dryness. The foreground tree on which the turkey perched was painted last using sharper detailing on a dry surface. Feather detailing on the turkeys was painted with a No. 2 brush working in small wet-in-wet areas to give a soft "sheen" to the plumage. Reference for the turkeys came from my wildlife photo morgue.

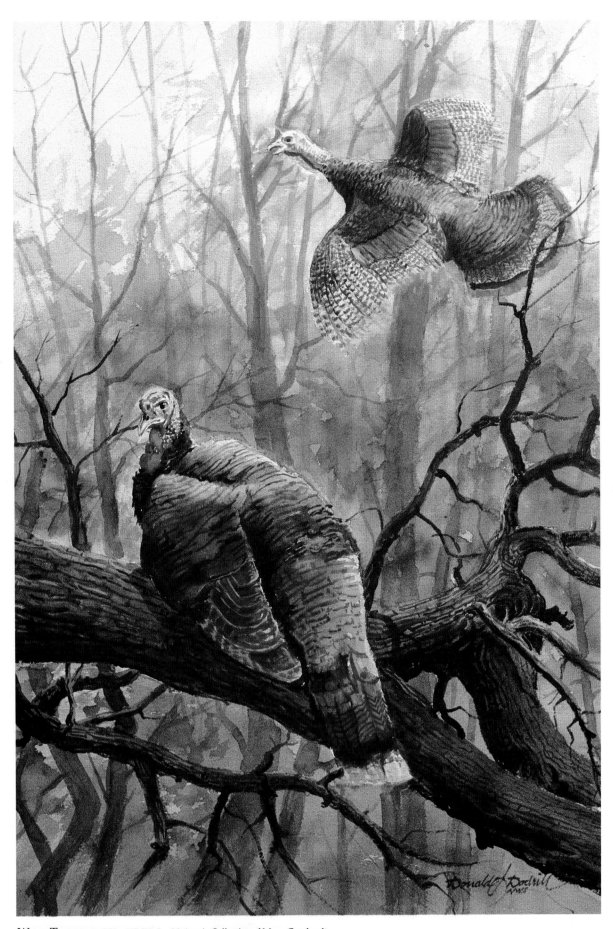

WILD TURKEYS, *22" x 15" (55.8 x 38.1 cm). Collection of Mary Gearkardt.*

Emphasis on Correct Shape and Anatomical Relationships

When painting wildlife, remember that the shape and anatomical correctness of the animal or bird is very important in conveying a feeling of life and reality. Minute detail, such as exact feather indication and precise coloration, is not necessary, especially in a painting like *Morning Flight*, where the ducks are in a flight pattern.

But the shape of the head, position of the feet, and size of the wingspan in relation to the body are critical to making a convincing painting of this waterfowl, as you can see in *Morning Flight*. When painting several birds in flight, varied positions of the wings create a more interesting and realistic appearance.

The Critical Details of Reality
A variety of ducks, particularly mallards, live year-round on the Scioto River near the Columbus Zoo. This river habitat affords an opportunity for close observation, photographing, and sketching. I painted *Morning Flight* basically from pencil sketches and an in-flight shot of several mallards. Color notes on the sketches helped to accurately define plumage color.

In *Morning Flight* I drew the ducks, concentrating on the correct shape and wing position. To retain the light values, I then masked out the ducks, intersecting dark areas of the background. Varying the size of the ducks helped to establish a spatial depth in the composition.

Plumage coloration of the drake and hen mallard differ, with the male being more colorful. When painting a number of mallards, I usually show a mix of drakes and hens, as in *Morning Flight*.

While both sky and water were in the wet stage, I allowed the warm early-morning sky to blend into the water surface. Next, I painted the reflections from the cattails and grass islands while the water area surface was still semi-damp. Further delineation of the cattails and mallards was the last work on the painting.

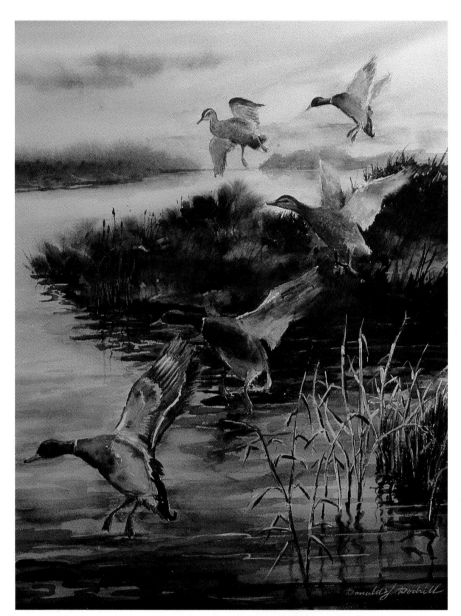

MORNING FLIGHT, *20" x 15" (50.8 x 38.1 cm). Collection of Thomas Bonasera.*

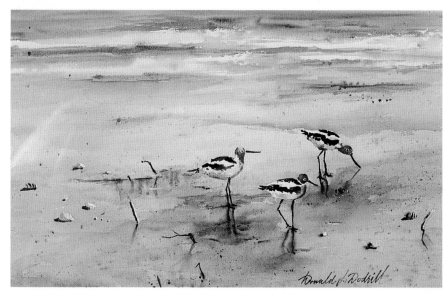

Relating Sand, Sea, and Shore Birds

I painted *Shore Birds* from sketches made in the Outer Banks of North Carolina. American avocets—long-legged, web-footed shore birds with slender up-curved bills—inhabit beaches, flats, and shallow lakes. With a scythelike sweep of the head and bill, these slim waders feed on insects, crustaceans, and other aquatic life. Their sharp excited *wheeks*, slender bills, and striking black and white plumage make this large slim shore bird easy to identify. During breeding, which occurs in their Western habitat, the plumage of the head and neck area is a pinkish tan, as indicated in this painting. In winter, this color is replaced by pale gray. Again, shape and proportioning become important when painting the avocets, and their positioning makes them the center of interest.

SHORE BIRDS, *15" x 20" (38.1 x 50.8 cm). Collection of Terry Thompson.*

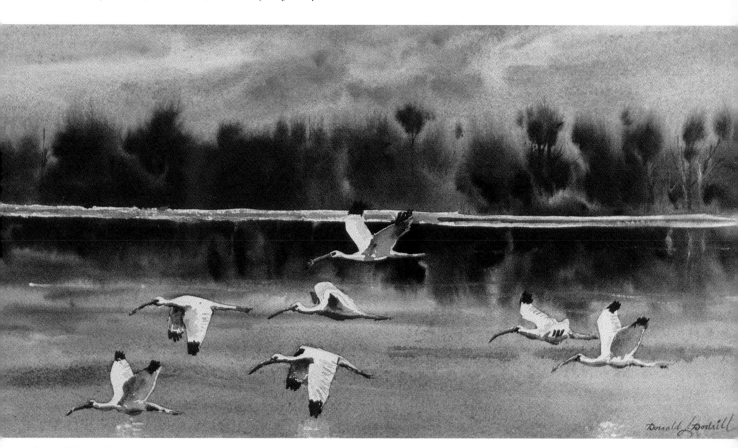

SEVEN FLYING IBISES, *8" x 16" (20.3 x 40.6 cm). Collection of Mrs. William Culter.*

Flight Patterns in a Horizontal Composition

On a trip to the Florida Everglades, I chanced upon a number of white ibises, long-legged waders with slender reddish color bills and restricted black wing tips, common to the marshes and mangroves of that area. I was able to obtain some flight shots of this unusual bird in various positions and used them for reference in this small painting. I kept the tree-lined bank simple, using the wet-in-wet technique to soften the tops of the tree shapes and their reflection in the water. Ibises fly with necks outstretched, and flocks fly in strings, flopping and gliding. I carefully sketched in the bird shapes at different elevations and masked them out with masking fluid to protect the shape while painting in the water area. I used a minimum of detail in painting each of the ibises and concentrated on value changes on the white undersurfaces of their wings to add dimension to shapes. The variety of shapes adds interest.

Flowers in a Nature Setting

Wildflowers growing uncultivated in a natural setting have always challenged me to capture their primitive beauty in watercolor. When living on an Ohio farm, I became familiar with a variety of wildflowers, each kind growing and blooming in its own woodland sanctuary.

When finding wildflowers in their natural setting, I always carefully study the setting, seeking out some other element of nature such as an old stump, log, or rock to serve as a backdrop or foil for the wildflowers. Adding a natural backdrop often serves to enhance the delicacy of the blooms.

Often I have discovered flowers—once cultivated, now growing wild—near porches of abandoned farmhouses or have observed twining plants blanketed with flowers clinging to weathered trellises. In these types of settings, I try to include some element of the architecture, such as a porch rail, window frame and sill, or trellis. In *Monarch and Morning Glories* (page 69), a butterfly extracting nectar from the blossoms lends additional life to the painting. These ancillary elements also serve to create contrasts in color and texture within the composition. Light and shade can help to dramatize flowers by focusing the eye on certain areas and playing down color and value in other areas of the painting composition.

BEGINNINGS AND ENDINGS, *16" x 22" (40.6 x 55.8 cm). Collection of Mrs. C. William O'Neill.*

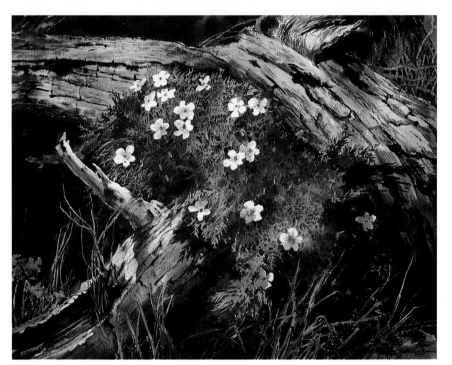

The Inspiration of the Delicate

The idea for *Beginnings and Endings* came primarily from a black-and-white photograph I had taken several years ago in a woods near our farm. As I was preparing the sketch for the painting, it occurred to me that it was somewhat of a paradox—a bright, new flower growing out of an old tree stump—so I gave the painting the name *Beginnings and Endings.*

Wildflowers offer an infinite variety of compositional possibilities. In this painting, I was able to depict a range of shapes and textures—the rough, weathered wood surrounding the flower; the delicate leaf and flower shapes; the fragile, dried grass. I masked out the white flowers to ensure crisp edges. Dry-brush techniques created the weathered look of the stump. I first painted the green leaf shapes surrounding the flowers in a light green value. When the initial wash dried, I painted in a darker green value in the negative areas to help define the leaves.

Each spring I take walks through the woods, accompanied by a camera and sketchbook for recording painting references. On these walks, when I have encountered wildflowers growing uncultivated, nestled against a natural background, I am reminded of a passage from Alfred, Lord Tennyson's verse, "Flower in the Crannied Wall," which reads: "Little flower—but if I could understand/What you are, root and all, and all in all,/I should know what God and Man is."

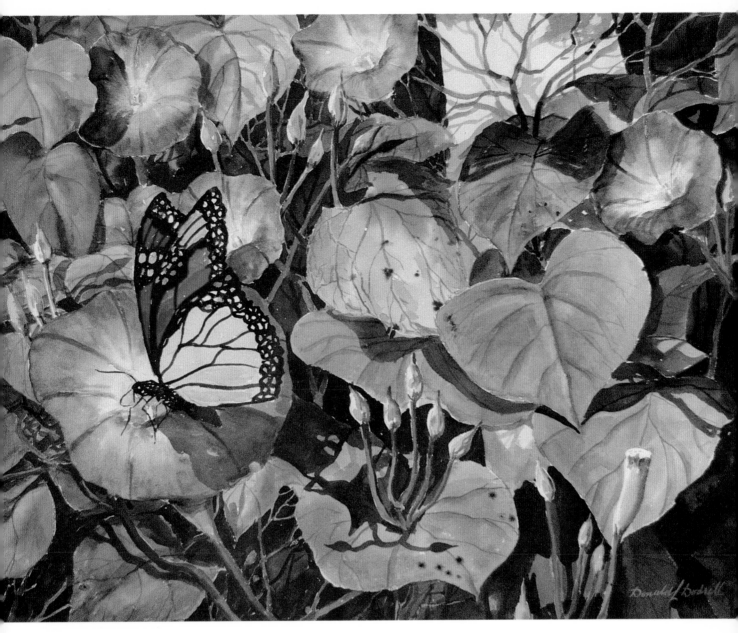

MONARCH AND MORNING GLORIES, *16" x 23" (40.6 x 58.4 cm).*
Collection of Sara Rebecca Dodrill.

A Tangle of Morning Glories

Not long ago, while on a painting outing in Tennessee, I came upon a tangle of morning glories twining themselves around a trellis on the porch of an abandoned house. A number of monarch butterflies hovered above the lavender-colored flowers. I took several color shots of them for painting reference. Combining possibilities from several different prints, I developed a composition showing a monarch butterfly alighting on one of the flowers.

 I painted the light values on the leaf shapes first, followed by the darker values in the negative areas. To compensate for the large areas of green leaves, I varied the green color considerably throughout the composition by adding burnt sienna, cerulean blue, and Naples yellow to the sap green. To create spatial depth in the leaf patterns, I worked into the negative shapes with varying degrees of dark brown/green values. Only the monarch butterfly was masked out in the final painting; it was the last element I painted in the composition, using cadmium orange, cadmium yellow, and neutral tint.

THE URBAN SERIES
Painting City and Suburban Architecture with Related Scenes

I have watched the Columbus skyline grow from one dominant structure, the LeVeque Tower (a National Register entry), to more than a dozen multi-storied corporate, state, and federal buildings, each new structure vying for dominance in the city's skyline. I have seen the city expand horizontally to a sprawling metropolitan area and have watched as its downtown continues to grow vertically, with the old coming down and the new rising upward to cast elongated shadows over the historic Statehouse and old Trinity Episcopal Church.

I have studied the city's physical and historical past, its present socio-ecological trends. I have thought about its future and the quality of life the future will offer. Change is the child of time, and time is governed by the temporal triad of growth, prosperity, and power. Everywhere in the large cities, time produces change. Each year, buildings are torn down, including some of major historic and architectural significance.

I believe that every artist who seeks to convey an element of realism in his or her work also consciously or unconsciously becomes a historian. Quite often, a painting of a historically significant building done before the building gave way to the wrecker's ball offers greater visual information than a photograph taken around the same time. With only one viewpoint, the camera falls short.

Every city, every town, has its own character, a uniqueness that distinguishes it. When I paint scenes of Columbus and its suburbs or other cities, towns, and villages, I seek this individualized aspect of place.

In addition to strictly architectural subject matter, many other facets of the city are equally challenging to a painter. Sculptures, parks, street vendors, marketplaces, shop windows, and even construction and demolition sites offer interesting possibilities.

Changing weather and light conditions can enhance the ordinary. Late afternoon sun striking the glass and steel in a skyscraper gilds it in gold and creates many abstract shadow formations. Fall rain, wet surfaces, snow-covered roofs, and a fog-enshrouded skyline present different interpretations of the city. Occasionally, I do paintings based on impressions and remembered images of the city, without a particular location or structure in mind. Sometimes I rearrange existing elements and use them in combination with imaginary ones. Examples of both approaches are included in this chapter.

Cityscapes of existing structures allow opportunities to record, interpret, and visually explore vistas that city dwellers and visitors hurry past, looking at but not seeing.

Sometimes the canyons of steel, glass, and stone can be intimidating by their very scale and complexity. Striving perhaps for mood and emotional impact, the painter can eliminate the unimportant detail, creating more stimulating color combinations than what the eye or camera can capture.

THE CITY REFLECTED

*Time changes man and
 man-made.
Each year the skyline soars
 and swells
Higher and wider, and each
 decade
Finds new and different
 images
Reflected in the river's mirror.
Yet it seems just yesterday
LeVeque Tower alone was here
With the iron railway bridge
As its only other peer.*

Painting City Architecture: Dealing with Detail

When painting city buildings, I use architectural detail only to the extent that it is pictorially necessary to describe the structure. Wherever possible, I simplify or play down small details such as windows, ornate cornices, and brick or stonework. I do, however, try to retain the building's character and overall shape and structure by use of value changes and reasonably accurate color indication. Where ornate detail exists, I try to simplify it by suggestion rather than precise rendering. The amount of detail used depends to some degree on viewing distance, type of light and shadow, weather conditions, and time of day or night.

In some of the paintings, vehicles and human figures were used, but only as they related to the scene. Figures and vehicles also serve as a guide to the scale of architectural structures.

Architectural subjects appeal to me, not solely for the beauty of the architecture but for their individual character and uniqueness, their relationship to the urban environment, and as indicators of their place in time.

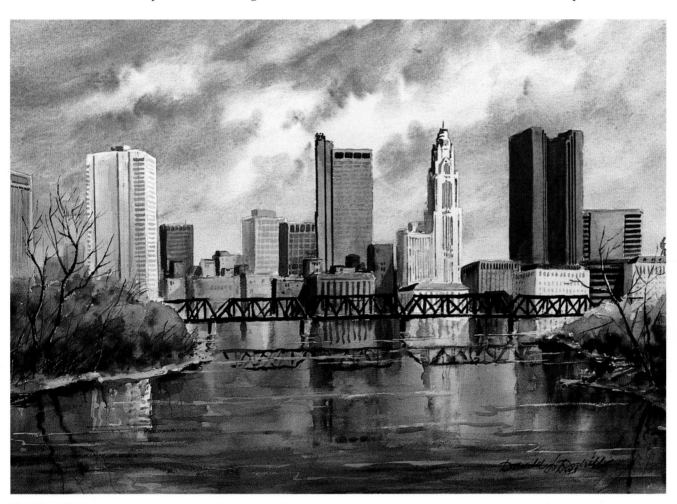

THE CITY REFLECTED, 14" x 19" (35.5 x 48.2 cm). Private collection.

Intermingling Mirrored Images

For many years and in all seasons, I have observed the city's changing skyline as I drove downtown. On a sunny afternoon, the buildings are in sharp relief, while in the early morning, they are backlighted against the eastern sky. Reflections have always been of special interest to me as a painter, with their intermingled variety of mirrored images—buildings, bridges, and riverbank trees. The calm river surface afforded the opportunity to abstractly repeat some of the color and shapes of the compositional elements. I adhered to the general position and shape of the buildings in the skyline but kept architectural detail to a minimum. By masking out the edges of the major buildings, I was able to paint the sky area with more freedom, avoiding a tighter "paint-around" approach. I concentrated on conveying the feeling of a bright October afternoon and the effect of its light on the varied building shapes and their reflections.

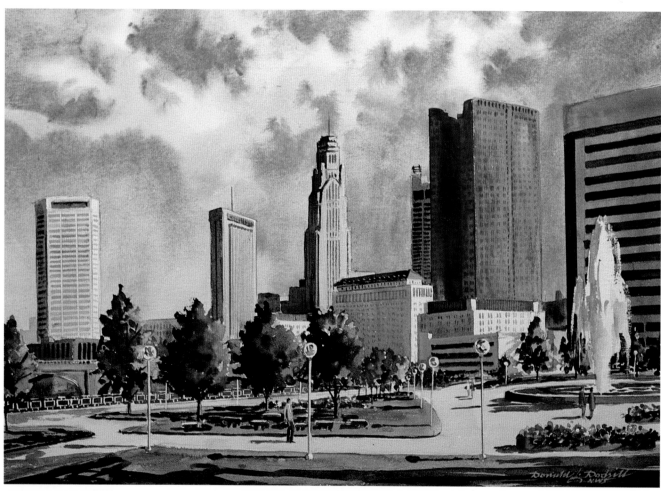

**SKYLINE FROM BICENTEN-
NIAL PARK,** *15" x 22" (38.1 x 55.8
cm). Private collection.*

Another View of the Skyline

The painting above presents another view of the Columbus skyline. From a viewpoint looking north, across Bicentennial Park bordering the Scioto River, the painting shows some of the same buildings as in *The City Reflected,* but they are seen from different angles. The time of year is October, and the strong midday sun illuminates the building surfaces from the right rather than on the frontal planes, as it does later in the day. Again, I minimized window detail, losing most of it into the deep shadow areas. Indications of small figures reinforce scale and dramatize the height of the fountain in the foreground. The shadows cast from the figures and the trees onto paved and grassy areas and their size relationships establish front, middle, and distant picture planes. The concrete walkway leads the viewer's eye to the central points of interest. As in most city architecture, the concrete, stone, and glass structures are mostly neutral and muted tones. Fall flowers and trees, together with colorful flags lining the Avenue of Flags, add brighter color notes to this painting of Bicentennial Park.

A Convergence of Different Styles

From a painter's viewpoint, the intersection at East Gay and North Third streets is interesting because of the variety of building styles, sizes, and shapes. Since I painted *Corner of East Gay and North Third Streets* at a closer viewpoint, I chose to be more exacting regarding architectural structure and detail. When painting architectural subjects of this nature close-up, I use watercolor in a draftman's ruling pen and work with a triangle and T-square to ensure parallel vertical lines and horizontal lines that are in perspective. This technique produces crisp straight lines. Midmorning light coming from the east (left) provided reflective quality for the windows and solidified building shapes. I chose to subdue the importance of automobiles and people by placing them in the cast shadow areas.

The foreground structure, a Modernistic style built in 1927, is a three-stage tower distinguished by its white-glazed terra-cotta and marble cornices. The building's interior is in Art Deco style.

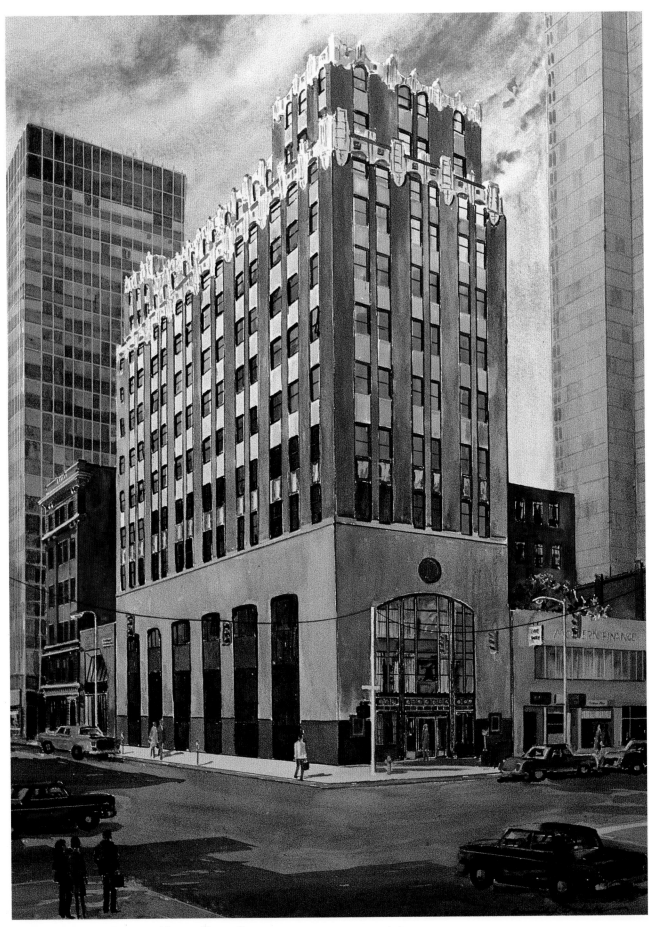

CORNER OF EAST GAY AND NORTH THIRD STREETS, *27" x 18" (68.5 x 45.7 cm). Corporate collection of E. V. Bishoff.*

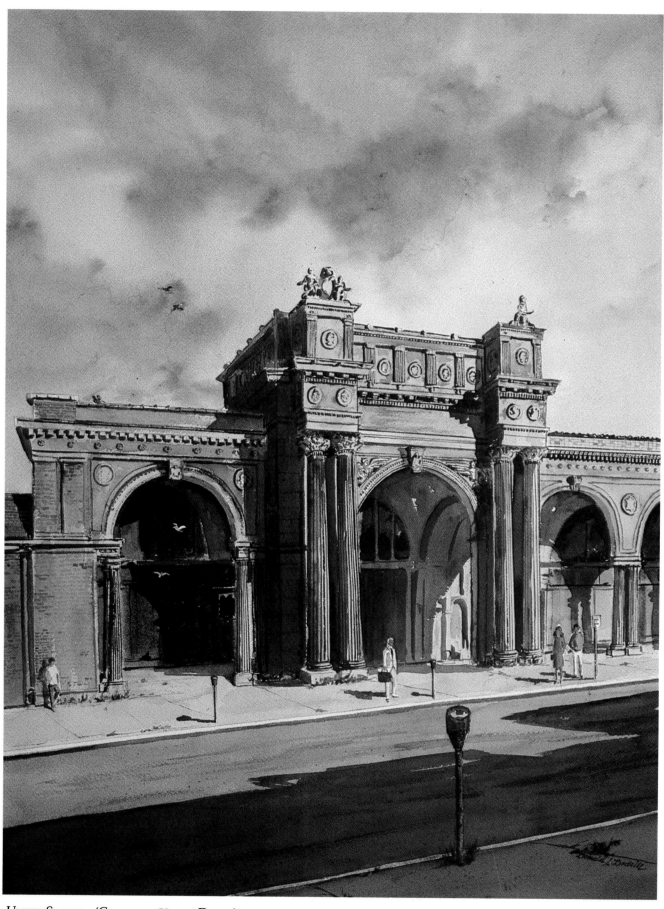

UNION STATION (COLUMBUS UNION DEPOT), *18" x 29" (45.7 x 73.6 cm). Corporate collection.*

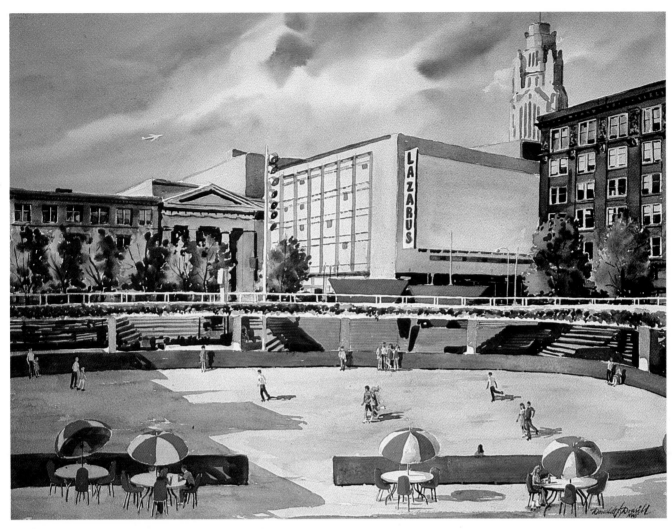

THE CENTRUM, *18" x 29" (45.7 x 73.6 cm). Private collection.*

An Oasis Amid the Humdrum Hustle of the City

The painting above depicts the Centrum in downtown Columbus. Until recently it served as a public recreational facility, an ice- and roller-skating rink. Patterned after New York's Rockefeller Center, the Centrum was a kind of "show of good faith" that Capitol South redevelopment would become a reality. This was in 1978. By 1987 the Centrum was closed, its space to be used for a large shopping mall.

As I painted, I thought of the Centrum as a kind of "oasis" surrounded by somewhat grim structures that scowled at the lighthearted activity of the skaters below. Trees planted at street level reinforced the impression of a non-urban area. By indicating small figures in a variety of poses, I sought to show a release from city business. The brighter colors of the skating area contrasted with the dour gray of surrounding buildings.

A Sense of Past Grandeur

Union Station is a painting of the Columbus Union Depot shortly before it was torn down to make way for the Ohio Center, a convention center complex. The impressive Beaux Arts High Street entrance to the depot was built of buff-colored brick and terra-cotta, with two large pavilions joined by an arcade and flanked by paired Corinthian columns. Above the columns rested an entablature, a cornice with dentals, a frieze with medallions, topped by a parapet. Above this, each pavilion had four groups of free-standing classical sculpture. In the center of the roof was an ornate flagpole.

To indicate the great amount of detail on the structure, I painted it with the afternoon sun lighting up the long horizontal front with its repetitive arches. I heightened the brick color with Naples yellow, a touch of burnt sienna and Davy's gray to relieve some of the drabness. To enrich what might otherwise have been a monochromatic color scheme, I used brighter colors for the window areas and pedestrians at the bus stop.

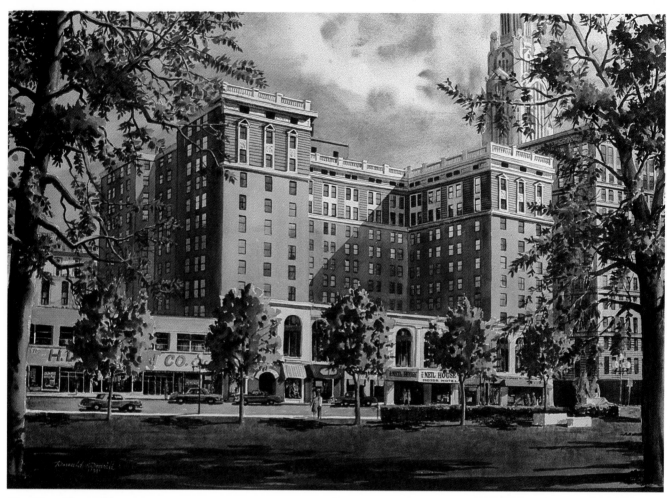

THE NEIL HOUSE HOTEL, *19″ x 29″ (48.2 x 73.6 cm). Collection of John Walton Wolfe.*

Capturing Classical Elements of a Time Gone By

My primary objective in painting the Neil House was to visually record an important part of downtown Columbus that was soon to disappear, but I also wanted to keep the sense of grandeur—the atmosphere and service the hotel represented.

Columbus almost always had a Neil House Hotel, and it was always on the same site. The last Neil House (the third), a Second Renaissance Revival style, was built in 1925, facing Capitol Square across South High Street. The first floor, with its jumble of small shops, was rather unimportant architecturally, but the second floor, which housed large meeting rooms and other public spaces, had classical elements typical of the Second Renaissance Revival style.

Since the hotel faced east, I decided to use mid-morning light, viewing the building from across the street near the front of the Statehouse. I took several 35-mm photographs from varying distances to record as much detail as possible. Later, working with photographic reference, on-site sketches, and notes, I sketched the hotel approximately one-half the final size, using the two-point perspective. I repositioned the foreground trees slightly so that more of the front of the Neil House could be seen. The smaller trees near the street were used to cover portions of other storefronts facing High Street, thereby minimizing the detail and focusing the viewer's attention directly on the hotel. After I had satisfactorily completed the small sketch, I projected it to the actual working size of 30″ x 20″ (76.20 x 50.80 cm). Changing the window colors and values served to reinforce the impression of glass and reflected light. There was no attempt made to show the texture of brick and stone, only the color values. Shadows cast from the right wing of the building helped establish the U shape and prevented the number of windows from assuming too much importance.

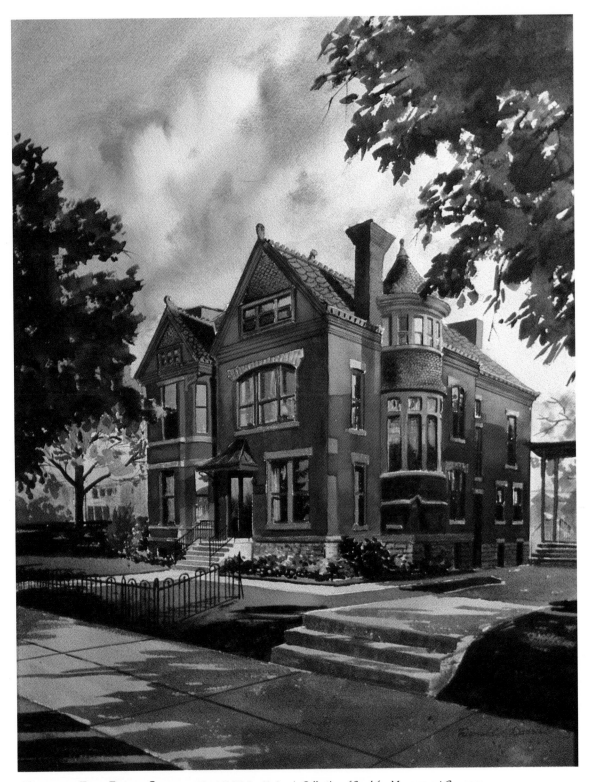

HOUSE ON EAST BROAD STREET, *20" x 16" (50.8 x 40.6 cm). Collection of Sandefur Management Company.*

Reminder of a Time of Distinction

Around the turn of the century, East Broad Street was a prime residential area in Columbus. Wealthy merchants and successful professional men hired architects to design and build grand high-ceilinged two- and three-story houses in various styles: French Second Empire, High Victorian Italianate, Romanesque Revival, Georgian Revival. Some truly eclectic houses were built during this time. Of the East Broad Street houses still standing, only a few remain as residences, their slate roofs, imaginative use of brick and stone, and distinctive detailing reminders of a time long ago. I painted the light playing on this building more as a diffused effect because the bricks display such a uniformity of color that there is little if any tonal variation.

The City Scene: Features, Faces, and Facets

Having spent most of my life in the urban environment, I find it impossible to ignore its painting potential. The painting possibilities are always there, whether in your town, your city, or mine, waiting to be sought out and recorded, an ever-changing source.

In addition to architectural features and façades, the city is alive with painting opportunities—open outdoor markets, urban renewal, construction scenes, sidewalk vendors, bus stops, and other people-related activities. Statues, fountains, landscaped courtyards—the city's adornments also capture my imagination.

Two painting subjects in this section, *Statue of Christopher Columbus* and *The Naiads on Capitol Square* (page 79) are enduring facets of the city's visage. *Urban Renewal* and *Near Central Market* (below) are fleeting impressions of human involvement in the city scene.

When painting stationary objects such as the statues, I frequently rely on sketches to provide adequate information for the painting. When people are involved, the city scene is in a constant flux, and I rely on the camera to provide some of the references. Sometimes I combine information gained from several photos.

Harmonious Patterns of Hard Work

Columbus has been involved in an accelerated program of urban renewal since the 1960s. This painting shows construction scenes typical of many locations throughout the city. A building had just been torn down here to make way for a fast-food restaurant. Although the scene appeared chaotic, I found harmony between the exposed wall surfaces of the adjacent buildings with their abstract patterns of color, texture, light, shadow, and the angular shapes of the construction equipment.

Color sometimes appears unexpectedly at demolition sites. Exposed interior walls decorated in bright colors contrast with the grim, gray textures of plaster, mortar, and brick. I purposely used a heavier, more forceful brushwork in this painting to emphasize the sense of hard work, the massive equipment, and the demolition effect of the men and the machines.

URBAN RENEWAL, *14" x 19" (35.5 x 48.2 cm). Collection of William Bassett.*

Marketing—from Dawn to Dusk

When the Central Market House opened in 1850, it was vital to the lives of the city's residents. Going to market on market days was a happily anticipated event. They say that nearly twenty thousand people shopped there on Saturdays. This small painting strives to capture this element of city life—the Central Market House and street-located market stalls once so important. I created the painting from a sketch of one of the overflow stalls near the end of the outdoor market area. Because the outdoor markets operated from dawn until dusk, in later years a string of electric light bulbs was installed above the displays of fruits, vegetables, meats, cheeses, and other food items. Under these garish overhead lights, the colorful variety of fruits and vegetables created a picture that is still vivid in my mind. Always present were hand-lettered price markers, hanging scales for weighing the produce, and customers composed of a cross section of the city's populace.

NEAR CENTRAL MARKET, *22" x 16" (58.4 x 40.6 cm). Professional collection of Plaza Dental Group, Inc.*

78

Reaching Toward the Sun

I have always admired the grace and beauty of *The Naiads*. With the unusual sunlight effect on the statue and walls of glass surrounding it, it is even more beautiful. For this painting, I took several shots of the sculpture at different exposures. Later, working from the prints, I incorporated the light patterns visible in the photographs, using a basically blue-green palette to accentuate the warm light-struck areas. To indicate scale, I added two figures.

To focus attention on the statue and the fountain, I positioned the light-struck surfaces of the statue against the darker values in the background building and the darker shadowed areas against the lighter values of the background. Overhead sunlight filtering into the partially enclosed courtyard area created strong shadow patterns on the statue, walkways, and glass-walled buildings surrounding the area.

The Naiads is a bronze sculpture over eighteen feet tall, which was commissioned by John W. Galbreath & Company. It is the centerpiece of a circular fountain in the downtown area, linking the Hyatt on Capitol Square and the Capitol Square Office Building on East State Street. The two-and-one-quarter-ton sculpture depicts two nude women reaching upward to touch doves while fish splash at their feet. This is his greatest artwork, according to the sculptor Jack Greaves. I had met Jack Greaves, an Englishman, during my teaching days at Capital University. He was a visiting professor and was working on the preliminary stages of the sculpture at that time. The work took eighteen months to complete.

THE NAIADS ON CAPITOL SQUARE, *23" x 16" (58.4 x 40.6 cm). Private collection.*

STATUE OF CHRISTOPHER COLUMBUS, *13" x 19" (33.0 x 48.2 cm). Corporate collection of Ingeborg Funk, Funk FineCast Company.*

Ever-changing Visual Patterns

When painting features of the city, I search for subject matter that bears a unique relationship to that city. The statue of Christopher Columbus created by Edoardo Alfieri is such a monument in Columbus, Ohio. An imposing bronze statue, it stands in front of City Hall in the Civic Center composition, facing West Broad Street. I tried to define the major changes in planes within the figure by using strong value changes. This technique should be observed even when the statue is not exposed to direct sunlight so that a solid "sculptured," or three-dimensional, impression is created.

To the right of the statue is Ohio's "first aerial lighthouse," the 555.5-foot tall LeVeque Tower, a Modernistic-style structure completed in 1927. The LeVeque Tower wields an interesting play of light and shadow across the face of City Hall, the statue of Christopher Columbus, and the floral plantings at its base. I tried to capture these alternating visual patterns here.

Villages, Towns, and Suburbs

I have recorded in watercolor the constant villages and towns and the inconstant city with its growing suburbs. Many of the scenes recorded in my paintings have been altered by the hand of time, particularly in downtown Columbus.

The suburban areas of the city and the small villages and towns with which I am familiar reflect less change than the metropolitan areas. During my early school years, I lived in two of Ohio's small towns, both with a population of less than two thousand. Years later, many of the downtown buildings in these towns remain much the same, the only changes being fresh paint, new signage, or a different function.

In the arena of life, man-made is but temporal. Each day, each person, each structure, each street of the city presents a face that may never appear quite the same. The paintings in this section portray architectural subjects in villages, towns, and suburbs. All have survived the passage of time and the wrecker's ball. Some retain their original function; others have been assigned a new role in the community. It is these faces and facets of the urban scene that I have sought to capture.

RIFE'S MARKET (GRANDVIEW HEIGHTS), *10" x 14" (35.5 x 25.4 cm). Private collection.*

An Enduring Bit of Americana
One of the few family-owned and -operated grocery stores in the area, Rife's Market sits stubbornly on the corner of West Fifth and Grandview avenues. A fixture there, it remains unchanged except for an occasional fresh coat of paint. To me, it is an enduring bit of Americana.

At the front of the market, flats of petunias and pansies bloom in spring. Melons, sweet corn, tomatoes, and green beans overflow baskets in summer. Fall brings quantities of pumpkins and Indian corn door-hangings. Winter sales include pine Christmas trees and green wreaths.

I have painted Rife's Market in all seasons. This particular painting was done in October when a large supply of Halloween pumpkins created an explosion of orange under the roof overhang. I made no attempt to indicate tight detail. Figures were indicated with minimum brushstrokes, relying on value and position for compositional effect. One of the key design elements was the variety of signs and posters: INDIANA MELONS, HILLIARD SWEET CORN, VERMONT MAPLE SYRUP, VIDALIA ONIONS, FRESH OYSTERS, and NEW YORK STRIP STEAK. The bright October afternoon created shadows that added depth and a certain character.

CORNER OF SOUTH FIFTH AND BERGER ALLEY—GERMAN VILLAGE, COLUMBUS,
OHIO, *16" x 22" (40.6 x 55.8 cm). Private collection.*

Preserving Old World Influences

Today German Village (so named in 1960) is nationally recognized as a private restoration of an ethnic area of a city. On the National Register, German Village serves as an example to all those concerned with preserving their architectural heritage. In 1959, the restoration of a little Dutch house sparked a movement to save the old German enclave. In 1960 the German Village Society was formed to work cooperatively with Columbus City Council and the community to restore and preserve the area. Old World customs, attitudes, and memories influenced the physical environment that the Germans created in Columbus. Houses still extant, built between the mid-1830s and the late 1860s, reflected the houses in Old World villages with flower boxes, iron fences, and brick streets.

The three brick houses featured in this painting rest on lime-

stone foundations. Steps were of hand-hewn Columbus limestone, the brick from area kilns. Windows had plain-stone lintels and sills, as did the doorways. As shown in the painting *South Fifth and Berger Alley,* dormers were sometimes added to the German Village houses to increase the upstairs space. Window boxes added at the time of restoration lend freshness and a lived-in quality with their colorful blooms.

To paint the brick surfaces of the German Village houses, I wet the entire area with a medium-to-large brush and allowed it to dry for about a minute before applying the basic brick color wash. I worked with a palette of cadmium red, Naples yellow, and a small amount of mauve and burnt sienna, using less water. Once the shadow areas were dry, I used a small flat-tipped brush to paint suggestions of brick, varying the value to delineate individual bricks.

Impervious to Time

Built in the late 1800s and originally known as The Opera House, this brick building now serves as a city building and houses city offices and the police department in the small town of Richwood, Ohio, some forty miles northwest of Columbus.

My family lived in Richwood for a time when I was in middle school. At that time, the old Opera House housed the town's only movie theatre. Admission to the movie was fifteen cents and a nickel bought a bag of popcorn. The clock in the tower gave an hourly report of time, and its melodious chimes could be heard by all even in the most distant corner of the village. Now the clock is silent, the hands still. The movie marquee once anchored above the entrance arch is gone, and the vacant windows stare blankly down upon the lone police car parked at the building's side. This is the mood I wanted to capture in the painting—an old brick structure, stripped of adornment, impervious to time, still serving the community.

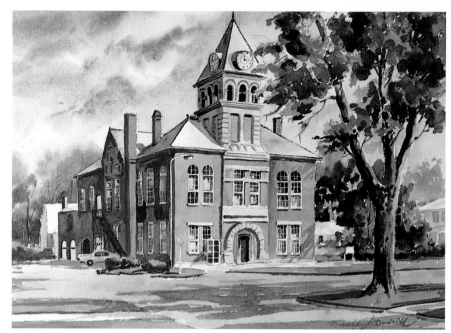

CITY HALL (RICHWOOD, OHIO), *15" x 20" (38.1 x 50.8 cm). Private collection.*

Street Scene in a Quiet Mood

Mood was the key element here, with little attempt made to depict any of the architectural and compositional elements in detail. I was struck by the quietness of this Sunday afternoon scene on Glouster's main street. There were only two youngsters on the street. Their youth and vitality contrast with the somber atmosphere of the aging storefront and deserted street.

Sunday Afternoon is more like a watercolor sketch, using simplified brushwork and values to establish the mood of a quiet, drab, almost deserted street scene. To emphasize the sense of emptiness, I used a muted color palette in keeping with my first visual impression of the village. The afternoon light accentuates the harshness of the shop fronts.

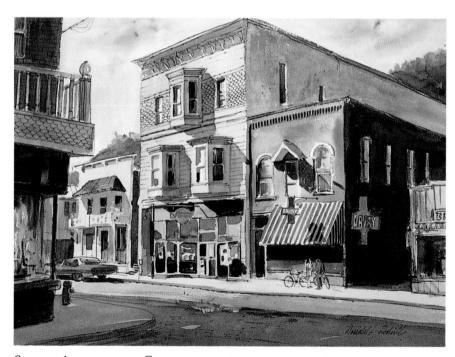

SUNDAY AFTERNOON IN GLOUSTER, *14" x 20" (35.5 x 50.8 cm). Private collection.*

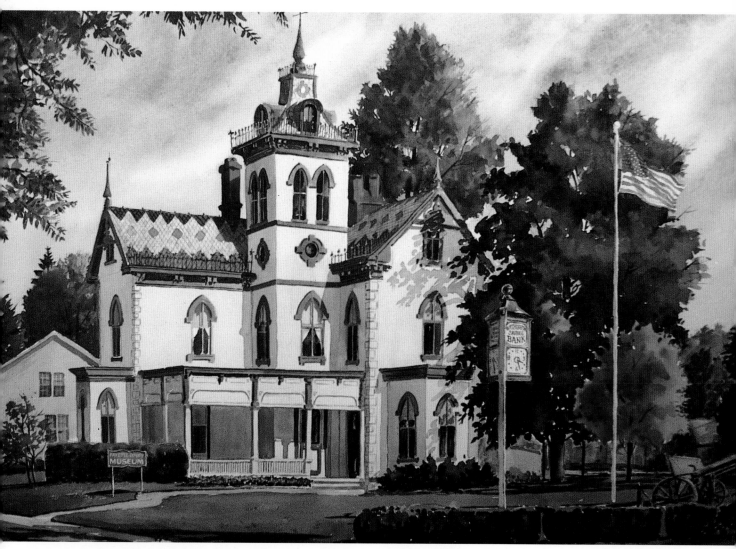

FAYETTE COUNTY MUSEUM (WASHINGTON COURT HOUSE, OHIO), *16" x 27" (40.6 x 68.5 cm). Huntington National Bank Commission for Fayette County Museum.*

Meeting the Challenge of the Commissioned Work

This 1875 structure is a good example of the fine homes built by wealthy residents of small Ohio towns toward the end of the nineteenth century. Located in Washington Court House, Ohio, the county seat of Fayette County, approximately forty-five miles southwest of Columbus, it is now used as a museum by the Fayette County Historical Society. The Morris Sharp house exemplifies architectural details of the Victorian Italianate style, including cathedral-type windows, iron fencing about the roof, massive woodwork, ten-foot doors, four ten-foot French windows, twelve-foot ceilings, and a series of bay windows.

I was commissioned to do this painting of the Fayette County Museum for a permanent collection. Commissioned paintings differ in several aspects from the ones I select to do. Usually the client establishes the size of the painting and the time of year. Many times the client requests inclusion of certain features—in this instance, the American flag, antique cannon, post clock, and identifying signage. The client might also request that certain pictorial elements be eliminated if he finds them offensive for one reason or another. Working to the specifications of others can sometimes be a challenge to the artist, who has to produce a good painting within a specific framework.

Alterations in Urban Scenes: Effects of Time and Weather

Time of day and weather conditions provide a variety of dramatic painting options for the urban scene. Early morning or late afternoon sun, twilight hours when the sun is below the horizon, falling rain, snow, fog, or mist give the painting another mood and a different visual impact.

When the sun is low on the horizon (either early morning or late afternoon), shadows cast by buildings are lengthened, shadow areas are darkened, and the scene is generally in a lower color key. Sometimes, however, on a bright day, and when the sun is a deeper red and near the horizon, it will heighten the color of sun-struck surfaces as shown in the painting *West Sun* (page 85).

The illusion of falling rain can be heightened by making pavement surfaces appear wet, creating reflections. Figures holding umbrellas or wearing raincoats also contribute to the impression of rain. When the scene is in semidarkness, as in *Tony's Marathon*, shown below, artificial light from exterior lights and signs and interior light from windows or doors play a large part in creating interesting reflections on wet surfaces.

Distant or middle-plane buildings are painted in lighter, more "grayed-down" values than on a sunlit day to achieve an appearance of rain and to create an atmosphere of fog or mist.

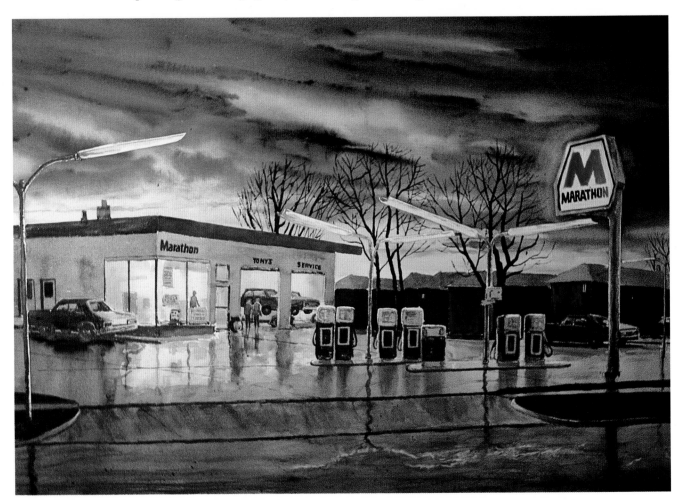

TONY'S MARATHON (GRANDVIEW HEIGHTS, OHIO), *22" x 30" (55.8 x 76.2 cm). Courtesy of Windon Gallery.*

Twilight Luster after the Rainfall

Our studio was once located catty-cornered across the street from Tony's Marathon station. Early one November evening after a hard rain, I noticed Tony and his helper still working on an automobile in one of the repair bays. The threatening sky with its bright pink bank of light near the horizon and the station lights reflected on the wet pavement gave the scene unexpected drama. I made a quick sketch of the scene and took notes regarding the color of the sky, interior and exterior lights, and other pertinent information. Later, when I painted the scene in the studio, I simply glanced across the street to check details.

Nighttime reflections of artificial light in a set surface pose

some interesting problems with regard to color and technique. Keeping the surface wet and at various stages of wetness is necessary to achieve the lustrous reflective effect. While the area was still quite damp, I brushed in Naples yellow, mixed with a touch of alizarin crimson in the area near the station where the station light would be reflected. At a point when the paper was semi-dry, I laid another wash of mauve, Davy's gray, and neutral tint over the entire surface, while working around and defining the reflected light from the station and the exterior lights. When this was nearly dry, I painted in the darker reflections from the building, pumps, and exterior lights with a darker mixture of mauve and neutral tint.

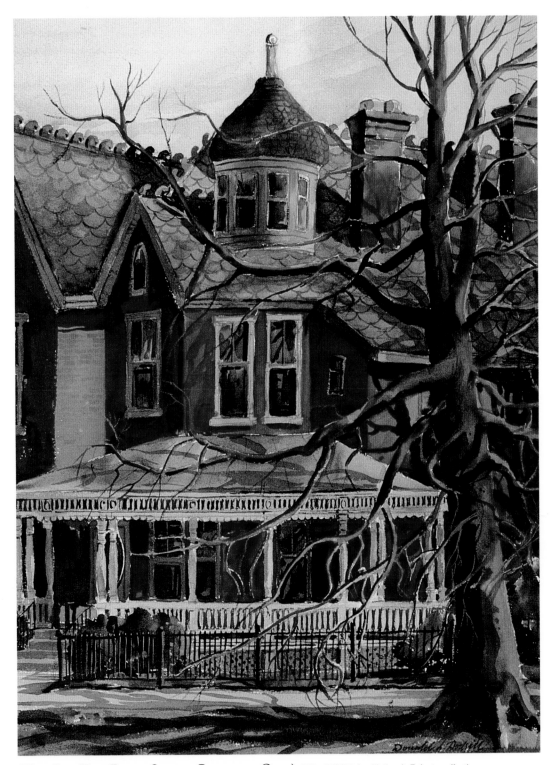

WEST SUN (EAST BROAD STREET, COLUMBUS, OHIO), *23" x 16" (58.4 x 40.6 cm). Private collection.*

The Extra Dimension of Strong Sunlight

Here, strong west sunlight gives extra dimension to the architectural details, windows, and bare tree limbs. Without that late afternoon sun to spotlight this old house on East Broad Street, I probably would have passed it by. But the light effect made me look twice. I made a fairly detailed sketch of the most interesting sections and took notes. Because light changes so fast—often within a matter of minutes—it is imperative to establish the highlighted areas and shadow patterns quickly, either by value sketching or by means of explanatory notes. I find that using colored pencils, markers, or a set of pan watercolors—if I happen to have them with me—is very helpful for these quick color and light indications. When I made my sketch, I used a colored pencil to indicate the reddish color of the sun hanging just above the horizon and the color intensity on the sun-struck tree surfaces and Victorian features of the house.

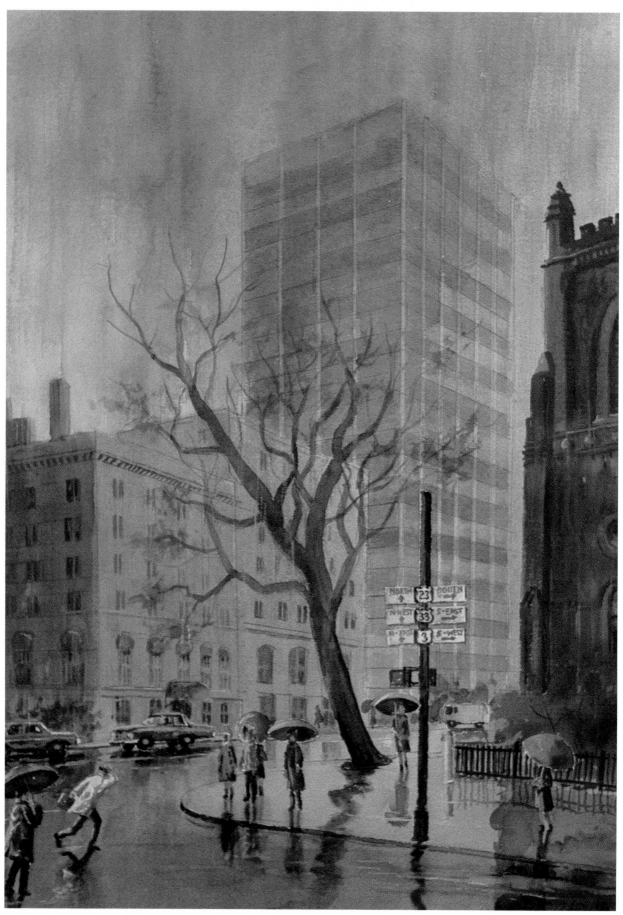

RAINY AFTERNOON AT BROAD AND THIRD (COLUMBUS, OHIO), *22" x 17" (55.8 x 43.1 cm). Collection of Kenneth Danter.*

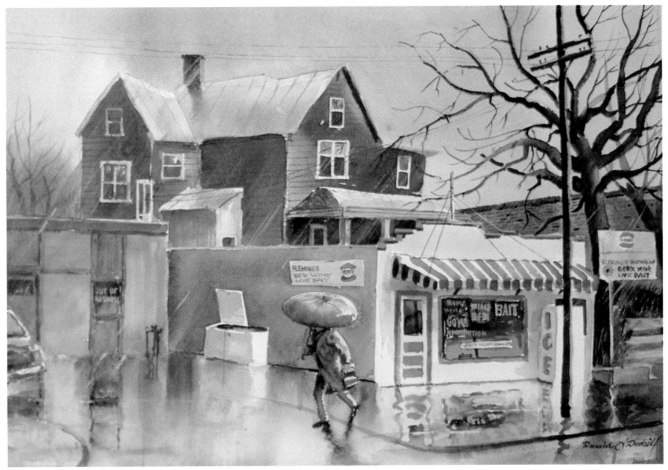

FLEMING'S BAIT STORE (GRANDVIEW HEIGHTS, OHIO), *15" x 20" (38.1 x 50.8 cm). Private collection.*

Muted Colors in a Diversified Composition

I made the above sketch of Fleming's Bait Store while sitting across the street in my car one rainy day. Notwithstanding the shabby appearance of the buildings, I found the scene compositionally interesting, with its diversity of shapes, textures, and surfaces. Because of the gloomy day and the rain, the color appeared more muted than usual. I wanted to keep this effect and restricted the only bright color to the bait store's window signs. Since the green-color house in the central middle ground is close to the viewer in this painting, I let it stay more in focus and used the tin roof to reverberate with the gleam of the other wet surface. A few diagonal "rain strokes" made the rain appear to be falling more heavily here. You can achieve this effect by placing two extra pieces of lightweight cardboard very close together over a particular area and sponging out the exposed strip or by using a ruling pen with a little Chinese white against a straightedge.

Impressions of Falling Rain

Transparent watercolor is an ideal medium for painting weather conditions, particularly rain. The painting at left gives the impression of falling rain without actually showing it through linear delineation. The effect of inclement weather is conveyed by the hazy atmosphere, wet reflective pavement surfaces, and the figures in raincoats with umbrellas.

All reflections in the wet pavement surfaces are painted in before the previous wash has completely dried, which permits reflected images to spread slightly to create the illusion. To depict a misty background, I generally decrease the value contrast by approximately fifty percent. Pictorial elements nearer the viewer, such as the section of the old church at the right and the foreground figures, are brought into sharper focus by stronger value contrasts.

City Impressions

Although I enjoy painting architectural subjects in urban settings, I sometimes feel the need to create paintings that incorporate some of the same elements but are not as literal in interpretation either in color, content, or composition.

As I mentioned earlier in the Preface, I consider myself simply "a watercolor painter" without a specific label, such as traditional, impressionistic, or abstract. Examples of each of these categories can be found in this book, although most of the work would be termed traditional.

The urban scenes in this section are impressions of city scenes or city-related activities. The scenes are imaginary, but they were painted from visual impressions and memories of specific sites or events. They are not recordings of actual scenes but reflect an emotional reaction to them. After painting a detailed architectural scene, I frequently do paintings of this nature to "loosen up." It also fulfills a constant need for experimentation with the transparent watercolor medium in creating different concepts in color, composition, and content.

Ominous Cityscape

Architectural shapes of buildings are suggested in this painting, but they are designed to create the impression of a city rather than individual buildings. Color has been used to work as part of the overall composition rather than as individual elements or structures. The ominous darkness of the sky area provides the impression of an impending storm but also creates a compositional foil for the suggested buildings.

Storm Over the City is an example of the use of wet-in-wet washes, with color brushed in at random points and left to spread and blend. After the paper dried, the harder edges—bridge indications, windows, reinforced building edges— were added.

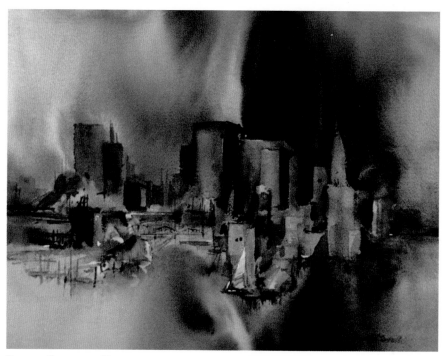

STORM OVER THE CITY, *15" x 20" (38.1 x 50.8 cm). Private collection.*

Festive Dispersion—A Flow of Colors

Every Fourth of July, the city of Upper Arlington, Ohio, has a holiday parade, with floats, bands, antique cars, unicycle riders, Shriners, politicians, and kids overflowing tree-lined Northwest Boulevard. This painting is my impression not of the parade but of the ending of the parade one rainy Fourth of July, just as the crowds began to disperse and the people started to wander toward home.

Because I was trying to create an impression only, I made no attempt at detail. I painted in the background and reflected street area very wet, leaving some lighter areas in the center. Before the blue and green washes dried, I dropped color into the center area and permitted it to flow into the foreground. When the washes were nearly dry, darker accents of blue, green, and sepia contributed to the overall image.

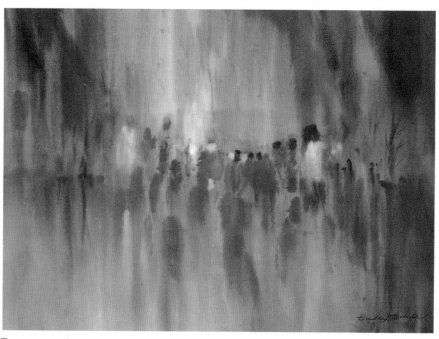

END OF THE PARADE, *15" x 20" (38.1 x 50.8 cm). Collection of Thalia Sippel.*

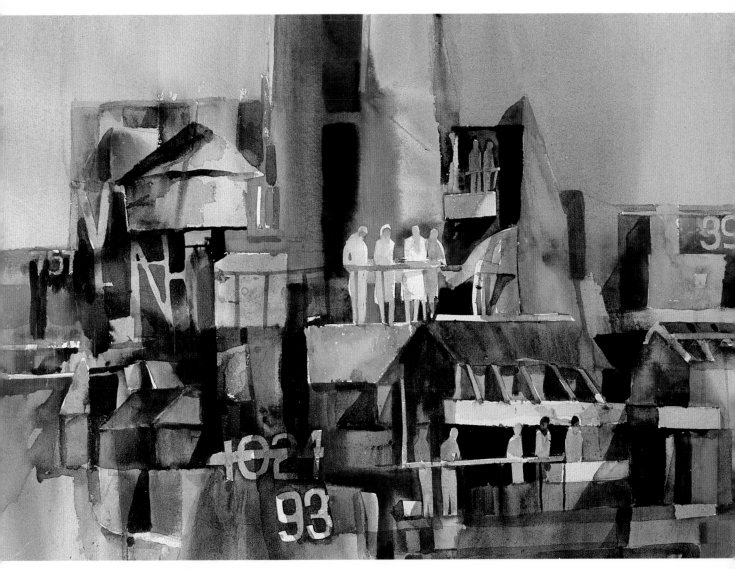

PAVILIONS, *16" x 24" (40.6 x 60.9 cm). Corporate collection of Hyatt Regency—Columbus.*

Lottery of Life—Everyone Has a Number
The concept for this work was to develop a painting that suggested city structures and city dwellers at different levels of life, and their dependence on numbers, such as street numbers, telephone numbers, license numbers, social security numbers, etc. Suggestions of figures at different elevations and symbolical numbers are part of the composition. I have included this painting here because it incorporated architectural elements but in a more preplanned approach than the others described in this section, which evoke a specific impression. In this one, I let the viewer form his own conclusions.

The composition for *Pavilions* was carefully penciled out insofar as the location of figures, the numbers, and various architectural elements that I wanted to keep white or in a light value. These elements were masked out. Wet-in-wet washes of various colors were applied over the surface and left to dry. Rewetting was done in some areas, and darker values were added to create the illusion of planes and structural details of buildings.

THE WINTER SERIES
Rural and City Snow Scenes

Artists working in all mediums have always sought to capture the mood and tone of the winter season, its serenity, its severity. Many Currier and Ives lithographs feature snow scenes. John Twachtman, George Bellows, and Charles Burchfield painted winter scenes of the Midwest and Eastern Seaboard in oils. Andrew Wyeth, Marc Moon, Lowell Ellsworth Smith, Nita Engle, and many other contemporary artists include winter landscapes among their painting subjects. Museums, galleries, and private collectors value winter landscapes as important painting acquisitions.

Winters in Ohio can be severe. Often the ground is snow-covered for several weeks, especially during January and February. Now the palette becomes more subdued but also more flexible, and the white of the paper becomes a greater consideration because of its use in the snow scene compositions. Winter trees in the distance usually appear a mauve-brown or blue-gray depending on light, weather conditions, and distance from the viewer. Barren tree branches, sometimes snow-covered, offer other interesting compositional possibilities.

Landscape greens are now relegated mostly to pine, spruce, and fir trees, which add color variety to the mauves, browns, grays, and blues of winter.

Partially covered snow areas, such as harvested fields, rooftops, streets, and streams create textural changes and abstract patterns. Snow-covered rock outcroppings along the edges of stone quarries and frozen and unfrozen areas on a river's surface provide variety in the compositional elements of the winter landscape. Skaters on a frozen pond, a pedestrian bundled up in winter clothing, or a person shoveling snow can help inject a note of human involvement.

I find that city and village architecture, streets, vehicles, and pedestrians take on a different, somewhat quieter, mood when painted in the ermine wrap of winter. Melting snow on rooftops, streets, and vehicles expose wet, reflective surfaces that contrast and complement the snow-covered areas. Snow remnants reinforce the impression of winter. Sometimes I use a fine spatter of opaque white on transparent surfaces to create the illusion of falling snow. The atmospheric conditions of the winter season vary from falling or blowing snow, mist, or fog to brilliant sunshine. Each condition can add its own special contribution to a painting.

Winter skies are often dramatic, especially at sunrise and sunset when unusual golds, mauves, pinks, and salmon colors light the sky and reflect from clouds. On bright, sunny days, the blue-gray shadows on snow surfaces provide many exciting possibilities for showing the use of light and its effect on three-dimensional objects and establishing a depth of field in the picture planes. Winter's palette can range from the muted winter hues of low-key grays, blues, and browns to exciting combinations of cool and warm colors depending on sky variations and compositional elements.

The paintings in the winter series are meant to help the artist look at the winter environment more objectively to see more color (or less), to use the white of the paper as a complement to color and as part of the compositional design. I would like the viewer to "feel the cold" and the special mood of winter.

SALMON SKY AND SILVER SNOW

Sparkles of silver light the new snow cover
Which blankets shore and river ice.
Reflections of the trees repeat their shapes
In open water, now a mirrored device
For reproducing winter's salmon sky
Bringing color warmth to silver cold.
Above the river a faint and distant cry
As a hawk circles, hoping to see
A rabbit or a mouse venturing out
From shelter beneath the fallen tree
Which lies snow-covered and resigned
To its final resting place.

Winter on Rivers, Streams, and Ponds

Winter touches and transforms inland lakes, rivers, streams, and ponds in a variety of ways. Sometimes the surfaces are completely frozen—a glare of ice. Other times, at warmer temperatures, the ice covering is only partial, rimming the banks and shorelines, and open water can be seen. Following a period of low temperatures and heavy snowfall, the open water areas become frozen solid, covered with a winter's blanket and blending into the surrounding landscape.

When the ice is frozen solidly enough, ice fishing is a popular winter sport, more so to the north on Lake Erie than in the central Ohio area. Ice skating is an enjoyed activity on solidly frozen rivers and shallow ponds. The paintings in this section are some of my impressions of frozen rivers, streams, and ponds, winter activities on ice, and how different surfaces and different times of day work together to enhance the winter landscape.

Next to water, snow and ice seem to reflect nearby environmental colors more than any of nature's surfaces. Yellow- and pink-tinted snow and ice are not uncommon in winter when those colors are dominant in the evening or morning skies.

John Pike, a nationally recognized watercolorist, first acquainted me with the potential of winter landscapes during a workshop at Woodstock, New York. Pike was a master at creating snow scenes and winter weather.

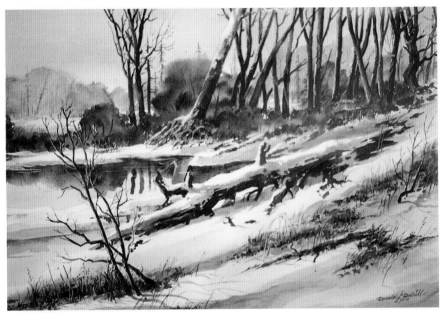

SALMON SKY AND SILVER SNOW, *19" x 29" (48.2 x 73.6 cm). Collection of Mr. and Mrs. James R. Thomas.*

Winter's Warm Glows

During the winter months, many of my paintings—like *Salmon Sky and Silver Snow*—originate from on-the-scene sketches. Usually sketches are done in the relative comfort of my car, which is parked as closely as possible to the scene of my painting. A variety of tree shapes, both vertical and horizontal, had initially attracted me to this particular area along the river. A part of the river's surface was frozen, but sections of open water remained. It was rather late one January afternoon when I began to sketch. By the time I finished, the sky had turned salmon pink and the open water areas reflected that color. Notes as to sky color and reflections were made on the sketch and later incorporated into the painting. Sky color can be an important part of a winter landscape, adding warmth and variety to the more somber color values.

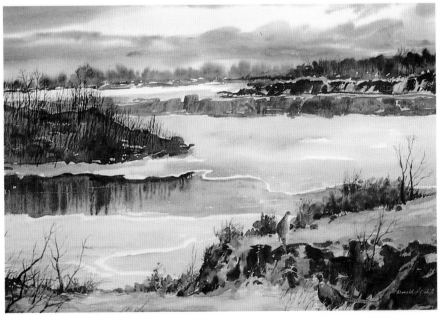

EDGE OF THE QUARRY, *16" x 24" (40.6 x 60.9 cm). Collection of Dr. and Mrs. George W. Paulson.*

The Bare Vistas of the Season

One afternoon in late December, I climbed to the crest of the Campbell Shrum Mound, an Adena Indian mound located at the western edge of Columbus, and made a sketch of this section of the partially frozen quarry. Two ring-necked pheasants glided across the edge of the quarry. Later, I couldn't resist adding them to the scene.

To describe open water areas, I left a highlighted rim on the far edge of the ice, used a darker color value for the water, and suggested reflected tree shapes. To capture the effect of the late afternoon sun peeking through the grayish mauve-colored clouds, I wet the entire sky area with wash of Naples yellow, dropped in a little cadmium orange and red to suggest the sun, and then brushed a mixture of mauve, cobalt blue, and Davy's gray in horizontal strokes for the cloud effect. While this area was still damp, I indicated trees on the horizon with a mixture of mauve and sepia.

One Moment, Frozen in Time

Like *Salmon Sky and Silver Snow,* this scene along the Scioto River was sketched from my car. I finished it immediately upon returning to the studio so that I could retain as much of the initial expression as possible in the painting. The cluster of purplish clouds just above the trees on the far shoreline was the most memorable feature for me. Between the tree tops and the clouds, a band of bright sky occasionally separated the two darker elements. Although most of the river is ice-covered, small sections of open water remind the viewer of warmer temperatures. Scattered patches of snow mark the bank and brush piles in the foreground with streaks of light. I completed *Ice on the Scioto* in less than two hours, but I felt I had captured that one moment in time when I had first viewed the frozen river, with its areas of open water under a dramatic sky.

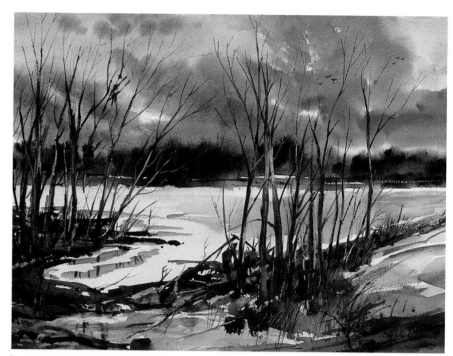

ICE ON THE SCIOTO, *16" x 20" (40.6 x 50.8 cm). Private collection.*

Combination of Soft and Hard Edges

I painted this scene from a black-and-white photograph taken months before. The ground near Big Darby Creek was covered by an early snow, but the streams were not yet frozen. The combination of water and snow-covered banks gave me an opportunity to use both soft and hard edges—hard edges at the juncture of the water and the snow banks, and softer edges in the snow areas, reflections, surrounding undergrowth, and distant trees. Hard edges are again repeated in the foreground trees and branches.

Early morning sun coming from the right creates shadows on the snow, which help to suggest the curving shape of the far bank. I kept the values of the snow shadows somewhat lighter than I normally do to increase the feeling of a bright day with the light filtering through the saplings bordering the stream. The color of snow shadows is composed of a dilution of mauve, Davy's gray, and cobalt blue.

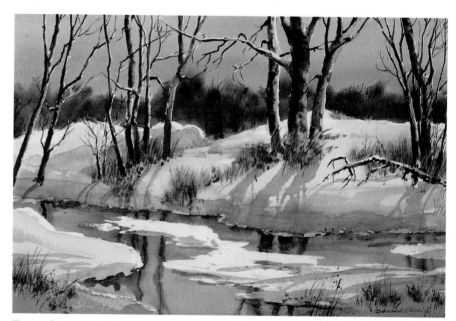

EARLY SNOW—BIG DARBY CREEK, *16" x 24" (40.6 x 60.9 cm). Private collection.*

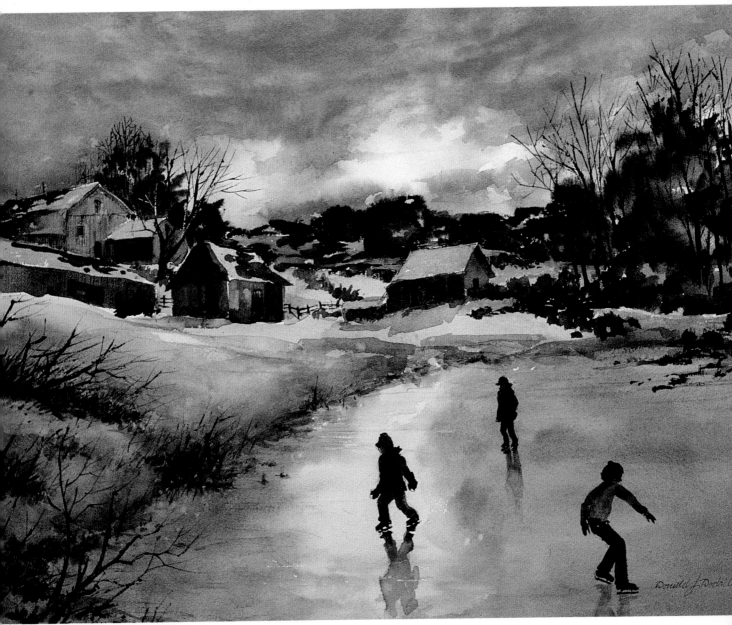

FARM POND AND SKATERS, *15" x 22" (38.1 x 55.8 cm). Collection of Mr. and Mrs. Davan James Dodrill.*

Light-struck Ice as an Arena for Action

Painted from two sketches, one of the background farm buildings and the other of a pond with skaters, this painting shows a typical Ohio farm pond. These shallow ponds freeze solidly in winter and offer farm children a convenient skating arena.

I have always been interested in the effects of backlighting. Here, the sun is lightly cloud-shrouded, and the skaters on the pond appear primarily in silhouette on the light-struck surface of the ice. Rooftops of farm buildings catch the light, while other surfaces remain low-key silhouettes. Mood was a prime consideration for me, and backlighting helped create that mood. Three skaters convey movement in the composition, and the difference in their sizes establishes depth of field.

Winter Landscapes and Rural Architecture

Snowfall in central Ohio varies from year to year, but depths of six to ten inches in the late winter months are not unusual. Farther north around the Great Lakes the coverage is more consistent and heavier. Because of the cold I frequently sketch and sometimes paint from my station wagon. For several years I spent some Saturdays each winter painting or gathering reference material in the surrounding central Ohio farm country. With the exception of *Edge of the Forest* (page 95), painted from a trip to northern Michigan, the paintings in this section were the result of these winter outings.

When painting winter landscapes and rural buildings, I use the white of the paper to a greater extent than for almost any other subject. Sometimes for the brightest accents I leave the unpainted white paper, but normally I tone it slightly even in the lightest area with pale washes of mixtures of Davy's gray, cerulean blue, and a little mauve. Darker values of these colors are added to suggest shadows and plane changes. When direct sunlight highlights the snow, I occasionally use John Pike's suggestion and drop a small amount of cadmium red and yellow into the wet paper surface and let it blend into the gray-blue values to add "sparkle." Virgin snow has a beauty all its own, but for color and composition, I like to break up the snow-covered land areas with exposed patches of tall dried grass, scrub brush, or fallen tree limbs or trunks. Combinations of warm and cool colors make the winter landscape more interesting. Snow creates varied abstract patterns on roofs, window ledges, and other architectural details, as well as on fallen trees, rocks, and other exposed elements. Look for these patterns when painting rural scenes.

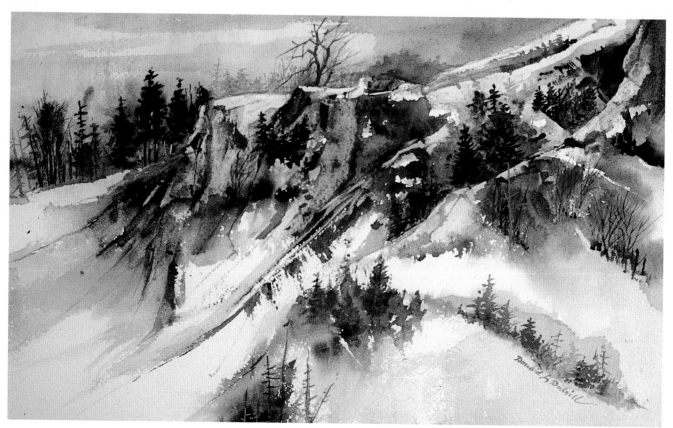

ROCK OUTCROP—HOCKING HILLS, *14" x 19" (35.5 x 48.2 cm). Private collection.*

A Scenic View: Exposed and Snow-covered Rock Formations

A band of sandstone cliffs runs intermittently through the lower, rounded and knobbed hills of the Appalachian Highlands. Where roads have been cut through, the hillside reveals layers of sandstone, shale, and occasionally limestone and coal. These cliffs are more pronounced in the Black Hand Sandstone in the Hocking Hills. *Rock Outcrop—Hocking Hills* is a painting of this rugged, scenic hill country—Ohio's oldest landscape.

I painted the rock areas first, using sepia, burnt sienna, and neutral tint on a damp surface. Before the paper surface had dried, I used a plastic scraper to create the rock ridges by scraping through the damp pigment. I added suggestions of trees and brush when the damp surfaces had dried. Contrasts in value and texture establish the basic strength of the composition aided by a variety of soft and hard edges. Paper-white emphasizes the highlighted area, with wet-in-wet washes of Davy's gray, viridian, and a touch of cerulean blue in the shadows.

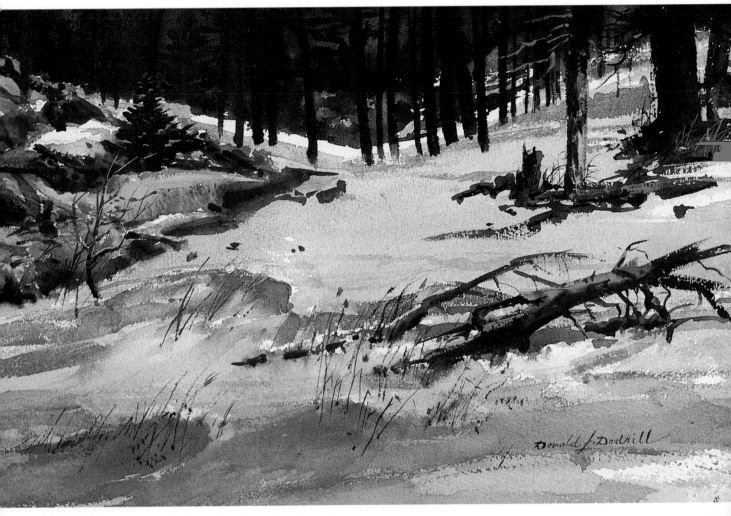

EDGE OF THE FOREST, *13" x 18" (33.0 x 45.7 cm). Collection of the artist.*

High Contrasts, High Horizon

Edge of the Forest was painted from sketches, photographs, and observation of pine forests and open snow-covered fields in northern Michigan. Winter comes early there. The shadow values of snow vary, depending on the amount of available light and the adjacent reflective elements. On this particular day, there was no direct sunlight, so I grayed the shadow value more than I would have, had the day been brighter, using more Davy's gray and neutral tint and less blue. A low-key palette helped to maintain the unspoiled yet somber beauty of winter. I kept the horizon line in a shallow V near the top of the composition with no sky area visible through the pine forest.

At the left of the painting a shallow ravine leads the eye to the brightest snow sections at the edge of the pine forest. Beyond that point, I leave the viewer to his imagination: What lies in the depths of the dark pine forest?

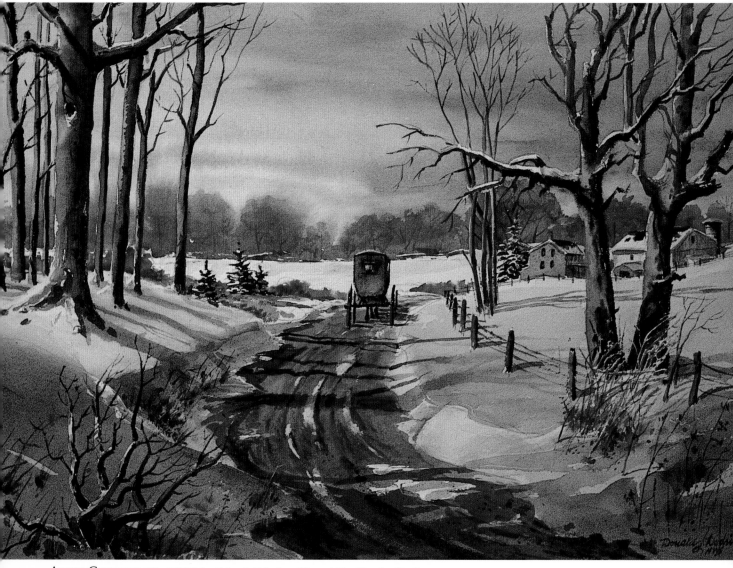

AMISH COUNTRY, *14" x 19" (35.5 x 48.2 cm). Collection of Dr. and Mrs. Herndon Harding.*

A Look Back in Time: Impressions of Another Kind of Winter
The horse-drawn buggy is a familiar sight near Plain City, Ohio. During Saturday
sketching trips into the Plain City area, I have encountered the Amish people making
their way to church and store in their horse-drawn buggies. I have a number of sketches
from that area. *Amish Country* is a kind of impressionistic painting of the people and
place rather than an exact rendering of a specific location. I worked from my sketches,
using the buggy as the principal focal point.

 Most of the Amish farms are located on lightly traveled country roads, and the farm-
houses, set back from the main road, are reached by dirt or gravel lanes, as you can see
in this painting. I decided to use late-afternoon sunlight streaming down from the left,
so that I could take advantage of the long tree shadows rippling across the lane and over
the snow-covered ground. I deepened the shadows by using stronger values of mauve,
cerulean blue, and neutral tint. For heightened color interest and warmth, touches of
alizarin crimson and Naples yellow were blended into the mauve-blue sky.

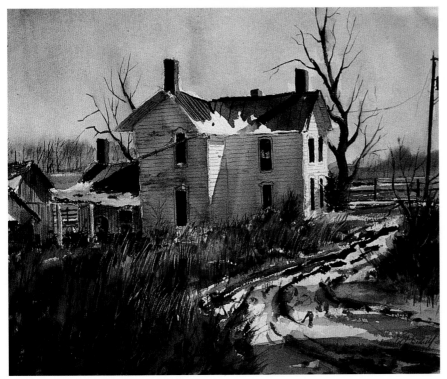

First Lights of Spring

When I painted this rural scene, the snow had partially melted, and only scattered remnants could be seen on the ground, the roof of the farmhouse, and the rutted lane. I painted in my station wagon on the site in Delaware County where a number of houses had been vacated to make way for a flood-control dam.

Strong morning sunlight illuminated the fading white siding of the old house. As I painted the shadow values in the white structure, I made them very close to a middle value, using a mixture of cerulean blue and Davy's gray. To emphasize the weathered look of the siding, I used strokes of darker values in the shadow areas. Shadows cast from the front projecting wing of the house give the structure a solid form, and the light-struck areas create a center of interest. Blades of high grass rising randomly in the foreground were highlighted by the use of a No. 11 X-acto knife, with which I scratched through the pigment.

MIDMORNING IN MARCH, *15" x 20" (38.1 x 50.8 cm). Private collection.*

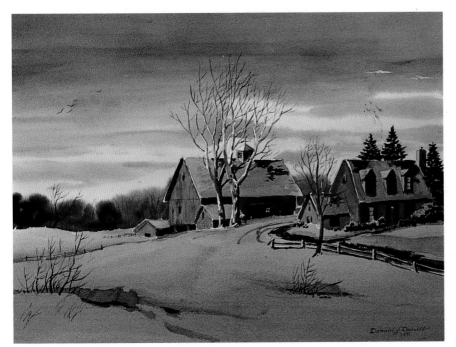

Adding Warmth to Winter with Exterior and Interior Light

This painting of a renovated farmhouse, weathered barn, and outbuildings illustrates the use of low-angle, pinkish-colored sunlight, a common sight in early morning and evening during winter months. The warm evening light adds color warmth to the barn, house, and trees facing the light source. All of the snow surfaces are in shadow with the exception of a light-reflected area near the distant trees.

Lamp-lighted windows on the darkened front of the house evoke the warmth of people inside enjoying their home. In Ohio's farm country, where houses are more and more being modernized by tenants who work in the city, barns and outbuildings remain unused, or they become storage facilities. Often neighboring farmers work the fields. Rural roads and entry lanes seldom receive the benefit of the city snowplow, but here the owner cleared the snow to the house and barn himself. The partially shoveled driveway leads the eye into the composition.

WINTER EVENING, *15" x 20" (38.1 x 50.8 cm). Private collection.*

Winter in the City

Winter's shroud of snow gives the city a softer look concealing some of the harshness of antiquated architecture and exposed asphalt and masonry surfaces. Mauve-gray skies and white rooftops create a gentler skyline. Snow clinging to the countless changes in building roof elevations, angles, and projections provides an abstract patchwork of light and dark value combinations. It is the transformation of the city in winter that always sparks a new interest in painting its architecture and activity.

Unlike the country roads, city streets and highways are kept relatively clear of snow by salt trucks and snow-plows. The cleared asphalt or concrete surfaces are usually wet from the salt-melted snow. Frequently I will use the reflective qualities of these surfaces to add extra impact and color to the painting by picking up reflected color from buildings and other compositional elements bordering the streets.

In city winter scenes I frequently use figures engaged in some activity relative to the winter season or sometimes pedestrians in winter dress. It is difficult to avoid showing vehicles on busy downtown streets, but I try to keep this to a minimum or avoid it if possible.

Symbols of the Season

Trinity Episcopal Church, dating from 1869, is Columbus's oldest downtown landmark. Its Gothic Revival-style structure is composed of sandstone and rests on a limestone foundation. The stone forming the fabric of the walls is rock-faced ashlar. Sleek new structures have risen in the vicinity, but Trinity remains—a long-standing symbol of faith.

In this painting, a recent snowfall still covers rooftops and portions of walks, lawns, and trees. The ice and snow are melting from the salt spread on the streets. When I paint city winter scenes, I often use a wet-in-wet technique so that the wet, glistening street surface can reflect surrounding buildings, lampposts, and other elements. Although important to the composition, buildings in the distance were dropped down in value so they wouldn't overpower the church. I painted the sky area using a large brush-stroke that repeats the vertical shapes of the buildings. Figures carrying Christmas packages bear out the seasonal theme.

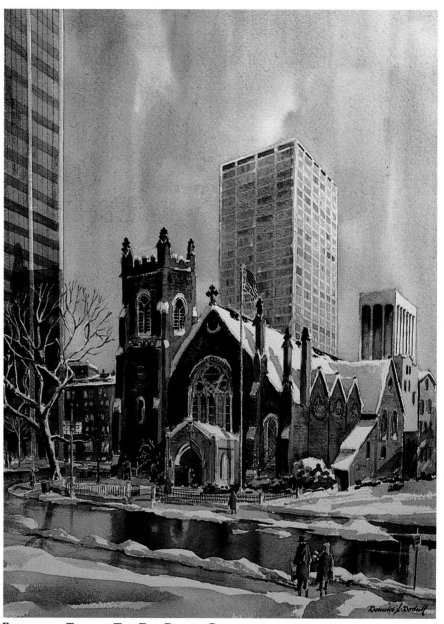

BROAD AND THIRD—THE DAY BEFORE CHRISTMAS, *24" x 16" (60.9 x 40.6 cm). Corporate collection of Midland Mutual Insurance Co.*

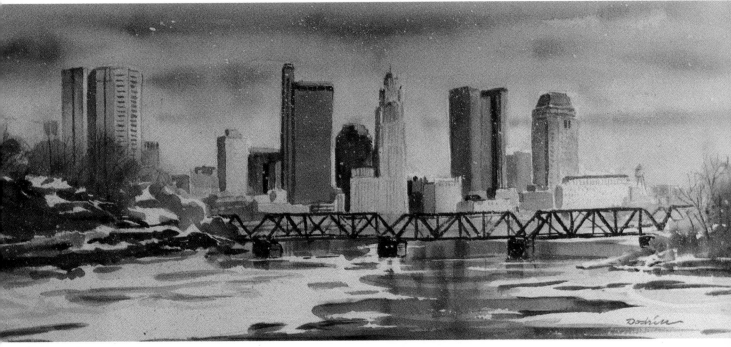

WINTER GRAYS, *10" x 16" (25.4 x 40.6 cm). Collection of Anne F. Trupp.*

City Skyline in an Ermine Wrap

This small painting, *Winter Grays,* is almost monochromatic in tone, with only a touch of Hooker's green added to the neutral grays of the water, burnt umber to the shoreline areas, and paler washes of siennas and alizarin crimson to some of the skyline buildings. On a cold January morning, such a scene as this is a familiar one as you approach downtown Columbus from the west on Long Street. The Scioto River rarely freezes over com-pletely, but frequently snow-covered frozen sections of the river extend out from the banks, creating a white and gray-brown ab-stract pattern beneath the city skyline. Usually, this occurs on a gray, overcast day, when the water is not affected by the blue of the sky but retains its natural hue of gray-green-brown. Lack of bright color in a painting does not necessarily limit its impact; sometimes it creates a special mood, very effective for certain scenes, like this one.

ACROSS FROM BECK PARK—GERMAN VILLAGE, *15" x 20" (38.1 x 50.8 cm). Private collection.*

New Fallen Snow on Aging Architecture

The Old World atmosphere of Columbus's Ger-man Village appeals to me as a source of inspira-tion for painting—particularly winter scenes. Most homes in this historic area are made of brick. The one-and-one-half-story and two-story houses that appear in this painting are typical of German Village, as are the early-style lampposts, wrought-iron fences, brick walks, lintels and hand-hewn limestone steps.

 This view from Beck Park looks across at the houses facing Beck Street. Although the three houses are constructed of brick, the difference in shape and architectural detailing provides an in-teresting arrangement of relationships. I used the foreground trees and the lamppost to tie the com-position together and to help focus the viewer's attention on the central house. The man and woman who have just finished shoveling snow are a perennial sight of the season. Another such sight can be noted in the detail in the fore-ground—two birds feeding on bits of bread.

THE SUNLIGHT/MOONLIGHT SERIES
Painting the Effect of Natural Light at Different Times of Day

Transparent watercolor as a medium is especially practical for painting the effects of light and shade. The transparency of the washes gives shadow areas life, and the soft- and hard-edge effects assist in creating the illusion of light-struck surfaces.

Whether natural or artificial, light is a necessary ingredient in painting. Sunlight or moonlight lend special enrichment to a painting by increasing mood and emotional content. Exterior sunlight is used in many paintings throughout this book, but this chapter deals particularly with the sun's or moon's effect on interior surfaces and objects as well as on exterior surfaces like brick, glass, flowers, trees, and water. Sunlight and moonlight striking the surface of any form assist in defining its three-dimensional shape.

Shadows help provide depth of field and give a three-dimensional appearance to structures, objects, or figures within the picture plane. Light-struck surfaces create shadows of differing lengths, depending on the angle and position of the sun or moon. If the shadows do not conform to the shape of the light-struck surface, the ultimate image is unconvincing. The position of the sun in relation to the form or object determines the type of shadow. A light source from the side and front or from above or below brings out different effects in the type of shadows created. One important aspect to remember is that once the light source has been established, all elements must be related to it.

> ### SUN PORCH
>
> *Sunlight floods the trees*
> * outside*
> *The sun porch and filters*
> * through its windows.*
> *It seems to play a game of*
> * seek and hide*
> *Among the flowers that*
> * compete*
> *With each other for its magic*
> * touch.*
> *The cat lies quietly, shielded*
> * from the sun*
> *By her mistress, who relaxes*
> * with a book*
> *On the summer sofa,*
> *Oblivious to the world*
> * outside her private nook*
> *And forgetting her second*
> * cup of coffee.*

Moonlight is more limited than sunlight in its effect on surfaces because its principal illumination is from an overhead position or from a high right or left location in the sky. And, of course, the light itself is weaker and much softer and more diffused.

Cloud formations and atmospheric conditions such as haze, rain, fog, and snow contribute to the quality and intensity of light. When the sun is partially obscured by a thin veil of clouds and the light is more diffused, a different effect is created with light-struck areas because there are no clearly defined shadows from pictorial elements. There is also a somewhat different and more diffused highlighting effect when the veiled light strikes a water surface, as shown in *Evening Reflections* (page 106).

Both Edward Hopper and John Singer Sargent developed many of their paintings around the effects of sunlight. Hopper's approach was simpler, with broader, more sharply defined sunlit areas, whereas Sargent painted in a looser, more fragmentary style, breaking up the shadow areas into abstract sections to complement the composition. I feel comfortable working somewhere between these two approaches and striving to develop an individual approach to the interpretation of light. I believe painters should be encouraged to study and observe the many types of direct, indirect, reflected, and diffused natural light. Properly used, light gives a painting life and vitality and provides a continuing arena for the exploration of values, indispensable to any work.

Sunlight on Interior Surfaces

Early morning or late afternoon sunlight filtering through a window, glass door, or any aperture creates interesting effects on interior objects.

The light patterns cast on the interior are structured by the nature and physical form of the opening. Mullions and sashes in windows and doors, the color of the glass, the size and shape of the opening, and objects hanging in the window or sitting on a sill—all affect the interior light patterns. When light of this nature strikes walls, floors, objects, or figures within, unusual patterns of light can develop. The four paintings in this section are examples of some of the effects of interior sunlight and how it can amplify color and produce interesting compositional variations.

SUN PORCH, *24" x 16" (60.9 x 40.6 cm). Collection of Mrs. Glen Wallace.*

Sunlight Playing a Game of Hide-and-Seek

Before being replaced by the family room in residential housing design, an enclosed area, sometimes called the sun porch, was popular with many residents in the Midwest. When our children were young adults, we lived in a house that had a sun porch with a wall of windows on one side facing south. Sun filtering into the room created interesting light patterns on the walls and furniture and touched the potted flowers we had in the room. A sketch I had made of our daughter, Dena, reading a book was included in the painting, which grew from a composite of sketches and photo references. The cat, T-cup, liked to bask in the sunlight, and her presence helped to intensify the air of tranquillity and relaxation.

Sunlight patterns on the far wall cross the framed art, touch the flowers, lamp, and furniture, and highlight the figure seated on the wicker sofa. I carefully worked out the values of the light and dark areas in pencil sketch before starting the painting. The brightest and lightest values are always painted first and the darker values added after previous washes have fully dried. With the exception of a few small wet-in-wet areas, I applied the paint to a dry surface.

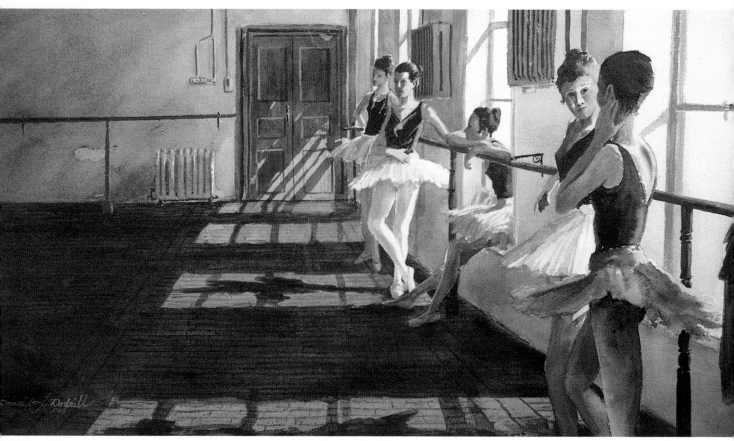

MORNING BREAK, *14" x 24" (35.5 x 60.9 cm). Collection of Mr. and Mrs. Davan James Dodrill.*

Five Dancers, Four Windows: Light Patterns

The composition for *Morning Break* places the center of interest on the right side of the painting, with the five ballerinas resting in relaxed positions. Only the foreground figures are engaged in conversation. The ballerinas' postures were selected from sketches and photographic references. The studio with the practice bar is similar to one I was familiar with in our neighborhood area. The empty room with the bare wooden floor focuses viewer attention on the light-struck areas and the figures.

This "midmorning" painting demonstrates the effect of a forty-five-degree angle of light coming through a series of undraped, mullion-divided windows in a dance studio. Light patterns on the wooden floor and highlights on the ballerinas and their costumes formed by light filtering through the rectangular windows establish light source and add depth and dimension. On the far wall, a wood-paneled door is also struck by sunlight from one of the windows, showing the forty-five-degree angular effect the midmorning light creates on a vertical surface. With the exception of the cool colors on the far wall and the ballerinas' costumes, warm colors of burnt sienna, sepia, alizarin crimson, Naples yellow, cadmium yellow, and cadmium red were used to enhance the warmth of sunlight.

THE HUNTER, *15" x 20" (38.1 x 50.8 cm). Private collection, courtesy of Keny and Johnson Gallery.*

Window Sunlight Brightens a Cat's Cafeteria

Interior light presents a challenge in value changes, especially when the sunlight intersects various surfaces, as here—wood, straw, metal, and concrete. Each surface must first be painted in its high-key color. Darker values are then painted in the same colors over the first washes when they are dry. Sunlit areas remain in the high-key values.

I painted two versions of this painting: The first was painted while I sat on a bale of moldy hay in the milking shed of an abandoned dairy barn in Delaware County. When I finished it, a black and white barn cat suddenly appeared and jumped atop the dusty feeder bin. I made a quick pencil sketch of him as he surveyed the barn for a sign of the two field mice he had seen scurrying by. Back at the studio, I redid the painting to include this cat with a purpose, and gave it the title *The Hunter*. As an example of a painting with light affecting interior elements, I find it an absorbing image. The time is midafternoon on a bright June day.

VANTAGE POINT, *16" x 22" (40.6 x 55.8 cm). Collection of Anne F. Trupp.*

Window Sunlight Combined with Reflected Interior Light

When my wife and I visited our friend, Anne Trupp, I was always fascinated by the quick, graceful movements and regal bearing of her cats, Archie and Duffy. On one visit, I took a number of black-and-white photographs of them. For this painting, I used a black-and-white shot of Duffy sitting on the mantelpiece in front of a large wall mirror, his favorite vantage point for surveying the human scene. Duffy had a beautiful beige and sepia coat of fur, which was highlighted by this source of light. His eyes were a light shade of aqua blue; I intentionally directed his gaze out of the picture to underscore his usual lack of human involvement.

Rays of direct sunlight came through the windows from the west, creating sharply etched shadows. The glass planter reflected the light back from its multiplaned surface.

Sunlight on Exterior Surfaces

Sunlight on exterior surfaces differs from interior sunlight in two respects: First, its effect is not limited to a specific source such as a window or door, and second, when the sun is positioned directly overhead, it creates a different type of illumination with top surfaces, such as roofs, receiving full sunlight. Interior sunlight at midday is minimal unless there is a skylight.

Morning sunlight illuminates the east side of a structure or landscape and the afternoon sun the west side. In the winter months, the sun is far enough south that a

southern exposure also receives a significant amount of sunlight. In the summer this is less prominent. The north side of a building, tree, or object does not receive direct sunlight in this area of the country.

I find the play of exterior sunlight on a building, landscape, figure, or object helps give it shape and dimension. By using cast shadows at various distances in the picture plane, a painter can establish a feeling of depth of field. Shadows can also help indicate slopes or changes in planes, as shown in the painting *Winter Patio*.

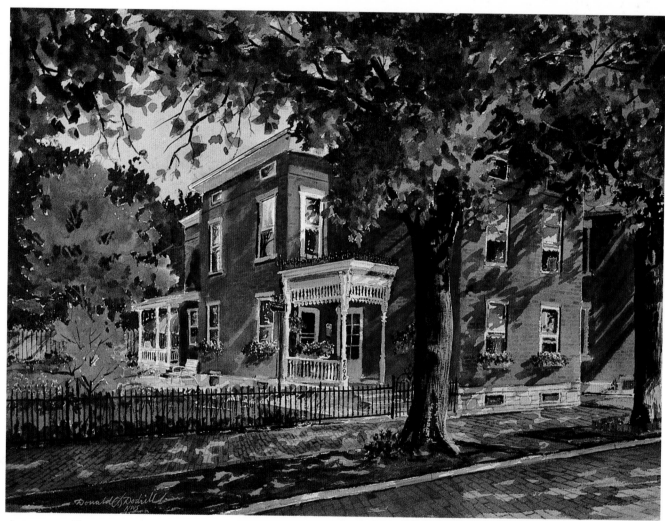

Afternoon Shadows, *15" x 20" (38.1 x 50.8 cm). Collection of David Brown.*

Tree Shadows on Brick and Glass Surfaces

City Park Avenue in German Village is lined with trees planted in a narrow grass strip between the brick sidewalk and the brick street. This house, which is representative of many of the restored houses in the area, would receive the full impact of the afternoon sun were it not for the shield of trees. Sunlight on the dull red walls is filtered through their foliage, producing interesting asymmetrical patterns. Shadows contribute to the spatial effect. Overall, sunlight creates a dappled effect.

Windows reflect light in an unpredictable manner. Sometimes glass areas on the shadow side of a building appear to have brighter reflective surfaces than those facing direct sunlight, possibly because of higher value contrasts between the windows and walls. On a bright day I will usually place the highest value at the top in the glass surface of a window and gradually darken it toward the bottom. Patterns of sunlight on both interior and exterior surfaces change rapidly, so one must establish the sunlight effect quickly.

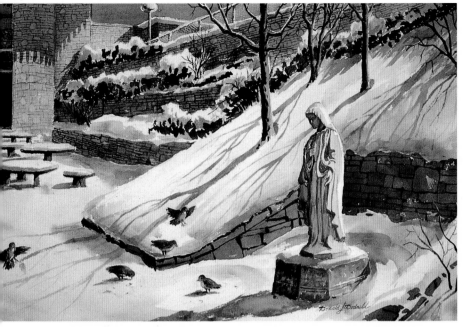

Snow Shadows on an Incline

This painting deals with the enrichment qualities of the sun as applied to a snow scene. I used a palette of cerulean blue, cobalt blue, Davy's gray, Naples yellow, burnt sienna, and neutral tint. The values in the stone and concrete are mixtures of Davy's gray, Naples yellow, burnt sienna, and neutral tint. *Winter Patio* is a view of the patio area just outside the cafeteria at Saint Anthony Medical Center.

Here, sunlight helps define changes in ground elevation, rounded surfaces (the statues), as well as trees, shrubbery, and some architectural detail. The sloped area of the terraced section of the patio to the right uses tree shadows to emphasize the gradation of the slope. The small statue of the Blessed Virgin is highlighted from the rear, which gives it a three-dimensional appearance that would have been lacking without the light source. Again, the birds of winter are feeding in the snow.

WINTER PATIO, *14" x 19" (35.5 x 48.2 cm). Corporate collection of Saint Anthony Medical Center.*

Morning Light on a Panoramic View

This is a panoramic view of the major buildings of the original Harding Hospital in Worthington. Because all the buildings were white, I used fall foliage for more color. Sunlight in this painting comes from the east. Since the main building faced north toward the viewer, it received no direct sunlight on that side; nor did the building behind it. The building on the right, however, was frontally illuminated. I highlighted the left edges of projecting architectural detail, such as posts and porch railings, to bring these details into dimensional relief. Darker values of blue-gray were used in the recessed porch areas to make the rear walls of the porch recede. As with the buildings, the left edge of the trees, figures, and other compositional elements were sunlit in order to ensure a compositional consistency in the play of light.

EAST SUN—HARDING HOSPITAL, *19" x 29" (48.2 x 73.6 cm). Professional collection of Harding Hospital.*

Moonlight—Special Effects of Light

Night scenes, where the moon is the only source of illumination, generally rely on a full moon. On occasion, painters use a little "artistic license" and a more romantic half moon in the sky. Light from a full moon can be quite strong, bringing out shapes in recognizable form. Since the strongest light generally comes when the moon is high in the sky, surfaces such as roofs and open-water areas tend to catch the most light. Painting night scenes with moon illumination is a good exercise in the use of dark, low-key values. *Moonlight Bay* (page 107), the first painting in this section, does not show a clear sky but one veiled with thin clouds.

When the sun has sunk below the horizon but its waning light is still reflected on the cloud cover, interesting effects can be noted on the light-reflecting surfaces. *Winter Beach* (below) is an example of this type of late-evening reflected light. *Evening Reflections* (below) shows a sky earlier in the evening with the sun still well above the horizon but veiled by a light cloud cover. The bright diffused light is reflected in a similar manner in the water surface below it. Different forms of natural light can add drama and interest to the ordinary land- or seascape. Watch for these infinite variations and record them in some manner for future reference.

Dramatizing Sea and Snow with Cloud-reflected Light

Watercolors with their luminous transparency and subtle blending characteristics make it possible to create the unique qualities of the type of "afterlight" in this painting. The cloud-shrouded sun is about to disappear below the horizon. Some of its late-evening light is reflected on the dark clouds, which, in turn, transfer the golden glow to the water's surface. Even with very little light from the sky, the snow-covered beach still appears quite light in value. The white snow amplifies the available light and creates a more luminous landscape than sand or other less-reflective surfaces. I used strong value contrasts here.

Color—with the exception of lemon yellow, Naples yellow, and cadmium orange, used in the sun-related areas—consisted of Prussian blue, neutral tint, cobalt blue, and cerulean blue. The evening sky offers an infinite range of compositional and color possibilities.

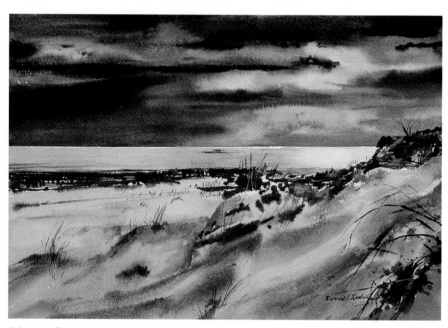

WINTER BEACH, *15" x 19" (38.1 x 48.2 cm). Collection of Mr. and Mrs. J. R. Lutmerding, Jr.*

Letting the Sea Mirror the Sky

Evening Reflections was based on a very quick pencil sketch of anchored boats in the Florida Keys, with only general notes about the pale pink and mauve colors of the sky. I kept the detail of the boats along the horizon sketchy and low-key, with accents of red and orange to break up the basic blue-gray palette.

The sun in this painting is low in the late-afternoon sky, obscured by thin clouds. Mirrorlike, the surface of the water below repeats some of the same colors and values that appear in the sky, and reflects the images of boats and buildings along the waterfront. Sky and water areas were painted wet-in-wet at the same time. Mauve, cobalt blue, alizarin crimson, and cerulean blue were brushed onto the wet surface and permitted to blend and intermingle, with care being taken to allow the palest of washes to occur in the brightest areas. The same effect was carried through in the water area. A bright sky highlights waves and wavelets.

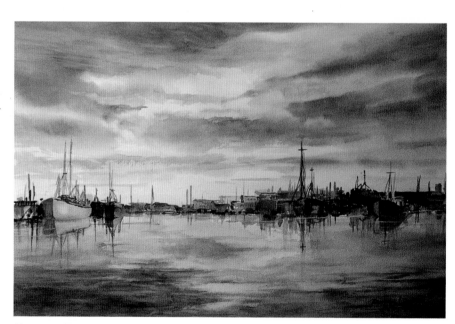

EVENING REFLECTIONS, *14" x 19" (35.5 x 48.2 cm). Private collection.*

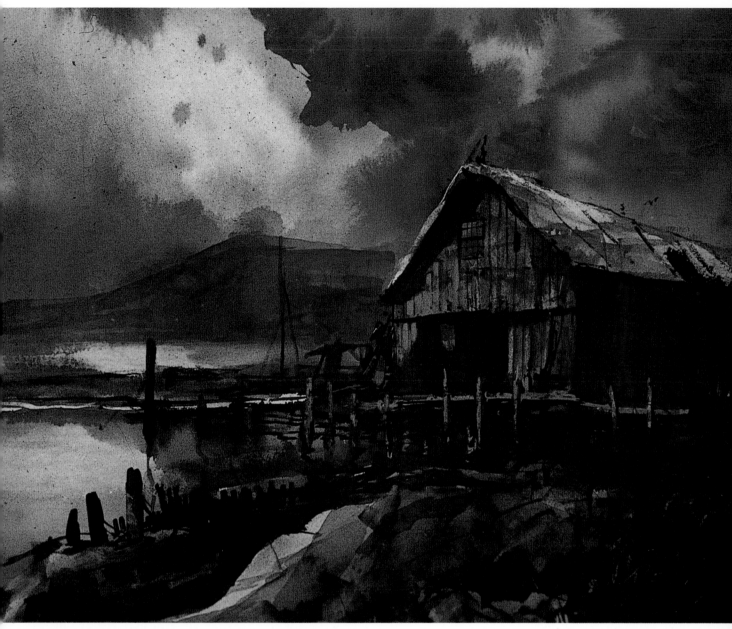

MOONLIGHT BAY, *15" x 20" (38.1 x 50.8 cm). Private collection.*

Letting the Moon Set the Mood

Moonlight Bay, one of the first paintings I made of the North Atlantic Coastal area, gives an impression of a dock and boathouse on a moonlit night. Partially obscured by thin clouds, the moon overhead is a light source that illumines the horizontal surfaces of the roof, water, and dock areas.

I used a dark, very low-key palette of Prussian blue, mauve, cobalt blue, sepia, and alizarin crimson to create the nighttime atmosphere. I find that certain surfaces, such as water and bright tin roofs, seem to reflect the moonlight quite strongly; I used these surfaces here. Detail was minimized: Only highlighted pier pylons and objects in silhouette were used to complete the composition, which was dominated by the old dock building. To create certain highlights and textures, I worked a plastic scraper through damp pigment.

THE MOVEMENT/MOTION SERIES
Painting Vehicles, Figures, and Animals in Motion

In fine arts, movement is the suggestion of motion in a work of art, either by represented gesture in a figurative painting or sculpture or by a relationship among structural elements in a design or composition. I urge painting students to study and observe the world about them, the movement and the motion, and to develop procedures that best convey these impressions in their painting. The possibilities are infinite, depending, of course, on the subject, whether it is a vehicle, a person, or an animal. To indicate the speed of a moving vehicle, such as a train engine or an automobile, streaks or a blurring effect can be used.

Choosing your own method of depicting motion and refining it can develop your personal style. Be sure you have a purpose for using motion, then depict it carefully, perhaps even subtly. Also be certain you know your subject or object well. For if you don't portray your subject accurately, then no amount of motion added—streaks, auras, color, etc.—can help, but will only point up the initial lack of knowledge.

In creating motion, photographic references may be used. The advantages of working with photographs is that you can better observe quick action, perspective, and the play of light and shadow. However, there are also disadvantages to relying solely on photography, especially when portraying the human or animal figure in action. You can end up with a static look, especially if you do not know your subject.

In this series, I have shown how to use streaks, blur-

ring, expression, light, and color to surround objects to suggest motion. The transparency and fluidity of the watercolor medium is ideal for portraying motion.

Physical scientists—in particular, classical and modern physicists—have studied matter and motion using the language of mathematics. For centuries artists also have been interested in motion and concerned with how to portray movement and suggest motion in their art. This interest even preceded the discoveries and writings of the physical scientists. Prehistoric artists tried to show animals running by painting them with many legs. Ancient Egyptians and Greek bas-reliefs portrayed figures in the act of moving, their body language suggesting motion.

Early painters and sculptors, such as Leonardo da Vinci and Michelangelo, gained a knowledge of the anatomy of the human body. They passed this information down from teacher to student. With this knowledge, they were able to portray concrete motion in their work, as with posture or gesture.

The positioning of the torso and limbs of people can be used to indicate movement and express motion, as in the case of athletes engaged in action sports. The positioning of the body and legs of animals can suggest the power of locomotion, the ability of an animal, such as a racehorse, to move from one place to another. Environmental elements—dust, splashing water, flying snow—can suggest the motion created by a moving force. These are also the "visual adjectives," the critical details.

MOVEMENT 253

Two black-striped gates move
* slowly down*
As red-eyed flashers repeat
* their rhythmic blink.*
Down the track on the way
* to town*
Roars 253, blurred in motion,
A red projectile screaming as
* in pain*
Towing its steel companions
Like links in a giant chain,
Passing my field of vision
A streak of white, red, and
* blue*
And as I look, I wonder,
Was it 253 or 352?

Vehicles in Motion

Movement and the suggestion of motion of vehicles, particularly at high speeds, creates a different visual impression than when the rate of speed is less or the vehicle is at rest. The blurred, out-of-focus impression results from the inability of the human eye to focus on detail as it can with slow-moving or stationary objects.

When painting fast-moving vehicles, I find that some of these same visual impressions must be observed and translated into an image that conveys this aspect. If figures are visible in the vehicles, they, too, must be treated in a manner consistent with that of the moving vehicle. Blurred detail in the linear motion lines helps create the illusion. Direction of these linear motion lines must follow the direction of the movement, whether horizontal, vertical, or angular.

Occupants of a fast-moving vehicle receive a reverse impression of speed with the exterior elements, such as a landscape, being viewed as blurred and out of focus.

The three paintings in this section illustrate painting techniques that can be applied to creating the illusion of vehicular speed and motion.

MOVEMENT 253, *19½" x 29" (49.5 x 73.6 cm). Corporate collection of National City Corporation, Cleveland, Ohio.*

Close-up Impression: Speeding Locomotive

In designing this painting, I kept color to a minimum, with red and blue dominating in horizontal sections. I changed the engine color to red to stir visual excitement. I used the horizontal band to emphasize the feeling of lateral motion. I had carefully worked out the composition, which I penciled in before I started the painting. To ensure crisp straight edges, I used masking tape to mask out some of the linear detail on the engine and the track. The number "253" was added to give the composition a vertical element. I worked the painting in the traditional manner, from light to dark values. When the painting was completed and dry, I placed two thin strips of cardboard over it, varying the distance between them from one-eighth to half an inch at several carefully chosen points on the engine and the wheel areas. Then I soaked a natural sponge in clear water and sponged out the area between the cardboard strips at varying distances. These sponged-out areas accentuated the illusion of rapid motion.

Creating the Suggestion of Motion via Passengers' Expressions and Gestures

While in high school, I had ridden on the Cedar Point roller coaster a number of times. I can still recall the experience—the falling sensation caused by the sudden descent and the screams of passengers as the open cars streaked over steep inclines and sharp turns.

Cedar Point, one of Ohio's oldest resort areas, is located at Sandusky on the shore of Lake Erie. I had a number of photographic references from this large amusement park, including several shots of a roller coaster car, but the passengers were created from impressions I had retained of people on roller coaster rides—flowing hair, white-knuckled hands gripping the retaining bars, terrified expressions, and open-mouthed screams. I didn't want detail—just color, posture, and simplified facial expressions. I used some of the techniques I had used in painting *Movement 253* in areas at the sides of the roller coaster. Background was eliminated to keep the focus centered on the plummeting roller coaster, where the principal motion was taking place in the passengers themselves.

ROLLER COASTER, 24" x 16" (60.9 x 40.6 cm). Collection of Mr. and Mrs. John Roessler.

MOVING UP, 14" x 20" (35.5 x 50.8 cm). Courtesy of Windon Gallery.

Using a Static Background to Intensify the Suggestion of Speed

Moving Up was inspired by the brightly colored race cars, the measured verbal instruction—"Gentlemen, start your engines"—the sudden roar of engines, the accelerated speeds, and the energy that permeated the atmosphere of the Columbus–500. In this painting, I chose to feature two cars—one yellow, one red—their helmeted drivers maneuvering for the lead in this annual contest of speed. After I had painted the cars, I used the sponging technique, with cardboard strips, at the tail end of the cars to heighten the sense of motion and speed. Also, I minimized the graphic signage, which has a tendency to break up the shapes of the cars and detract from the feeling of movement. Automobile racing cars are like mobile outdoor advertising boards, completely covered with graphics—car numbers, manufacturers' and sponsors' logos, and signage.

People and Animals in Motion

To create the illusion of movement and speed in the human figure and animals, I use some different approaches in addition to the blurring effects used with vehicular movement. The first painting in this section, *Maestro in Motion* (below), portrays movement by showing the head and hands in a sequence of continuous movement. This is a simplified version of animation as used by a film animator when drawing figures to indicate motion. Although the movement is much more animated when converted to film (as in motion pictures), these sequential gestures create a feeling of movement within the single plane of the painting. I also use environmental elements, such as dust, flying particles of dirt, and snow particles, to indicate swift passage. The pose of the figure or animal is also important. Position of head, arms, legs, and torso in the human is a key to suggested motion. The same can be said for the body and leg positions of animals and the wing positions of birds.

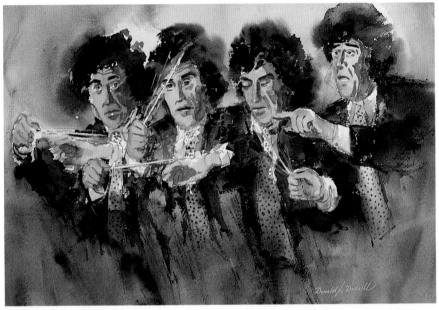

MAESTRO IN MOTION, *19″ x 29″ (48.2 x 73.6 cm). Collection of Wagnalls Memorial—Lithopolis, Ohio.*

Using Sequential Poses to Create Movement

Originally, when I planned *Maestro in Motion,* I had intended to use only one of the sketches I had made during a performance of a symphony orchestra. But each sketch seemed to impart its own interpretative movement and motion of the conductor, so I decided to use four of them. The slender baton and hands serve as visual guides, leading the viewer's eyes from left to right. The wet-in-wet and free brushstroke treatments united the four positions of the maestro.

Maestro in Motion is a very loose, sketch-like rendering, which can be considered an action study. "Four" became almost symbolic in this work: of the four movements of a symphony; the four sections of the orchestra—string, brass, woodwind, and percussion; and the harmonious unification of symphonic work, conductor, orchestra, and audience. And I used four colors: cadmium red, cadmium yellow, neutral tint, and Prussian blue for the remainder of the painting.

Using Dust, Dirt, and Flying Hooves to Depict Oncoming Movement

Home Stretch is a small watercolor based on action shots of thoroughbred racing taken at the Beulah Park Jockey Club, a racetrack near Grove City. The viewpoint I selected for this painting—a straight frontal view—made it more difficult to paint the scene as a motion scene because the action moves directly toward the viewer. To indicate movement, I had to rely on the positioning of the horses' hooves—some barely touching the track, others partially obscured by dust, and still others poised in mid-gallop. Underlining this forward movement, jockeys are bent forward over their horses. This relationship of jockey to horse is critical here.

Airborne track dust tossed up by the flying hooves also establishes movement. I used muted earth colors for the horses and the dirt track against a blue-black background to highlight the colorful attire of the jockeys, who sport their owners' colors in this pageantry-filled event.

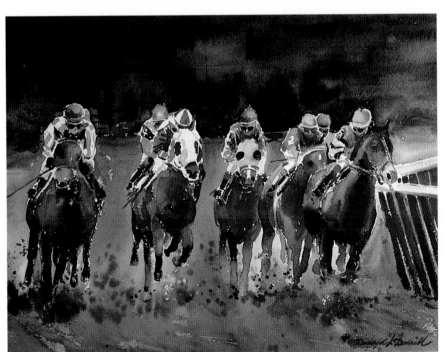

HOME STRETCH, *12″ x 17″ (30.4 x 43.1 cm). Collection of Schumacher Gallery, Capital University, Columbus, Ohio.*

Airborne Skiers: Letting the Disturbance of the Snow Describe the Motion

Skiers was inspired by action photography and observation of downhill skiers at Mad River Mountain near Bellefontaine and Snow Trails near Mansfield, ski resorts.

After I had sketched in the figures loosely indicated in the foreground, I dropped liquid frisket on at random spots around the skiers and brushed it in. I masked out other highlights on the ski poles and skies. Then I painted the background, working around the skiers. Before it had thoroughly dried, I painted the foreground evergreen trees, allowing the paint to blend slightly into the damp background. I then painted the skiers, using a combination of soft and hard edges. To emphasize movement and suggest forward motion, the hair on both male and female figures was swept back. When the painting was dry, the liquid frisket was removed. Flying snow and the "speed streaks" give the effect of swift descent.

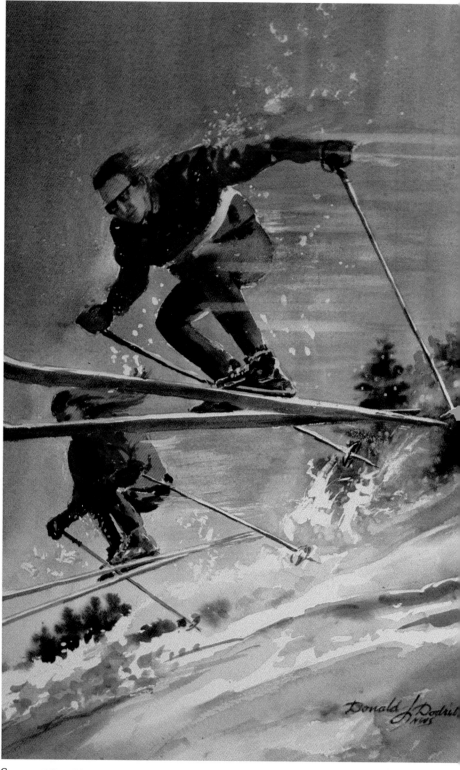

SKIERS, *20" x 15" (50.8 x 38.1 cm). Courtesy of Windon Gallery.*

Implied Motion: Inanimate Objects

Throughout the centuries, artists have been intrigued with man, animals, birds, and vehicles in motion. This is true not only of painters but also of sculptors who work in three dimensions and must rely solely on position and pose (suggestion of direction or intent as with the position of the hand or body) to create a feeling of movement. *The Naiads on Capitol Square,* which appears on page 79, is an example of implied motion.

Carousel animals, although not considered in a strictly fine arts definition as sculpture, have always interested me because of their animated poses and expressions.

Even when the carousel is motionless, the horses and other assorted animals attached to the circular platform appear to be on the move. *Quiet Carousel* (below) was painted when the merry-go-round, as it is often called, was motionless. But as I looked at the chargers with flying hooves, they seemed to be in full gallop.

Study the sculpture in your community and look for other areas where "implied motion" may be incorporated into painting subject matter. Store mannequins and some of the animal forms available in children's toys may be sources for this painting concept.

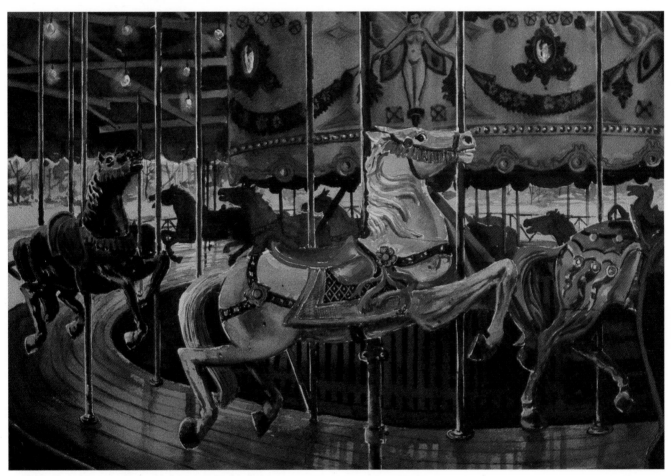

QUIET CAROUSEL, *16" x 23" (40.6 x 58.4 cm). Collection of Mr. and Mrs. M. R. Lutmerding, Jr.*

Suggested Movement in a Circular Format

Quiet Carousel is a painting of a carousel sitting motionless at the Franklin County Fair, emptied of the crowds. For me, the carousel at rest or totally inert is most intriguing. Strangely enough, it puts me in mind of some of the greatest sculpture—in that it portrays this "implied motion." I enjoy seeing horses sculpted at full gallop; birds that appear to be airborne; the human figure caught in midstride; a tiger shown leaping toward its prey.

To create the effect of "implied motion" in my painting of the carousel, the key factors are the position of the horses' legs and heads. And, on the far side of the carousel, I had to keep the horses almost in silhouette so that the viewer's attention would remain on the foreground animals. The light source I used is principally from natural light outside the canopied structure, but some highlighting on the horses and the vertical posts results from artificial interior lighting.

THE TIME SERIES
Using Time as a Theme for Creating Painting Concepts

I n this chapter I want to dwell on only one theme—time—and consider how it can be used abstractly or concretely with different subjects in a painting. Basically, I explore three approaches to interpreting the subject of time by using the watercolor medium: (1) combining a symbol of time with time-related subject matter; (2) using a specific time of day, week, month, or year, and relating it to a particular subject or place; (3) painting the effects of time, such as physical deterioration, obsolescence, and the corrosive effects of time and weather on exterior surfaces.

These approaches deal primarily with finite time, its changes and duration, a subject that can be portrayed realistically, rather than time as infinite, a subject that would command a more abstract painting approach.

Through the centuries, astronomers and physicists have sought to understand concepts of time and space. Philosophers, theologians, poets, and artists have attempted to distinguish finite from infinite time. Although time is a most familiar concept, useful in thought and action, it is also a most elusive one. As Saint Augustine said in the fifth century, "What then is time? If no one asks me, I know what it is. If I wish to explain it to him who asks me, I do not know."

As inhabitants of planet Earth, mankind is affected by measurable time—the time it takes the planet to revolve around the sun; the time it takes the moon to revolve around Earth; the span of time for the seasons; the periodicity of sunrise, sunset, the tides. Man's activities are influenced by time, but his schedules can be disrupted by the forces of nature.

One aspect of time can be considered as a kind of

> ### ELEMENTS OF TIME
>
> It is the element of time that sets
> The stage for all that life will know,
> And when it passes, one forgets
> That each moment was a grain to sow
> In the fertile garden of eternity,
> A particle of time to grow
> And shape the future
> Of all who pass, both fast and slow.
> The clock's gears guide its hands
> Marking seconds, hours, and days
> As humanity, like hourglass sands,
> Slips through time in many different ways.

linear progression measurable by the clock and the calendar, which has a dimension of our past, present, and future. This idea of continuous progression is important—in Western civilization especially.

The first four paintings in my time series are related in composition and theme. All four paintings use the theme of finite time by incorporating clock mechanisms and gears with a particular activity. To integrate the mechanical elements into the composition, I overlap areas of the composition with the image of clock mechanisms so that a "see-through" effect is achieved.

The next five paintings relate to human activities that are engaged in during specific days or at a particular time of day. These examples illustrate how a painting concept can be built around a regular activity or situation in special environmental surroundings. The pose of the figure or figures can be indicative of active involvement or passive involvement and can strongly influence the mood of the painting.

Paintings by Edward Hopper frequently reflect a specific time of day and, in many instances, a passive involvement of the people depicted in the painting. Passive involvement can sometimes be as interesting as intense activity, and frequently it adds to the mood and holds the viewer's attention.

Time of day also creates an effect on the light, its source varying with the position of the sun, weather conditions, and interior or exterior surroundings. In its progression, time affects everything: Sometimes it heals; sometimes it erodes; it can enrich; it can deprive. The final two examples in this chapter illustrate two of time's more negative effects—abandonment and deterioration.

Time Symbols

Throughout the centuries, concepts and symbols of time have been many and varied, depending to an extent on man's enlightenment and his place in history. In early cultures, the concept of time did not involve mechanical indicators like clocks or watches. Celestial bodies were relied upon to determine the progression of time, and to some extent they still are.

There are many symbols that are time-related; hour-glass, sundial, and clock are the more familiar ones. When I was pondering the initial concept stages of the first painting *Elements of Time* (below), I explored a number of possibilities for subject matter relating to time symbols. I finally decided on the gear mechanisms of watches and clocks as the time symbols, principally because of the variety of shapes in the wheels and other related working parts, as well as their function. A disassembled watch and two books from the local library provided some of the reference information. One book showed detailed drawings and photographs of watch parts; the other was a book on antique clocks. *Elements of Time*, *Time and Again* (page 116), and *Time Frames* (page 116) used details from watch parts, and *Time Mechanisms*

(page 116) used some of the detail from a clock, an antique dating back several centuries.

The mechanism detail was drawn and redrawn, altered and expanded to fit the individual composition of each painting. *Elements of Time*, the first painting, relied primarily on the watch gear element, set in a background of the "sands of time." The other three paintings combined the watch or clock gear parts with figures or nature subjects related in some way to the time theme. Transparent overlapping of the subject matter with the watch or clock components was used in these paintings to create an integrated composition.

The composition for the four paintings was worked out in considerable detail on tracing paper and transferred in light pencil line to the watercolor paper. Liquid masking was used to protect the watch and clock gear elements while the wet-in-wet backgrounds were being painted.

Transparent watercolor provides the artist with the opportunity to overlap thin washes of color to achieve the effect of transparency. Sometimes called glazing, this effect permits the viewer to look through an object and see what lies behind it.

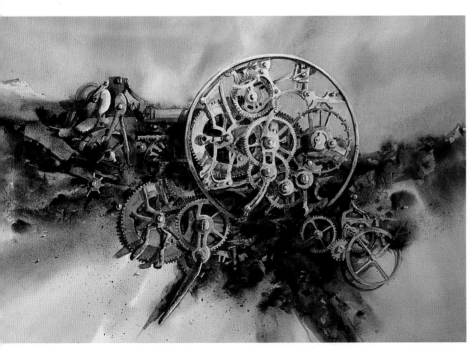

ELEMENTS OF TIME, *19" x 29½" (48.2 x 74.9 cm). Collection of the artist.*

Past, Present, and Future: Elements of Measurement and Indication

This painting differs from the others in the series in that it concentrates solely on an arrangement of watch parts somewhat submerged in the "sands of time."

I sketched the watch gears and inner mechanisms from a disassembled pocket watch, referring for accuracy to a manual on watch parts. I drew the large circular watch gear carefully and worked out the remainder of the composition one-half the final size, projecting the half-size sketch to working size on a full sheet of D'Arches watercolor paper. I masked out the large gear with liquid frisket, but the other watch parts were not covered, which allowed some of the wet-in-wet washes— burnt sienna, Naples yellow, cerulean blue, and Davy's gray—to bleed into these areas. After the paper had dried, I defined smaller elements in stronger values. The gears were tinged with burnt sienna to give the appearance of deterioration.

Symbolizing Time and Motion

Time Mechanisms was the first painting in this series to incorporate a combination of clock-related elements and other subject matter—here, a group of modern dancers. I transformed the dancers' harmony of time and movement into a rhythm of line, form, and color. As the viewer follows the line of dancers to the painting's edge, he has already observed the main visual impact and need not go back through the composition. I used Davy's gray, cerulean blue, burnt sienna, alizarin crimson, mauve, neutral tint, and a small amount of cobalt green and cadmium yellow light. I applied spatter effect on the semidamp surface with a mouth-blown atomizer.

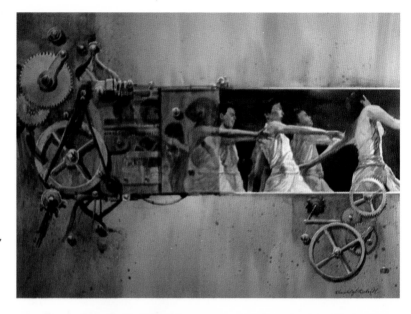

TIME MECHANISMS, *19" x 29" (48.2 x 73.6 cm). Collection of the artist.*

The Cyclical Symbols of Spring

The watch gears assume a transparency as they overlap and intermingle with the leaves and branches of the tree bearing the apple blossoms. The apple blossoms were drawn from a close-up shot I had taken before. The composition was worked out in pencil on tracing paper and transferred actual size to the full-sheet working surface. I masked the watch gears with liquid frisket before the painting was begun. When the background and the apple blossoms had been painted, the frisket was removed and the watch gears were painted in, changing the value where they intersected the leaves and branches of the apple blossoms. This helped to integrate the diverse elements of the composition, create the sensation of a dimension of time, and add visual interest.

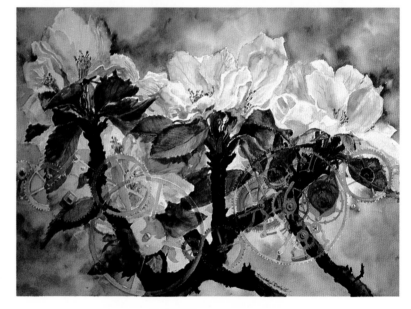

TIME AND AGAIN, *19" x 29" (48.2 x 73.6 cm). Collection of Rosemary Burkhart.*

Framework of Life

A physician times contractions of a woman about to give birth, a worker begins his day, and a retiring employee receives a gold watch. Three time-related situations—birth, midlife, and senior age. The watch mechanism ties the compositional elements together, permitting the figures to overlap and "show through" the gears. Varying the values in the watch gear from the front to rear planes increases the feeling of depth and dimension. The transparency of watercolor is ideal for creating transparent and translucent effects, where one image shows through another in a lighter or darker value.

TIME FRAMES, *19" x 29" (48.2 x 73.5 cm). Collection of Gilbert Black.*

Using Time to Establish Mood

Time of day creates a certain mood in a painting; it also plays a part in what is happening in that scene at a particular time. Certain activities or nonactivities are related to specific times of day, certain days of the week, or designated times of the year. The setting can be interior or exterior. Light or lack of light can be an important factor in the composition, affected by the time of day and the position of natural or artificial light.

I find sometimes that lack of involvement by people in a scene is as interesting as when they are busily engaged in activity that emphasizes movement. The enveloping hush created by stillness creates a mood of quiescence that is transmitted to the viewer.

The five paintings in this section reflect different times of day, dissimilar places, and varying interplay among the subjects involved.

WEDNESDAY AFTERNOON, *16" x 22" (40.6 x 55.8). Collection of Samuel Ladrach.*

Passing the Time of Day
While working on a commissioned painting in a town near Columbus, I stopped at a small downtown restaurant there. Afternoon sunlight highlighted the yellow countertop and red plastic seats and silhouetted the two figures against the window. The waitress was gazing out the window. The young man, whom I judged to be a salesman, sat with his face turned toward the window. I made a quick sketch of them and took general notes

on the interior. I finished the painting in the studio sometime later. I used a light wash of Naples yellow over the entire window area to accent the feeling of exterior sunlight. Details of exterior buildings and automobiles were painted in very light values of Davy's gray and cerulean blue. The countertop, stools, showcases, and jukebox gleamed in the strong light from the front window. Because the figures were between the light source and the viewer, I painted them in muted color tones.

A Time of Anticipation

A large number of widowed, divorced, and single people live in one-person residences. For them, the arrival of the morning mail can be an anticipated time of day. I had witnessed this at my mother's and grandmother's homes many times, and I recall their expressions when they were remembered by someone. *Morning Mail* is based on memories of those occasions. But the actual model was Grace Potter, a member of one of my watercolor classes. She was seated in front of a large window with the light source coming mostly to the right side and behind her. Her facial expression was intended to convey a memory-filled look. Her clothes were warm browns, tans, and yellows. I used mostly cool blues and greens in the background to create a compatible color balance. I carried the white of the letter, the model's hair, and the window curtain through the painting to create an interesting pattern of dark and light areas. The skin tones were composed of cadmium yellow, cadmium red, alizarin crimson, and mauve.

MORNING MAIL, *19" x 14" (48.2 x 35.5 cm). Collection of Grace Potter.*

Catching Up on the News Before Customers, Combs, and Clippers

The community barbershop is a bit of Americana that has managed to survive in many small villages, towns, and suburban areas. My earliest barbershop recollection is of my father taking my brother and me to the barbershop early, and Charlie, the barber, sitting there in the one and only chair, reading an out-of-town paper that was delivered to the shop even earlier. I do recall that he had white hair and wore glasses, a black bow tie, and usually a bright-colored shirt.

For this painting, I made several sketches and finally came up with the composite shown in this painting. I used early morning light coming through the front door. The viewer's eye is directed to Charlie by the patch of bright sunshine on the worn linoleum-covered floor.

MORNING PAPER, *14" x 20" (35.5 x 50.8 cm). Courtesy of Windon Gallery.*

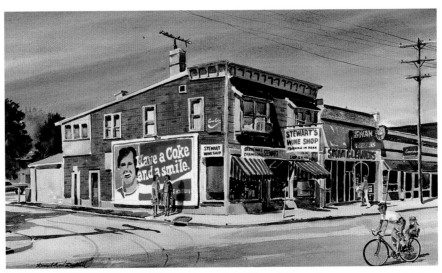

Time for Leisure, Time for Laundry
The composition for this painting was worked out using a combination of sketches and photographs. The bicycler and his passenger were positioned in the right front of the painting to redirect the eye back into the composition. With the exception of the rooftop edges of the building and the bicycler, no masking agent was used. The background area—behind windows, signage, and other details—was painted first, working around the lighter areas. I used a generally warm palette.

Strong afternoon sunlight creates shadows and adds a sense of tranquillity to the scene. Signage adds bright color notes.

SATURDAY AFTERNOON AT WYANDOTTE AND WEST FIFTH AVENUE, *15" x 21" (38.1 x 53.3 cm). Collection of John T. McWilliams.*

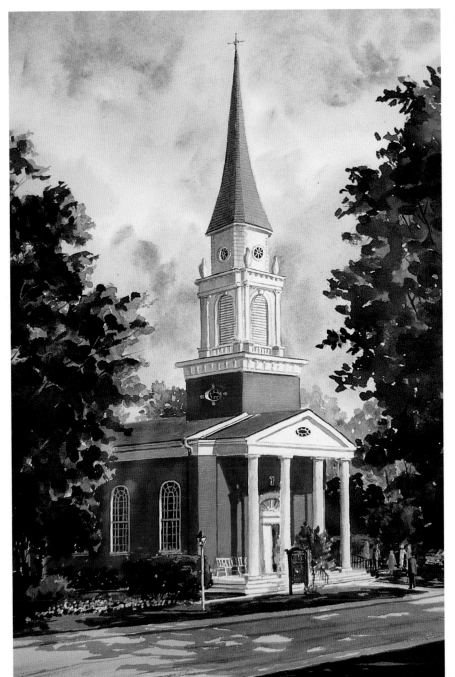

A Day of Rest, A Time of Prayer
When I sketched out this composition, it was obvious it would have to be in a vertical format. To focus all the attention on the light-struck front elevation, I darkened the values of the green in the trees on either side. I treated the entire brick areas as a consistent color. I changed the color value only in the shadow areas. The light brick color was a mixture of burnt sienna, cadmium red, and Naples yellow. I added neutral tint and a little mauve to the same colors for brick areas in shadow.

The Worthington Presbyterian Church catches the full effect of the morning sun. On a bright June morning, shadows from the trees in front of the church frame it with luminous patterns of dark and light. Church members and visitors exchange greetings with the pastor, converse with one another, and then return to their cars. That is the time and setting here. People leaving the church were painted with minimum detail, relying on color to enliven the composition.

SUNDAY MORNING,
*20" x 15" (50.8 x 38.1 cm).
Collection of the Reverend
Jane Mykrantz.*

119

Capturing the Effects of Time

Although this segment of the chapter examines the deteriorating effects of time, I would like to point out that time can also be viewed from an enrichment viewpoint, such as an improvement of appearance—physical, mechanical, structural, and environmental (each with the help of the two-letter prefix *re*) showing restoration or rebirth. However, I have always found that the effects of the progression and duration of time create a wider range of possibilities for employing different painting techniques, such as the indication of rust, weathered wood, eroded land, and the mood created by abandonment, obsolescence, and aging.

CONNECTION TO THE PAST, *14" x 17" (35.5 x 43.1 cm). Courtesy of Windon Gallery.*

Textural and Color Changes Created by Time and Weather

Connection to the Past is a painting of a coupling, a linking device joining two rusted metal boxcars standing idle on an unused railroad siding. The arrangement of the components of the coupling created an unusual abstract combination, which I found particularly interesting because of the rusted metal surface, which showed the corrosive effects of weather. Working from a closeup photo of the coupling, I cropped the elements to obtain the most interesting composition and silhouetted the parts by eliminating any detail in the background.

Connection to the Past was painted on D'Arches hot-pressed 140-pound paper, a surface that makes painting detail with a sharper image easier and yields a different effect when salt is applied to the damp pigment on its surface than occurs on cold-pressed paper. The use of salt contributed the grainy "corroded" effect on portions of the metal surface. I applied it and then scraped it off when the surface was dry.

I encourage artists and students to examine the effects of time on different types and shapes of metal surfaces and to consider this development as a challenging painting exercise, even though it may be only a small detail or section of the vehicle or structure.

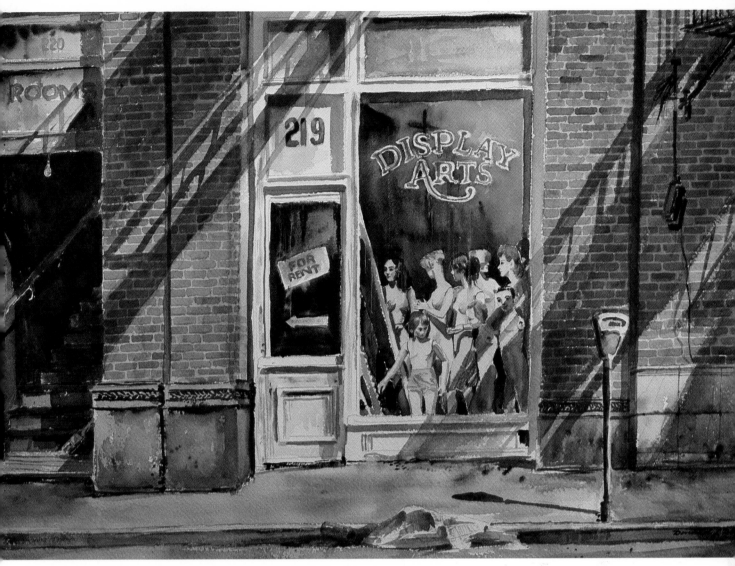

TIME EXPIRED, *19" x 28" (48.2 x 71.1 cm). Collection of Mr. and Mrs. Davan James Dodrill.*

Mannequins Without Merchandise—a Window of the Past

Time Expired was painted from sketches and photographs of a series of storefronts awaiting the wrecker's ball. The naked and semiclad plastic figures in the store window appeared oddly alive and apprehensive, peering in different directions, as though searching for their future. Their polished plastic flesh glistened in sharp contrast to the dingy crumbling brick building, the rickety iron railing above the shops, and the street litter. A parking meter just outside, its red flags up, stated: TIME EXPIRED. The iron railings and remnants of a rusted fire escape leading to the floors above the shops created diagonal shadows across the brick front and window. I played up the shadow effects to a more intense degree than actually existed to create additional compositional interest and to focus attention on the mannequins. When painting shadows across a brick surface such as this, I generally paint in all the bricks in the light areas, first changing some of the values in individual bricks. The shadow is then painted, using a value of the brick color that is approximately fifty percent darker than the average brick in the light-struck area. When the shadow crosses the lighter areas, such as the window frame and the mannequins, the value is also darkened to about fifty percent, keeping in mind that it must be the same basic color as the surface crossed, only deeper in value.

THE EXPERIMENTAL SERIES
Letting Imagination and the Medium
Set the Painting Direction

Experimentation can be pursued by concrete or abstract research, but exploration should always be directed toward artistic development or progress. One should always proceed on an individual basis, but every artist should remain open to any new and challenging aspect that will extend and enliven his painting potential.

The stimulus for experimentation can come from anywhere. In previous chapters, I have shown how man and the environment have been used as inspirational factors in creating paintings. In this chapter, I will show work that derives its inspiration from the unconscious: from imagination, mental images, dreams, and intuition.

A sense of experimentation can lead an artist to begin a painting without the slightest idea of what the final result may be. In this approach, he simply applies paint and any added painting aids, such as salt, for example, to a thoroughly wet paper and allows the applications to take their own course. New colors may be added at different stages of drying, and sponging may be used, to a degree, to mop up and control areas of the painting. By tilting or holding the paper in a vertical position, he can enlist the force of gravity to create certain runs of color. As the paint dries, it may assume a direction that the artist can follow, perhaps toward some form suggested by the paint itself, which can be interpreted either as objective reality or as abstraction.

Contemporary painters who use water mediums—such as Marilyn Hughey Phillis, A.W.S., of Wheeling, West Virginia, and Mary Todd Beam, N.W.S., of Cambridge, Ohio—have produced many award-winning

RENDEZVOUS

My hand records the vision
of the mind,
A scene not seen by eyes of
mine,
Yet somehow I feel I'll find
A place akin to this in time,
Where strangers who aren't
strangers meet
From worlds apart and
rhyme,
Each somehow knowing each.
Was it a rendezvous that's
déjà vu
From another life? another
world?
A dream I've had. Or is it
true?

watercolors based on their interpretations of the cosmos. Sometimes their subjects are recognizable as elements found in nature—water, rock, leaf patterns, blossoms—or other even less definitive elements of time and space, arranged into abstract composition. Or their paintings can be emotional interpretations of mental images, consisting of flowing colors and exciting shapes that form compositions designed to involve viewers in the completed work. I find their work conceptually thought-provoking.

Another experimental approach I tried involves the use of photomicrographs, photographs taken through the lens of a microscope. Photomicrographs of microorganisms are frequently illustrated in medical journals and biology and chemistry books. These illustrations are particularly interesting for their new vistas of color use and for the innovative combinations of shapes and shape relationships that are suggested by these images, normally not seen by the human eye.

Sometimes I randomly mask out strips, panels, or shapes on watercolor paper before it is wet and the paint is applied. As the painting proceeds, these areas are then worked into the composition. What results can be realistic, impressionistic, or totally non-objective.

I have done several painting demonstrations in which I have completed a traditional rendition of a scene and then reinterpreted it, using an entirely different color palette and painting approach. You will see an example of this type of experimentation under the heading "Reinterpreting a Realistic Painting," later in this chapter.

Dream Images

Most of us have had vivid nighttime dreams—thoughts or images passing through our minds while we've slept. Sometimes these thoughts or images, some of almost unreal beauty, are retained hours after awakening. Several paintings I have produced have originated from this source. If, upon awakening, a dream has triggered the kind of visual or emotional response that a painting can be based on, I make notes or even sketches of the image still etched in my mind. *Rendezvous* (below) is an example of this source of inspiration. Other paintings in this section, although not originating from nocturnal dreams, are based on mental images gleaned from various visual experiences or even dreamlike thoughts that have left a lasting impression on my mind. Sometimes the remembered concept is fragmentary or incomplete, but the essence is strong enough to base a painting on it. *Sunken Treasure* (page 125) and *Red Sun at Night* (page 124) are examples of these images based on previous perceptions.

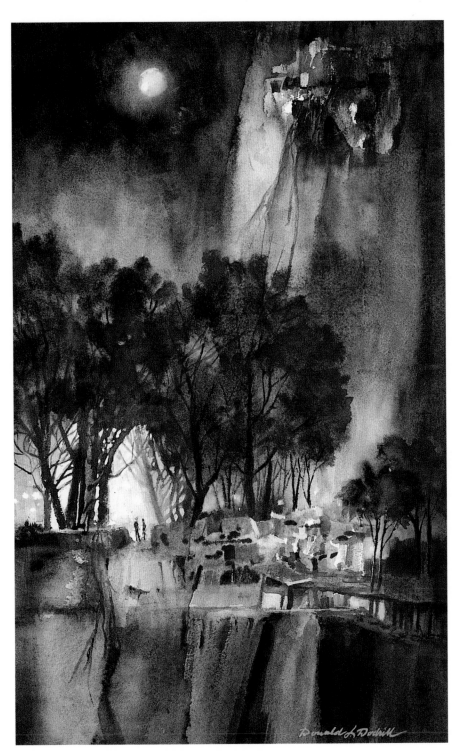

Creating a Painting Concept from Dream Images

Dream images can be so vivid that they remain as strong impressions in our minds for days. Such was the case of *Rendezvous*. I was never entirely sure whether I was a participant in the scene depicted in the painting or simply a viewer. But the impression of the bright circular object in the sky—either a moon or a mother ship— was very clear in my memory, as were the dark trees, steep cliff, bright background, and the two almost insignificant figures silhouetted in the middle ground of the painting. The impression was so strong that I sketched out the basic elements the very next day.

I used the maximum contrast of strong dark values and strong light values to create the impression of a night scene, which lingered with me from the dream. I used a plastic scraper to bring out some highlights on the cliff and in the foreground rock. I used masking on the circular sky-shape and the central bright areas behind the trees. My color palette consisted of sepia, burnt sienna, Prussian blue, Naples yellow, and Indian yellow.

RENDEZVOUS, *19" x 14" (48.2 x 35.5 cm). Collection of the artist.*

123

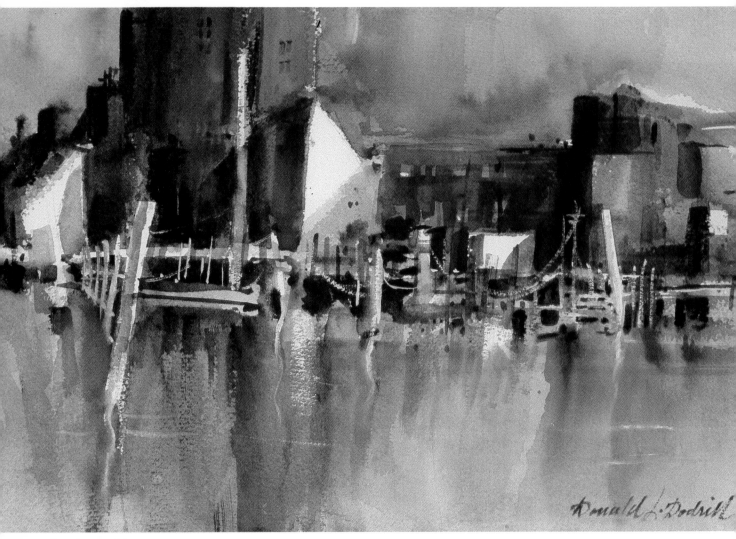

RED SUN AT NIGHT, *13" x 17" (33.0 x 43.1 cm). Collection of Mr. and Mrs. Roland Lane.*

Imaginary Images of a Waterfront

Although this painting is entirely imaginary, it has elements I remember from visiting several commercial docks along the Atlantic Ocean. Again, the composition originated from the strips and pieces of paper I had pasted down before applying any color washes. These paper segments preserved the paper-white areas. Later, when the large areas were painted, these smaller sections constituted the compositional framework. I used five colors—cadmium red, cadmium yellow, mauve, cobalt blue, and burnt sienna.

I find that experimental painting of this nature aids in keeping me aware of the overall composition and limits my concern for minor details that do not necessarily contribute to the finished painting. Color, shape, and composition take precedence.

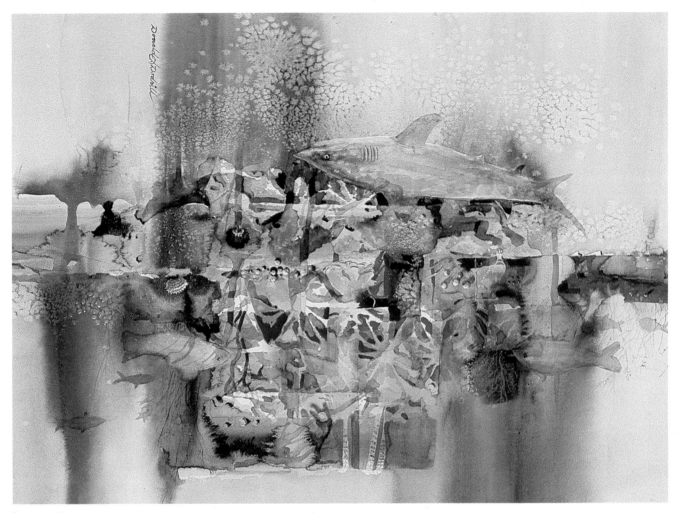

SUNKEN TREASURE, *15" x 20" (38.1 x 50.8 cm). Collection of Samuel Ladrach.*

Letting the Medium Assist the Imagination

This painting took its inspiration from remembrances of a number of slides of under-
water scenes. But it is a completely imagined work, without photographic reference. I
had sketched some of the painting elements—the shark, for example—many times be-
fore, from various species that our son, Jon, had caught in the Atlantic Ocean. Before I
started this painting, I pasted down several small pieces of paper doilies and cutouts to
the painting surface with rubber cement; the pattern resembled intricate wheel spokes.
After applying the first large washes of cobalt blue, cerulean blue, and viridian to the
wet surface, I dropped salt onto the middle and foreground areas. When the paper
dried, I removed the doilies and brushed off the salt. Than I worked in smaller areas,
taking advantage of the created shapes and the effect of the salt. I sponged out parts of
the background to clarify shapes and intensify color. The area near the top of the paint-
ing reminded me of a treasure chest with its contents overflowing . . . hence, the paint-
ing's title.

Imaginary Painting Concepts Derived from Nature

Nature offers an infinite variety of painting possibilities untouched by the hand of man—the tiniest crevice or the largest canyon; the smallest pebble or the largest boulder; a flower or a forest; a twig or a trunk—passages of the Earth and all its natural phenomena designed as if for the artist alone.

Of all the imagery created by imagination or memory, I find that natural phenomena are the most easily remembered. Mental images of rocks, trees, flowers, snow, grass, sky, and water are with us throughout our lifetime, reinforced in time by visual observation.

As an exercise in painting imagery, focus mentally on a natural phenomenon, one not momentarily perceived through the senses of sight or touch. Then start to paint.

You will be surprised, perhaps even amazed, by how the mental image, in the absence of concrete stimuli, can be transferred from your mind to the paper's surface— not so much in detail but in essence, an embodiment of the sense of perception and emotion, always more important than exact detail.

Creating imagery in painting is somewhat akin to creating passages in music, images in poetry, or imaginary numbers in math.

The four paintings in this section are examples of mental imagery of natural phenomena—snow, trees, rocks, roots, and landmasses. Different techniques used to portray surfaces and effects are explained in the painting illustration legends.

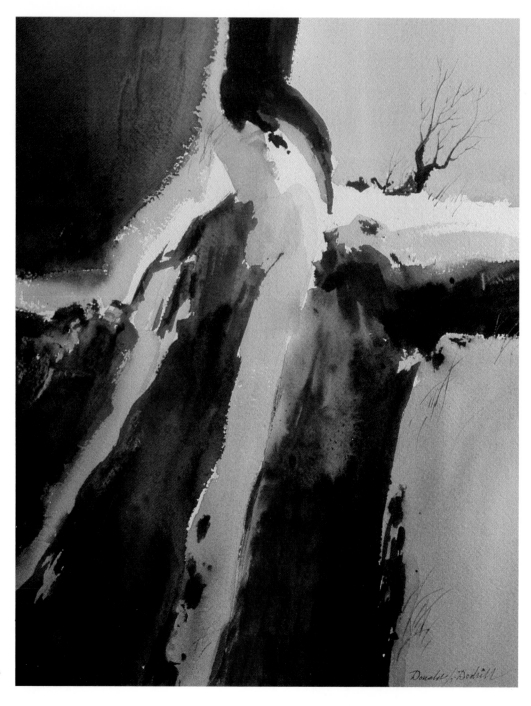

SNOW PLANES,
17" x 13" (43.1 x 33.0 cm).
Private collection.

126

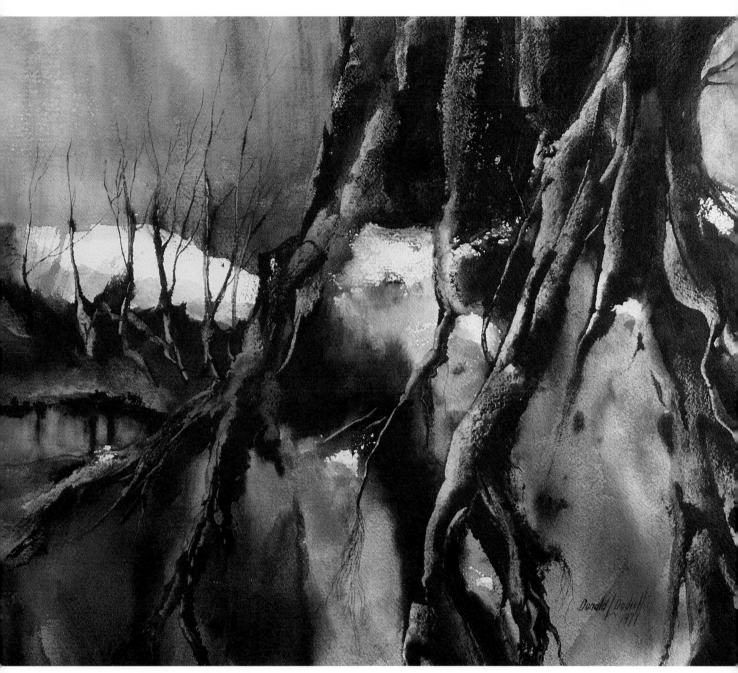

WINTER ROOTS, *15" x 20" (38.1 x 50.8 cm). Collection of Mr. and Mrs. Tom S. Gianas.*

Strong Shapes in a Simplified Composition
Snow Planes is a small, compositionally simple painting with strong vertical and horizontal shapes, each designed to draw attention to the smallest element—a tree—in the upper-right-hand section. I limited my palette to mauve, cobalt blue, burnt sienna, and Vandyke brown because I decided that anything more would detract from the strength of the composition. Lighter values were painted first wet-in-wet; strong dark values were painted after the light values had dried. Like *Snow Planes, Winter Roots* focuses on simple elements of nature—tree roots, snow, sky. I divided the composition into three main areas: the old tree, the sky, and the landmass. I used the wet-in-wet technique in the sky, beneath the tree, and below the horizon. Keeping parts of the paper dry made it possible to retain pure white areas for highlighting the snow.

I used Prussian blue, cerulean blue, and lemon yellow in the wet washes. When the color washes had dried, I painted the tree stump with a mixture of neutral tint and sepia, applied in the large areas with a 2½-inch flat brush and in the root section with a smaller No. 6 sable brush. I used a plastic card to scrape out the bark textures on the tree stump and to delineate the smaller trees in the background. Generally, this technique is most effective when it is used on cold-pressed paper and on large close-up areas requiring a rough effect, such as the tree roots, which dominate this composition.

ROCKS AND ROOTS, *13" x 17" (33.0 x 43.1 cm). Collection of Beverly Johnson-Nahman.*

Experimental Shapes of Natural Elements

Rocks and Roots is similar in composition to *Winter Roots* except that the vertical element is positioned more centrally and the rock and root elements are more detailed. I used a smooth-surfaced hot-pressed watercolor paper, which permitted finer detailing and allowed another variation in using the plastic scraper to achieve texture. Instead of the heavily textured effect of *Winter Roots,* here is a smooth stonelike surface. Various tonal values affected change in planes and rock surfaces. Liquid frisket had protected the fine rootlike areas, which were painted after the background dried. I emphasized a three-dimensional appearance by indicating root shadows on the rock surfaces.

 Golden Cliffs incorporates sky, land, and water in a compatible relationship with only minimum detail. I used a wash over the entire sheet, consisting of Hooker's green and Davy's gray on a wet surface. When it was about fifty percent dry, I painted the central land area element with burnt sienna, sepia, cadmium yellow, and cadmium red, varying the amount of color throughout. Small, light flecks of the background were permitted to come through various wet-in-wet areas. When the paper dried, I defined certain areas more sharply, such as the darker edges on the cliffs at the right. This experimental approach to a generalized indication of landmass shape shows how you can suggest rock, foliage, and land areas without much detail and use wet or damp surfaces for reflections.

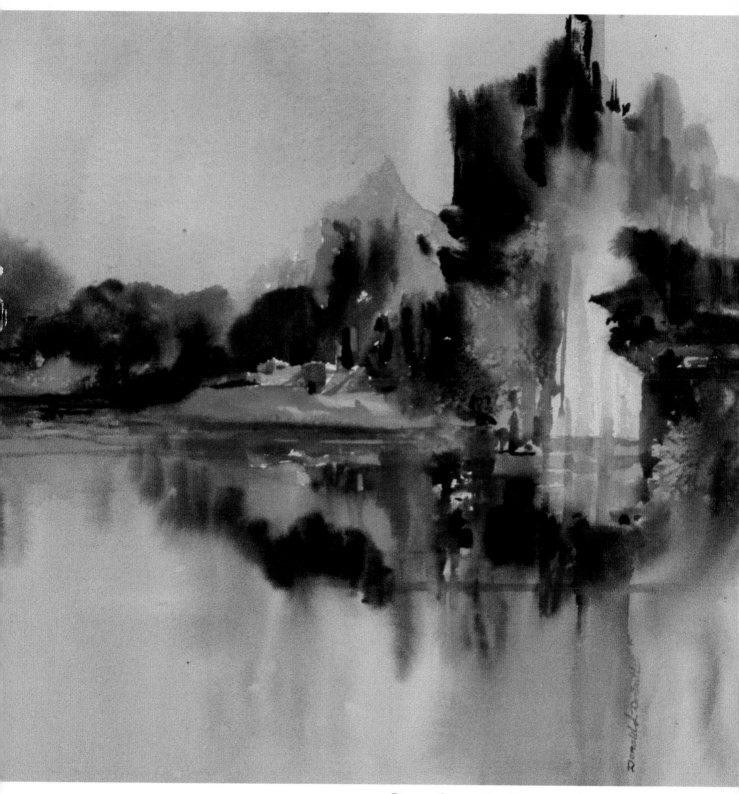

GOLDEN CLIFFS, *19" x 29" (48.2 x 71.1 cm). Collection of Don Barcza.*

Painting with No Preconceptions

The five experimental paintings in this section are basically nonobjective, or abstract, with recognizable elements playing a minor role in their compositions. None of the paintings were based on any preconceived composition or subject. I did not select the color palette beforehand but built upon it and added to it as the painting progressed. To achieve special effects, I used certain techniques, which are explained in the captions. The watercolor medium itself becomes a guiding force in this approach.

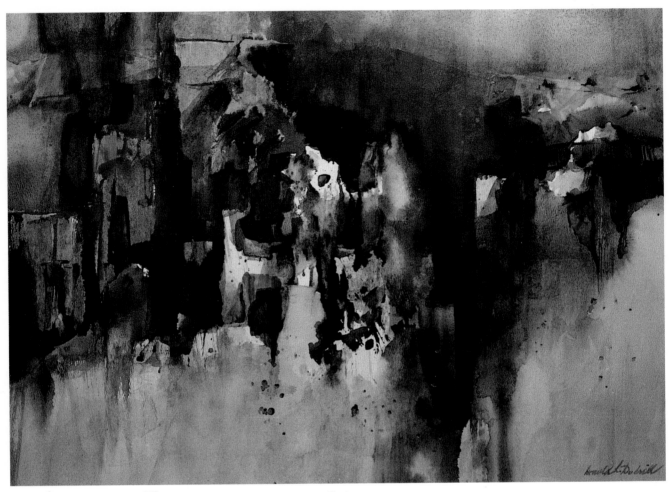

FRAGMENTATION OF THE WALL, *15" x 20" (38.1 x 50.8 cm). Private collection.*

Using the Watercolor Medium as Creative Force

Fragmentation of the Wall is an exercise in taking advantage of the "happy accidents" that can occur when painting in transparent watercolor. I used a strong color palette—cobalt blue, Prussian blue, cadmium orange, cadmium red, cadmium yellow, and cobalt green, with a small amount of burnt sienna—and brushed into the prewet surfaces of the paper, blending in some areas. I let the paint run toward the bottom, tipping and turning the mounted paper to achieve the most interesting effect.

Before starting *Mechanization of Man*, I randomly pasted down circular wheel shapes cut from paper onto the surface along with a few slivers of paper positioned vertically and horizontally, and then wet the entire surface. To experiment further with blending colors, I used a wider range of pigments—cadmium yellow, cadmium red, mauve, cobalt violet, cobalt blue, alizarin crimson, cobalt green, and Davy's gray, working with the lighter colors first, followed by the darker ones. I sprinkled a generous amount of salt and a small amount of starch into the bottom portion of the painting and let the painting dry. When I removed all masking elements, I brushed off the salt and starch and used brushwork on those areas that had been masked out. Some shapes, such as those that evoked the human form, were sponged out.

Sun, Land, and Sea was an experiment in working predominantly wet on dry surfaces, with wet-in-wet treatment for special effects. I had loosely penciled in the abstract shapes and painted in the two major shapes—the sky and midnight blue "sea" in the foreground. I worked around the rectangular shapes at the horizon. Still working on dry paper, I brushed gray, blue, and green values into the areas I had painted around. Then I used a combination of sponging and scraping to create texture and differentiate values. Careful sponging with a cotton swab created the tree shapes and some of the finer negative shapes. I added small dark negative areas to a portion of the lighter areas to increase textural interest. Last came the orange sun and red and orange accents.

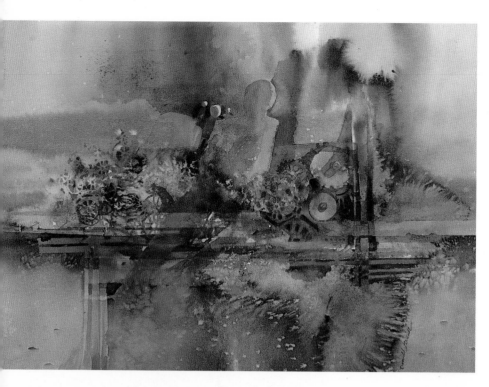

MECHANIZATION OF MAN,
*19" x 29" (48.2 x 73.6 cm). Courtesy of
Windon Gallery.*

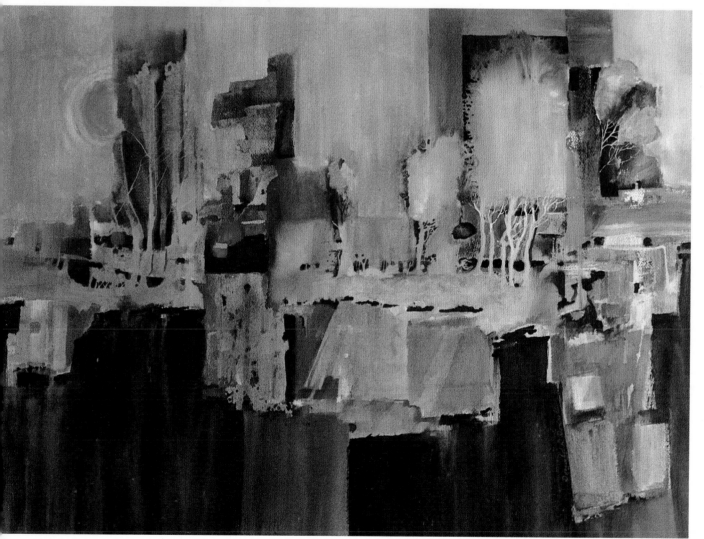

SUN, LAND, AND SEA, *16" x 24" (40.6 x 60.9 cm). Collection of Frank Keusel.*

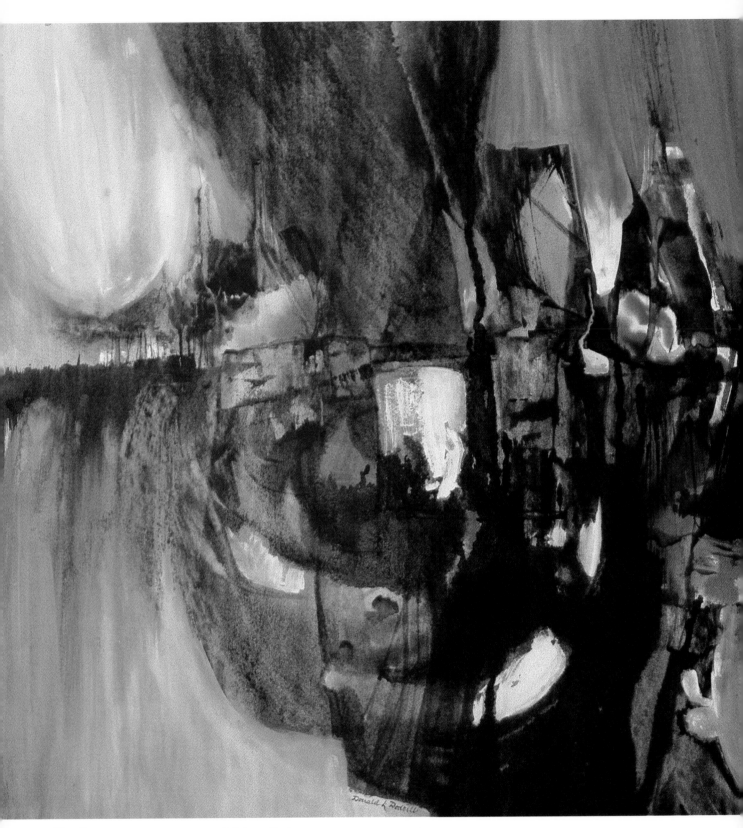

CITY LIGHTS, *16" x 22" (40.6 x 55.8 cm). Private collection.*

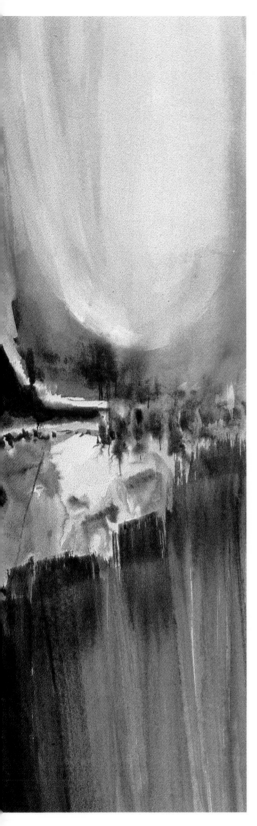

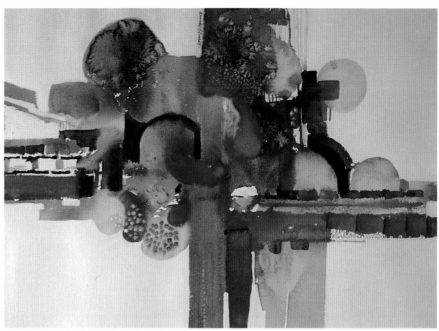

OVAL SHAPES AND COLOR RUNS, *14" x 19" (35.5 x 48.2 cm). Private collection.*

Forays into the Abstract

Although *City Lights* was a completely abstract painting, the experimentation process opened new avenues for me, principally in the use of a variety of brushstrokes but also in the combination of hard and soft edges. The light blue areas around the central dark shape were painted first wet-in-wet, with vertical strokes to create a streaked effect. Sponging out the center in the light blue areas created a halation effect indicative of a light source. As the shapes evolved and the painting neared completion, the image of lights became more prominent—some shining through haze, some bright, some colored, like those you see in the city at night while peering through half-closed eyes. And so I named the painting *City Lights*.

 Oval Shapes and Color Runs is an experimental abstract painting based entirely on transparent color runs and blending, with texturing created by wood pencil shavings in the upper right-hand corner and small pieces of rock salt in the lower left-hand corner. At various times in the drying process, color was dropped and brushed on the wet paper surface and left to blend and run. The painting was totally soft-edged at this point, and I left it to dry. When the transparent washes were completely dry, I painted in the background area in acrylic white, outlining the various transparent shapes, reshaping some, separating others, and painting in small negative areas.

Compositional Concepts Derived from Preselected Elements

The paintings illustrated in the previous section were entirely imaginary, without the reliance on any preconceived element or reference material. The four paintings illustrated in this section, although still predominantly abstract, were more preplanned compositionally. The painting below, *Landscape Masks*, derived its concept from the study of a photomicrograph of a microorganism.

Using this more preplanned approach, I usually work out the composition loosely on a sketchpad before I begin work on the painting. Most of the detail and painting nuances are added as the painting progresses.

A more limited color palette was also employed in these four paintings, particularly *Landscape Masks* and *Shadows and Shapes Suspended* (page 137). I find that some watercolors painted in the abstract vein have a stronger visual impact when the palette consists of one dominant color or a few related colors.

Three of the paintings in this section, *Dock Birds* (page 135), *Alien Landscape II* (page 136), and *Shadows and Shapes Suspended* use masking tape to reserve shapes when painting wet-in-wet backgrounds. *Landscape Masks* relies on leaving dry paper areas when working with wet washes.

Inspiration Stemming from Photomicrographs

Through the years, I have collected examples of illustrations of photomicrographs from medical journals and technical publications in various fields. These illustrations show minuscule elements of nature, microorganisms, and minerals, which open a whole new world of color, shape, and shape relationships to the artist.

Landscape Masks was inspired by this type of reference, a photomicrograph of a microorganism that I found to be unusual in both color and form. The image stimulated me to a fresh way of looking at shape relationship and color selection. My finished work was a complete rearrangement of shapes into a unique composition, one with much greater impact.

Landscape Masks is basically a blue and green painting with only a touch of cadmium yellow and cadmium red in certain areas. Most of this painting was done on a wet or damp surface so that soft edges were formed to complement the hard-edged elliptical shapes that evolved as the painting progressed. From an experimental standpoint, I find that working from this source of reference material develops exciting leads to a fresh creative inspiration for many design approaches, both realistic and abstract. At a certain stage, this painting looked like an exotic landscape. As the shapes were completed, they appeared to have a masklike quality, which suggested the title to me—*Landscape Masks*.

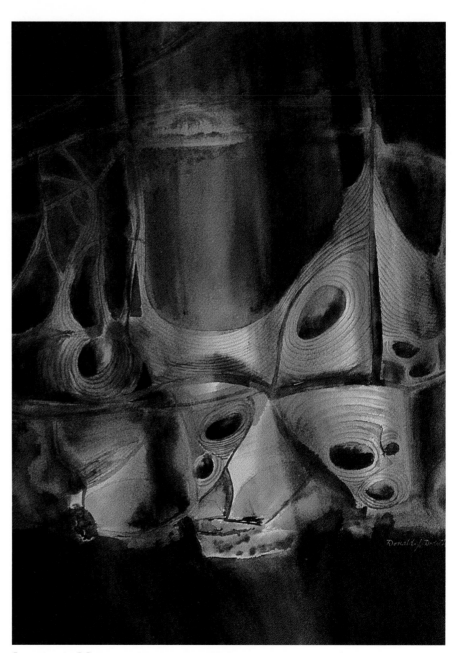

LANDSCAPE MASKS, *24" x 16" (60.9 x 40.6 cm). Private collection.*

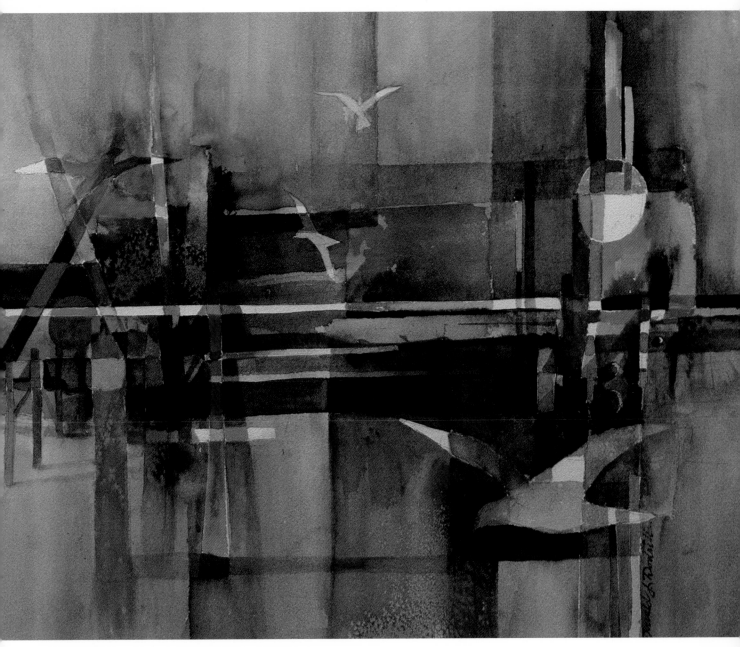

DOCK BIRDS, *15" x 20" (38.1 x 50.8 cm). Collection of Rhoda Zaner.*

Creating an Abstract Composition from a Theme

Dock Birds was painted as a class demonstration to illustrate how certain key elements, or a theme, can be used as a basis for a painting. In this instance, I used two words— *Dock* and *Birds*.

I started to work by masking out four sea gull shapes on the paper in different positions and in various size relationships. Also, I placed strips of masking tape both vertically and horizontally on the unpainted sheet to approximate dock pilings and masked out three circular shapes at random. These elements set the parameters of my painting. When some of the large background washes had been painted, I removed the masking at various stages during the painting and drying. While the surface was still damp, a pinch of salt was also sprinkled in certain painted areas. To relate the circular, vertical, and linear shapes and the masked-out sea gulls. I allowed transparent areas of various colors to overlap these white areas. In other areas, I kept the pure white of the paper. I felt that the white areas of the paper provided a certain rhythm of movement that helped carry the viewer's eye through the composition. *Dock Birds* is an experiment in working from preestablished elements and combining them with unplanned elements in a painting.

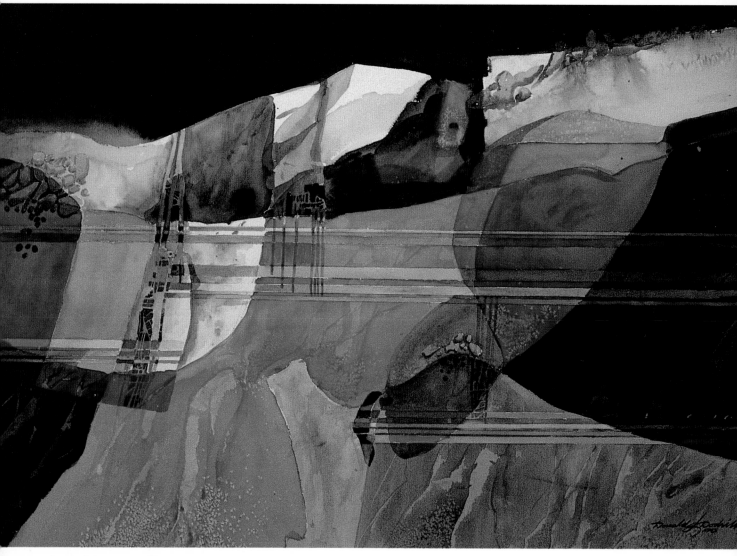

ALIEN LANDSCAPE II, *19" x 29" (48.2 x 73.6 cm). Collection of Mr. and Mrs. Tom S. Gianas.*

Combining Large Shapes with Linear Color Strips

In this experimental painting, careful preplanning and rearranging of shapes was worked out before the painting was begun. On a 15 x 10-inch sheet of drawing paper I sketched out several possible shape arrangements and indicated values in graphite in dark, medium, and light tones. After making a selection, I projected the image in linear form onto a full sheet of watercolor paper. I then cut several strips of masking tape of varying dimensions and taped them parallel to one another on the surface, experimenting with the distance between the strips and their position on the paper. Next, I proceeded to work in the individual pencil-outlined areas, putting in the lightest color values first and then adding the darker values as each area dried. Some wet-in-wet treatment was used in individual areas, and I used the plastic scraper and salt to create texture in certain larger shapes.

When all the color areas were dry, I removed the masking tape and painted the stripes, playing down the value of each colored stripe as it intersected another color and shape. For the final touch, I painted in a few details and some color overlaps.

The experimental value of this painting was directed toward shape and color relationships and value changes of intersecting elements. I named the work *Alien Landscape* because of its resemblance to a landscape—though not one of this world.

SHADOWS AND SHAPES SUSPENDED, *19" x 28" (48.2 x 71.1 cm). Collection of Windon Gallery.*

The Interplay of Dimensional Shapes Within a Confined Area

As in *Alien Landscape*, the major shapes in this painting were arrived at through pencil sketches before the painting was begun. I selected my color palette before beginning: Davy's gray, mauve, cobalt violet, burnt sienna, and Vandyke brown. I had not used this procedure in the previous experimental paintings.

After lightly penciling in the large vertical and horizontal shapes, I applied strips of masking tape up to two inches in width along with tape strips of narrower dimensions to areas in both the large vertical and horizontal panels. In the central horizontal panel, I cut masking tape into a number of small, irregular rectangular shapes and angled some, overlapped others, and positioned still others vertically and horizontally. The background was then painted in Davy's gray on a prewet surface separated from the large shapes by masking tape. When the background was dry, the large cross-shaped element was painted using a mauve, burnt sienna, and sepia palette. The masking tape, which had been positioned on both the horizontal and vertical panels, was removed at various stages of the painting, and a selection of colors and color values was painted into the stripped areas. A few of the strips were left paper-white.

I added darker values of the same colors to the edges of the individual shapes to create a feeling of dimension. Shadows cast from individual elements onto the background also added to the three-dimensional effect.

Although certain procedures used here are also similar to those used in *Alien Landscape*, the compositional elements are entirely rectangular and linear as opposed to curved shapes. *Shadows and Shapes Suspended* is also an experiment in the use of color values to create spatial depth on a two-dimensional surface.

Reinterpreting a Realistic Painting

Although most of my paintings are in a realistic vein, I find it helpful at times to explore the avenue of reinterpretation. I sometimes go back to a painting that I had done previously in a realistic bent and repaint it using the same pictorial content but altering color, composition, and painting techniques. Sometimes the results are disappointing, but often exciting things happen and a whole new mood and atmosphere emerges. It is an exercise in looking at the same subject or idea from a different viewpoint and with a different emotional input. It is a way of developing the desire to interpret rather than record.

Beached Boats I (below) and *Beached Boats II* (page 139) are examples of the "before" and "after" of this approach. Obviously, reinterpretation is limited only by the imagination and creativeness of the artist—an infinite number of solutions are possible. Try it as an exercise in opening new avenues of expression as well as gaining experience from using the watercolor medium divergently and with different painting tools.

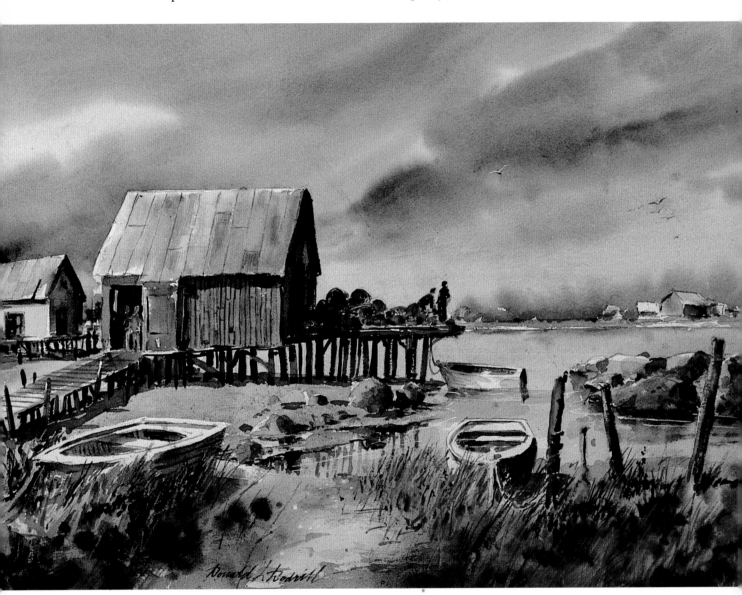

BEACHED BOATS I, *15" x 20" (38.1 x 50.8 cm). Private collection.*

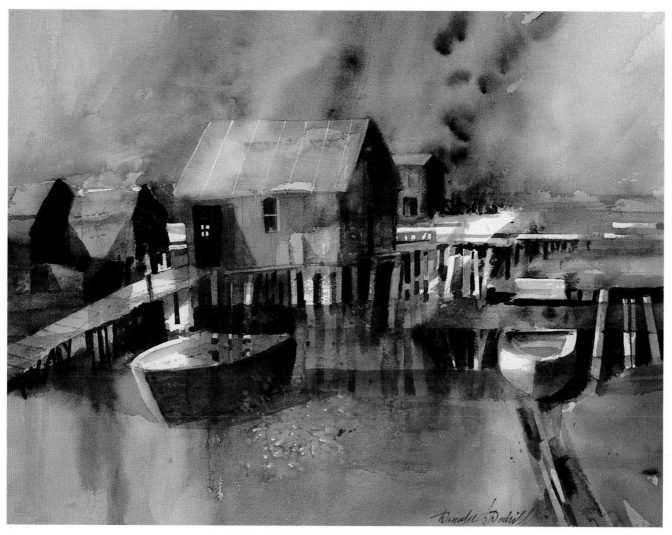

BEACHED BOATS II, *15" x 20" (38.1 x 50.8 cm). Collection of Gail Miller.*

Variations from Similar Pictorial Elements

One of the experimental procedures that I use from time to time is to reinterpret a painting that I have done in the past, using the same elements but altering mood, color, and composition. *Beached Boats I* is a painting from my coastal series from the late 1970s. The basic elements—weathered fishing shacks, docks, boats—were used in *Beached Boats II* but in a somewhat different arrangement. I made the dock area to the right of the fishing shack a light area, the reverse of the original painting. I used masking on the middle-ground dock and on the boats to secure the light areas. I did not mask the roof areas of the building, although I had done so on the original painting. From this point on, *Beached Boats II* was primarily a wet-in-wet painting, using mainly three colors—cadmium yellow, cadmium red, and cobalt blue, with neutral tint to deepen and strengthen the values. I wet the entire surface, and I brushed cadmium yellow into the wet surface, quickly letting it spread in stronger and lighter values at different places in the composition. This procedure was followed by similar applications of cobalt blue and cadmium red. While the surface was still wet, neutral tint was painted

onto some areas to bring down the color intensity. A few grains of salt were placed in the foreground area to the right of the larger boat. Blending the three colors created other colors—a dull green, aqua, burnt orange, grays, and browns. I let the painting dry and then brushed off the salt and removed the masking. I defined planes in the building and boats and added and strengthened areas behind the dock pilings, using the neutral tint mixed with cadmium red, cadmium yellow, or cobalt blue as the color of the area being defined required. In evaluating the two paintings, I believe *Beached Boats II* has a more dramatic emotional content and that the light areas lead the viewer through the composition with greater ease. Although the painting lacks control in certain areas, and in other areas, the color values, such as the roofs, may be difficult to separate from the background, many interesting combinations occurred, which did not happen in the safer, more traditional way of working.

This form of experimentation can be used to reinforce or to enhance specific directions the painter may already be following. Reinterpretations can also relax and loosen a style that may be becoming too rigid and predictable.

FRAMING
The Final Touch

After a painting is completed, and here we are referring to works on paper, the next step is to specify framing, a problem in design. The framing process involves choice of a frame, insert mat, and glass. There is a wide variety of mat boards, molding styles, and glazing materials from which to choose; yet the choices are not simple.

Technically, a frame protects a painting against many kinds of damage, the wear of time, soil, jostling. However, the technical role a frame plays is secondary. The primary role a frame plays is to limit precisely the extent of surface that a viewer is to consider. Once the space has been defined, consideration must be given to the relation between the painted area and its surroundings or environment. It is the frame that supplies this definition, providing a transition from one surface to another—from the imaginary world of the image to the real world of the wall.

Frame and insert mat selection often involve personal taste. Some clients insist on being "do-it-yourselfers" and make their selections at a frame shop or build their frames in a basement workshop. Other clients are eager to work cooperatively with the artist or an interior designer in frame and insert mat selection and use the services of a professional framer.

Although I specify frame moldings, insert mats, and glass for my paintings, I have for several years worked with a professional framer, Maxine Tracy in Columbus, who provides quality in materials and workmanship. Long ago I decided this was the best route for me. I believe an artist has to decide if he or she wants to be a painter or a framer. I also firmly believe that a painting displayed in a private gallery or shared with the public in an exhibition should be professionally framed to show to best advantage. If a painting is worth keeping, it is worth framing well.

Literally, a frame can be many different forms; it can take any shape, any color, and be made of almost any solid material from tape to precious metal. Here our discussion of framing materials is limited to wood and metal moldings.

In terms of design, there are no absolutes, no specific rights and wrongs about what a frame should be. Aesthetically, a frame should blend with the style of the painting, although it needn't be of the same period. In size, it should be in proportion to the work of art and not overwhelm it or underdefine it. Other aesthetic elements should also be taken into consideration, such as color, values, texture, and mood of the work.

Historically, the need for frames arose when there was a demand that paintings be portable. Prior to that time, works were done with suggestions of borders, or they were a part of architectural elements. The first framers were painters who considered the painting and frame as a whole. As demand for portable paintings increased, artists had to decide between painting and framing. Frame artisans evolved into artists themselves and, toward the end of the sixteenth century, frames became very elaborate in design, embedded with mother of pearl, glass, and other decorative material, most often overpowering the painting. By the seventeenth century, frame making was a recognized guild. The finest frames of the period were carved, gessoed, and gilded. They were followed by frames cast in plaster and gilded, often very contrived in appearance. By the end of the nineteenth century, painters, especially the Impressionists who were concerned with light, color, and texture, rebelled against all the gingerbread and began constructing their own frames, wedding art and frame design. Although the works of the Impressionists were predominantly oils, many of their frame designs were (and still are) applicable to watercolors.

Today, artists have a wide choice of frame moldings, profiles, and colors in both wood and metal frames. Usually for landscapes or seascapes, I will specify a wood frame because wood is a part of nature. For more abstract works, I may select a metal frame. Georgia O'Keeffe often used metal moldings for paintings; they worked very well for her colorful yet severe style.

In the selection of metal moldings, care should be taken that the molding and hardware fit and that both are strong enough to hold the weight of the painting and glass. I specify Nielsen moldings because they are consistently reliable in construction and finish.

Inserts

While care should be taken during the painting process to keep the edges square and clean, the addition of an insert—a mat—seems to "clean up" the edges. It also serves as a foil for values and colors in the painting and protects the painting from the glass, which may contain acid.

An insert mat can provide a soft transition between subtle aspects of a painting and the frame. It should never overpower the painting or be aesthetically unpleasant in proportion. It is suggested that frame and mat not be of equal widths. Repetition of widths is monotonous.

If there is a perceptual problem, the top and sides of the mat should be the same dimension, with the bottom dimension a half-inch wider. The difference in width at the bottom corrects for a perceptual illusion if the painting is hung above the eye level. The human eye is unable to judge properly the vertical distance between the frame and picture center. An additional one-half inch on the bottom corrects our inaccurate perception. If the

painting is to be hung at eye level, this illusion is not created; therefore, it is unnecessary to have a larger margin at the base.

In addition to a wide range of colors, mat board is available in several textures—linen, silk, pebbled, smooth, cork, velvet, felt, burlap, or special hand-covered cloth. Care should be exercised in the use of textured mats such as burlap or grass cloth because roughly textured mats overpower delicate details of a watercolor painting. Usually the most usable mats for watercolors are made of mat board, linen, or silk. I almost always specify mat board, 100 percent rag, acid-free throughout, plus acid-free tape, etc., with the painting backed up by acid-free foam core.

As for color, each painting presents its own design problems. I would never base a mat color decision on the color of furniture or woodwork but on the painting itself. Care should be taken in the selection of a bright color mat, since the wrong color will distract from the color balance of the painting or overwhelm its values. The human eye tends to be drawn to bright colors.

Personally, my mat preference for my own work is a mat that will not take attention away from the painting itself. A good rule is to use white, cream, eggshell, or pearl, either smooth or pebble finish. On occasion, I will use a three-eighths-inch color underlay mat, selecting a color from the painting, but more often if I do use an underlay mat to secure added depth, I will use the same color as the overlay mat. Some readers may feel that I am ultraconservative concerning the use of color mats, but I believe that for the artist who displays his or her work in a gallery or an exhibition, the focus of attention should be on the painting not the mat. In addition, people have color preferences that may differ from your own, and this very color preference may psychologically discourage a potential buyer.

I like mats to be cut with a beveled edge, which gives the mat an appearance of greater depth and provides an interesting shadow line around the painting image. I specify Bainbridge or Crescent mat boards for my work. I find these brands to have fewer flaws and clean, creamy bevels.

Once a painting is matted, then the work should be photographed. (If you use the services of a professional framer, use a temporary mat for this purpose before turning your painting over to the framer.) Photography at this stage eliminates the problems associated with photographing the work through glass.

Glazing

Glazing is used to cover surfaces that need protection from damage or dust, such as works of art on paper. There are several glazes available on the market today in addition to regular glass. Sixteen-ounce picture glass has greater optical clarity than regular glass because it is thinner and is free from distortions. Also available for glazing is nonglare glass. Although this glass has the advantage of reducing reflections, it also reduces the optical clarity, diminishing visibility of fine details and colors in the painting.

If sun is a problem, Denglas (trade name) may be used. This clear, antireflection glass filters out approximately 45 percent of ultraviolet rays, offering additional protection to the painting. This glass does not distort the image as does nonglare.

Glazing is also available in acrylic or styrene (plastics), which are manufactured in clear and nonglare. Again, if sunlight is a problem, UF3 (trade identification) acrylic glazing also filters out ultraviolet rays.

Although acrylic and styrene glazing is lighter in weight than regular glass and is specified by painting societies for exhibition purposes, primarily because of less danger of breakage in shipping, there are problems involved in the use of these materials, namely, scratching of the surface and sensitivity to ordinary glass-cleaning fluids. If a painting is framed using acrylic or styrene glazing, it is only fair to inform the purchaser of the painting.

Concluding the subject of framing, I quote from Henry Heydenryk's book *The Art and History of Framing* (James H. Heineman, Inc., New York, 1963): "Today it is understood that to frame a painting properly the artist's mood, his intent, must be understood, and that the most harmonious enclosure, the subtle stage that enhances the painting best, is the one that does not distract from the authority of the work of art." To this statement I would add: In framing, listen to your eye.

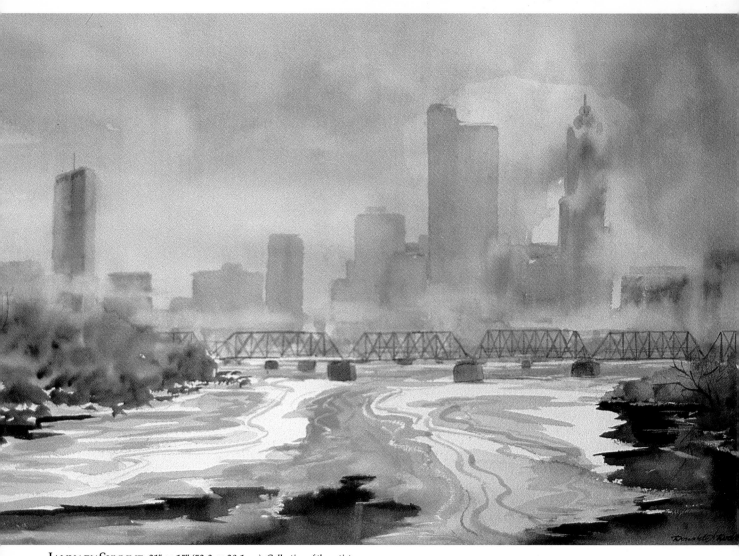

J ANUARY S KYLINE, *21" × 15" (53.3 × 38.1 cm). Collection of the artist.*

INDEX

Edited by Grace McVeigh
Designed by Jay Anning
Graphic production by Ellen Greene